BLACK COUNTRY
MURDERS

BLACK COUNTRY MURDERS

DON COCHRANE

AMBERLEY

Dedicated to my wife, Margaret,
for her help in the research and production of this book

First published 2011

Amberley Publishing
The Hill, Stroud
Gloucestershire, GL5 4EP

www.amberleybooks.com

British Library Cataloguing in Publication Data.
A catalogue record for this book is available from the British Library.

ISBN 978 1 4456 0467 1

Typesetting and Origination by Amberley Publishing.
Printed in Great Britain.

CONTENTS

Acknowledgements 9

Illustrations 10

Introduction 11

The Poisoning of Francis Moreton (Evesham, 1743) 13

The Killing of Daniel Smith (Red-Ditch, 1750) 14

A Den of Thieves (Caunsall, Cookley, 1753) 15

The Murder of John Adney (Pershore, 1753) 17

The Fatherless Barn Murder (Halesowen, 1759) 21

The Murder of Francis Best (Kidderminster, 1771) 23

The Shocking Murder of Obadiah Rollason 25
 (Amblecoat, Stourbridge, 1773)

The Gummery Family Murders (Berrow, 1780) 27

The Murder of Mary Higgs (Belbroughton, 1781) 30

The Barbarous Murder of John Webb (Northfield, 1783) 31

The Murder of Elizabeth Dean (Chester, 1790) 32

Murder Most Foul of Henry Yates (Wolverhampton, 1793) 33

The Murder of William Parker (Swindon, Womborne, 1807) 34

The Murder of Mr. Robins (Stourbridge, 1812) 39

The Murder of Richard Cooke, the Watchman 42
 (Wolverhampton, 1822)

The Murder of Samuel Whitehouse? (Halesowen, 1822) 46

The Murder of Sarah Newton (Bridgnorth, 1823) 50

The Murder of Ann Spencer, at Gorse Cottage 56
 (Wolverhampton, 1825)

The Killing of Joseph Parsons (Rowley Regis, 1827) 61

The Murder of James Harrison (Drayton, Shropshire, 1828) 63

The Murder of Ann Cook (Lye, 1829) 68

The Dreadful Murder of Little Sally Chance (Lye, 1830) 71

The Wilful Murder of William Higgins (Coventry, 1831) 77

The Killing of Joseph Holmes (Blowers Green, Dudley, 1832) 79

The Murder of Mr. Paas (Leicester, 1832) 80

The Murder of Mark Cox (Cradley, 1833) 81

The Murder of Jonathan Wall (Bromsgrove, 1834) 82

The Murder of Joseph Hawkins (Areley Kings, 1837) 88

The Murder of John Orchard (Stourbridge, 1838) 92

The Murder of Christina Collins (Rugeley, 1840) 99

The Coventry Street Murder (Stourbridge, 1842) 105

The Murder of Ann Griffiths (Wednesbury, 1844) 107

The Murder of Lucy Richards (Lye, 1852) 112

The Murder of Mary Pardoe (Stourbridge, 1852) 122

The Murder of Ann Mason (Dudley, 1855) 131

The Murder of David Taylor (Quarry Bank, 1856) 138

The Murder of Elizabeth Millward (Lye, 1856) 140

The Murder of Sophie Ockold (Oldbury, 1862) 142

The Murder of Henry Swinnerton (Coseley, 1862) 151

The Murder of Hannah Thompson (Sedgley, 1863) 153

The Murder of Eliza Sillitoe (Coseley, 1864) 154

The Murder of Alfred Meredith (Woodside, Dudley, 1878) 157

The Murder of Little Jimmy Wyre (Wolverley, 1888) 158

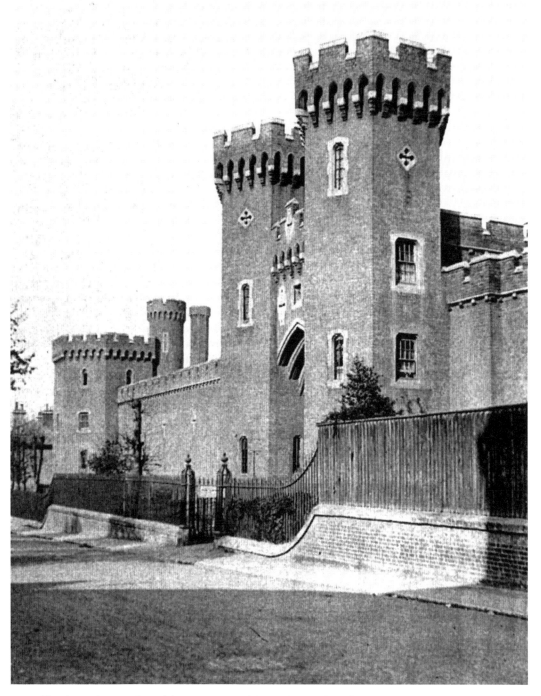

The above photograph is of the twin towers of the gatehouse of the Castle Gaol of Worcester, where at one time murderers and others were publicly executed in front of the gaol, and later on the roof. The gaol once stood in Castle Street, where this photograph was taken in 1927 by A. J. Woodley. (Courtesy of the Holland-Martin family of London)

MURDER.

ONE

Hundred Pounds

REWARD.

WHEREAS *William Hawkeswood*, late of SWINDON, in the Parish of Womborne, in the County of Stafford, farming Servant, stands charged by the Coroner's Inquest with the wilful MURDER by Poison of *WILLIAM PARKER*, of Swindon aforesaid, Gentleman, in whose House he lived as a domestic Servant.

Whoever will apprehend the said William Hawkeswood, or cause him to be apprehended and safely lodged in any of His Majesty's Gaols of the United Kingdom, so that he may be brought to Justice, shall receive

ONE HUNDRED POUNDS,

to be paid on Application to Mr. *John Wilson*, one of the Executors of the Deceased, at Swindon aforesaid.

The said William Hawkeswood is a Native of Pedmore, near Stourbridge, Worcestershire; is twenty Years of Age, about five Feet six Inches high, florid Complexion, his Eyes quick and lively, either hazle or dark blue, high Cheek Bones, full Mouth with front Teeth large and projecting, dark brown Hair, and is slim made.

The said William Hawkeswood had on when he absconded on Friday last, a smock Frock, dark brown lapelled Coat, and white metal Buttons, with cloth Collar, and corduroy Breeches.

December 3, 1807.

A wanted poster printed by J. Rann of Dudley.

ACKNOWLEDGEMENTS

My thanks go to:

Archives Office of Tasmania
Dudley Archives
Guildhall Worcester
Rugeley Library
Shire Hall, Stafford
Shire Hall, Worcester
William Salt Library, Stafford
Worcester Records Office
Wolverhampton Records Office

My thanks also go to PCSO Debbie Gardener, Rugeley; Jill Guest; and Robyn Eastley and Christine Woods of Tasmania.

ILLUSTRATIONS

Gatehouse of Worcester Gaol	7
Wanted poster	8
Rock Tavern	16
Alexandra Road sign	22
Newspaper report	22
Murder handbill, Berrow	28
Stone tablet, Berrow	29
Single-sided bill hook	29
Gibbet Lane sign	41
Dunsley Hall	41
Severn Hall	54
Severn Hall gate sign	54
Sketch of gatehouse of Stafford Gaol	59
Shire Hall, Stafford	60
Stafford Prison entrance	60
The Lime Kilns	70
Map of Lye	72
Sketch of Worcester Gaol	85
Castle Street sign	85
Gatehouse, Worcester Gaol	86
Shire Hall, Worcester	86
Guildhall, Worcester	87
Prisoners in cell	87
Church House	91
Grave of Christina Collins	103
Sorrowful Lamentation for Mary Robins	119
Convict record of Mary Robins	121
Seven Stars, Oldswinford	123
Grave of Mary Ann Mason	137
Christ Church, Quarry Bank	139
Interior of a small nail shop	141
Deepfields Junction Bridge	152

INTRODUCTION

All societies require laws, and all societies require recognised forms of punishment to enforce those laws. One has to realise that twenty-first-century laws and their administration, which most of us are familiar with today, are far more lenient than they were in the past.

In early times there was no police force; law and order was kept by the parish constable, who was appointed by the parish council – the post was part-time and additional to his normal day job. The first uniformed police force was established in 1829 by Sir Robert Peel; they were known as 'Bobbies' or 'Peelers'. Parish constables still continued to serve their parish and assisted the uniformed police until as late as 1852. In the absence of a police force, large-scale insurgency, such as street riots and mob violence, could be controlled by the army, but the army was no use in solving crime.

Minor crimes were dealt with using quick forms of punishment, by humiliation or extreme pain, such as the stocks or the pillory, and whipping or burning in the hand (a form of branding).

The parish constables and early police had no scientific resources to help them solve any crime, let alone murder; cameras, fingerprinting, forensic science and DNA were unheard of. Generally they tended to be totally reliant on witnesses or informers, who were often unreliable, their honesty depending on the size of the reward, and who might even be settling old scores.

The legal officials were very similar to those of today (coroners, judges, lawyers and solicitors) except for one additional man, who came last, after judgement had been made – the executioner or hangman. The latter was well rehearsed in his duties, since many of the people he met ended their criminal careers on his scaffold for crimes other than murder, such as burglary, horse stealing, forgery, rick burning, highway robbery (mugging), assault, etc. In the eighteenth and nineteenth centuries there were more than 220 capital crimes, including murder, for which offenders could be executed.

The most significant person in the legal chain was the coroner, who carried out the inquest on any corpse that had died a sudden death. He was assisted by the surgeons who carried out the post-mortem, and the verdict would be recorded as natural causes, accidental death, suicide, murder, manslaughter, or in the case of a heart attack or stroke, etc., as 'Died by the visitation of God'. If his judgement was wilful murder, he would name the suspect, who would then be arrested, providing there was sufficient evidence, and sent to the Assizes for trial.

The Court Sessions consisted of Quarter Sessions, held four times a year, and Assizes, held twice a year, with some Special Assizes, in addition, when necessary. Both courts tried civil and criminal cases. The Quarter Sessions were conducted by judges chosen from local gentry and clergy, who served as magistrates and were unqualified in law; they tried the less serious crimes. The Assize Judges tried the more serious crimes, including murder, and gave out more

severe punishments. These judges were more experienced in the law, having previously served the Assize courts as prosecution and defence lawyers.

The judges were appointed from London, and each session, Lent (spring) or summer, went around a circuit of County Courts administering the law, spending a few days at each. There were six circuits covering the whole of the country, all starting on the same date. Worcester, Stafford and Shrewsbury were all on the Oxford Circuit. The arrival of the Assize Justices at each county, usually in pairs, with their wives, was treated with a degree of pomp and pageantry. They were met at the county boundaries by the High Sheriff of the county and joined him in his carriage, and a body of Javelin-men would then escort the cortege to the city; they would alight at the Guildhall/Shire Hall, where the commission for the county was opened. This was usually followed by a sumptuous banquet, washed down with the best wines, usually provided by local wealthy landowners from their grounds and cellars. The next day they attended a service at the cathedral or principal church, where they prayed for guidance. Immediately afterwards they would go to their respective courts, and take their seats, and the Grand Jury would be sworn in.

Again, the solicitors, judges and juries relied upon witnesses, rather than real evidence. The judges, many of whom seemed to come from strongly religious backgrounds, seemed to believe there was some divine power in control and that some of the worst criminals under the sentence of death could be reformed, and possibly saved if they put their trust in God, and many openly wept as they pronounced the death sentence on the accused.

The actual reporting of murders by the newspapers at this time was sensationalist, with every gruesome detail being given, not only by the reporter, but also by the doctors and surgeons who examined the corpse and carried out the post-mortem, and once the guilty verdict was reached, the judge lost no time in putting on the infamous black cap and pronouncing the death sentence. (The cap consisted of a piece of black silk material, about nine inches square.) Most executions were in public, within a few days of the sentence being given, sometimes even on the same day, leaving no time for appeals or to correct any mistakes. The general public were encouraged to attend so that they might be deterred from committing a similar offence; they came in their thousands, men, women and children, as if it was a day of public entertainment or 'Gala day',, a festive occasion, which was an abbreviation of 'Gallows Day', a day when a number of prisoners could be hung in one go.

Finally, the poor wretch, in the last remaining moments of his life, and even after the hood had been placed over his head and the noose carefully adjusted around his neck, still had one final act to perform before he was launched into eternity – this was to signal, by dropping a white handkerchief, that he was ready to meet his maker and his victim(s)!

The newspapers then described the scene of the hanging and what happened to the corpse afterwards, putting in every detail, leaving nothing to the imagination.

The pay of executioners was poor, but strangely there was always a list of applicants, both male and female, who were willing to do the job, which must have had some attractions!

Early hangings were crude and inhuman, a rope and a convenient tree being all that was necessary to provide 'the means to the end!' The victim was hoisted up, by the neck, on a rope slung over the branch of the tree, and died by strangulation, and not instantaneously, taking at least half an hour to die. Hanging off a ladder, by turning the ladder over, rarely produced sufficient drop required to break the neck; neither did dropping off the back of a cart.

THE POISONING OF FRANCIS MORETON AT EVESHAM

WEEKLY WORCESTER JOURNAL, 5 JANUARY 1744

Last Saturday Elizabeth Moreton, otherwise Owen, was committed to the Castle Gaol by William Churchley, Gent. Coroner of Evesham, for murdering with Poison Francis Moreton, her Husband. She is a very young Woman, and 'tis said she had been married about a Year, and that she is at present big with Child.

Worcester, 29 March 1744
Elizabeth Moreton, otherwise Owen, who was sentenced at the last Lent Assizes to be drawn and burnt, for feloniously and traitorously poisoning her Husband, she pleaded her Belly, but being found Quick with Child, her Execution was respited, was called to the Bar, and having nothing to say why Execution should not be awarded against her, she is order'd to be executed according to her former Judgement, which is to be Friday 7'Night [se'nnight, i.e. seven nights, or seven days], the 10th Instant, near Evesham and at the Place where she committed the horrid Fact.– She will be convey'd from the Castle very early the same morning.

Worcester, 16 August
Last Friday Elizabeth Moreton, alias Owen, condemned at the last Lent Assizes to be burnt for poisoning her Husband and whose Execution was respited on pleading her Belly, was pursuant to her sentence, executed near Evesham, (the Place where her late Husband liv'd) in the Presence of a vast Number of Spectators, many of whom were greatly surprized at the shocking Sight.

Elizabeth Moreton was said to be twenty-two years of age when she was burnt at the stake, close to the place where she poisoned her husband. The charge for a crime of this nature was 'Petty Treason', which was punishable by death by drawing to her execution and burning at the stake rather than hanging and quartering, which would be the punishment for men. At the time of her trial 'she was big with Child' and was examined and found to be 'Quick with Child' (near her time) and is said to have pleaded her 'Belly', which gave her some respite or delay in her execution, until she had had her child. Shortly afterwards she was executed; what became of her child is unknown. 'Drawing' means being tied to a hurdle (a form of fencing) and dragged by a horse to the place of execution. Guy Fawkes was never burnt, except on bonfire night; he and his fellow conspirators were sentenced to be drawn, hung and quartered, i.e. drawn on a hurdle, then partly hung, followed by being quartered, beheaded and other mutilations.

THE KILLING OF DANIEL SMITH
OF RED-DITCH

WORCESTER JOURNAL, 14 MARCH 1750

On Tuesday last ended the Assizes here, when the three following persons were capitally convicted, and receiv'd, the Sentence of Death, viz. William Mackcolly, for the murder of Daniel Smith, a Baker, at Red-Ditch; Anthony Craddock for returning from Transportation and since that stealing a Bridle, and Saddle out of the stable of Jesson Humfray; and Francis Hemming, for breaking into the house of Walter Steward and stealing there from several things: but before the Judges left this City they were pleased to reprieve Francis Hemming; and the execution of the other two will, we hear, be next se'nnight the 27th instant. –

Worcester, 28 March
Yesterday, between 11 and 12 o'Clock, William Mac Auly and Anthony Craddock, condemn'd at our last Assizes, were carried in a Cart, to the Place of Execution, where they remained about an Hour before they were turn'd off. [This is presumed to mean 'Turned off a ladder'.]

They hung about three quarter of an Hour, then, being cut down, their Bodies were put into Coffins, and deliver'd to their friends. – Both of them very devoutly join'd in the prayers, and Mac Auly addressing himself to the People, desir'd them in pathetick Terms, to take Warning by his unhappy Fate, exhorting them, in particular to be very observant of the Sabbath Day; to avoid Drunkenness, Profaneness, and Debauchery, which have brought such Numbers, to so untimely an End; concluding with a declaration, that he was in perfect Charity and Forgiveness towards all Mankind, and in humble Confidence of Forgiveness from God resign'd with great Courage, to his Divine Will, dying in the Faith of the Church of England.

Up until 1812 most condemned prisoners were executed at the County Gallows at Red Hill, and some were executed at the City Gallows, at Pitchcroft, better known today as the racecourse. Elizabeth Morton and Walter Kidson were exceptions; they were executed in their home towns.

There are other places where executions are thought to have taken place, such as Gallows Brook, near Hagley Hall, named after the gallows which might have stood nearby, and the Gallows Elm Tree, which stood in a field at Kinver. Both sites suggest that local hangings might have taken place, but no evidence has been found to support this theory. There is also a Gallows Green near Droitwich.

A DEN OF THIEVES

WORCESTER JOURNAL, 19 APRIL 1753

On Thursday, the 5th Instant was committed to Stafford Gaol, by the Right Hon. the Earl of Stamford, the Landlord and Landlady of a House known by the Name of the Rock Tavern, at Caunsall, near Stourton, on information that their House had a long Time been a Reception for Highwaymen, &c.

In a Stable hewn out of a Rock were found many valuable Things, and a Horse worth thirty Pound. And the Person taken up at an Inn in Stowerbridge, on Suspicion of being a Horse stealer, &c. is said to have been a Frequenter of the above House.

Worcester, 19 April 1753
WHEREAS a Person, who calls himself JAMES RIPPON, and says he is the Son of Robert Rippon of Oldbeck, in the Parish of Leeds, in the County of York, Brasier, was apprehended at Stowerbridge, in the County of Worcester, and is committed to the Gaol for the said County of Worcester, by the Right Hon. The Earl of Stamford, and John Soley, Esq., on suspicion of stealing Horses, and other felonious Practices: The said James Rippon is about 28 Years of Age, five Feet five Inches high, a thick well set Man, flat Faced, has three Scars on his Forehead, (one above his left Eye) a Dimple on his Chin, is of a brownish Complexion, and his Hair is dark and grows low on his Forehead. He had on a brown Bob Wig, a thick set lightish colour'd Coat, with a small Velvet Cape, a black Cloth Waistcoat, and a blue and white check'd Linnen Waistcoat with small Glass Buttons, and Leather Breeches. – When he was taken he had with him a Dark Bay Gilding, with a Silver Tail, and broad bald Face, the near Eye-lid grey, four white Legs, about 14 Hands and a Half high, and five Years old; also a Bay Mare, both Feet before and the off Foot behind white, a grizle Snip full 14 Hands and a Half high, and six Years old. – There was found in possession of the said James Rippon a black quilted Petticoat, a blue Calamanco Women's Gowns, a small Trunk, with a Shift, Apron, and Women's Caps, two Pair of Stockings, One Pair white and the other green, and a brown Joseph. – N.B. the Horse, Mare and Goods, above mentioned, are now in the Hands of Mr. Josiah Powell, Constable, at the Cock Inn, in Stowerbridge, Worcestershire.

James Rippon, charged at the Worcester Summer Assizes with stealing a Mare, was discharged by Proclamation.

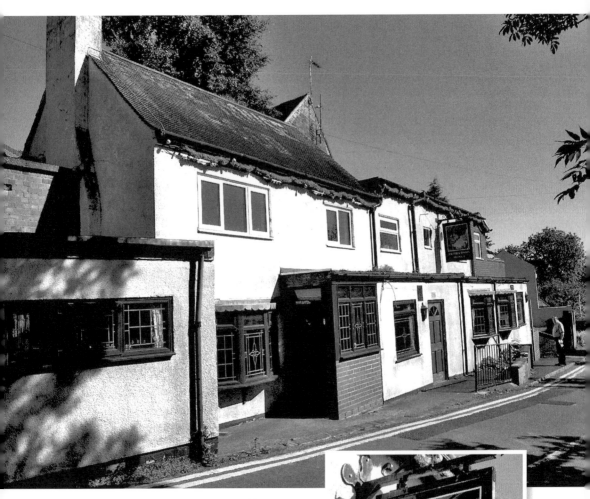

The Rock Tavern at Caunsall, near Cookley, as it is today. It dates back to at least 1753, and was probably a beerhouse before that; it is now closed. The original building still remains, with additional new extensions built in front. It still has caves in the rear, cut into the sandstone, where the beer was stored to keep it cool, and the caves where the highwayman's loot was stored can still be found. The last landlord is the present owner.

THE MURDER OF JOHN ADNEY AT PERSHORE

WORCESTER JOURNAL, 26 JULY 1753

On Sunday last one John Morris, a Brass Clock maker, in Pershore was committed to our County Gaol, for assaulting and dangerously wounding John Adney, who kept the 'Sign of the Plough' in the town. – The Affair, we hear was as follows, viz. a Quarrel happened between them, yet seemed reconcil'd soon after: But as Adney was returning home that Evening, Morris, 'tis said, way-laid him, and took an Opportunity as he was getting over a Stile to strike him a violent Blow on the Head with a Soldering Iron, of which Wound the said Adney remain'd very ill 'till last Tuesday Morning, and then died. – The Coroner's Inquest sat on his Body Yesterday, and, we hear, brought in their Verdict, Wilful Murder.

Worcester, 9 August 1753

At our Assizes (which ended Yesterday) three Prisoners were capitally convicted, amongst whom was John Morris the Younger, for the murder of John Adney.

He was found guilty on Tuesday, and; agreeable to the late Act of Parliament, received sentence to be hang'd, dissected and anatomis'd, this Day: Accordingly, between 12 and 1 o'clock, he was convey'd from the County Gaol to the common Place of Execution, where he suffer'd; after which pursuant to the above Sentence, his Body was deliver'd to the Surgeons. –

John Morris, who was executed here last Thursday for Murder, could not be brought to acknowledge he intended to kill Adney, tho', from the strongest Circumstances it appear'd he not only intended his Death, but likewise to rob him; he however confess'd he had been guilty of many heinous Crimes, even that of Murder, but could not be prevail'd on to descend to such Particulars as would have made a Discovery of his Accomplice. – When he came to the Place of Execution he seem'd very impatient to make his Exit, pulling the cap over his Eyes two or three times before things were in Order for his being turn'd off.

Just before the Rope was put around his Neck, he call'd out very audibly to know whether there was any Body there from Pershore, and being answer'd in the Affirmative, he pull'd off his Coat and gave it to a Man to carry to his Father.

He was about 23 Years of Age, and has left behind him a wife (who is a very good Sort of Woman) and one child; and, 'tis said, he inveigled her into Marriage (she having a little Money, tho' a Servant at the same Time) by pretending to be violently in Love with her, and telling her he was a Country Esquire of considerable estate at the same Time appearing, as to Dress agreeable thereto; and to prevent all Doubt of his being such a Gentleman, dress'd up a Relation in a very grand Manner, and sent him to confirm what the other had declar'd.

The cap or hood was either black or white, and served the double purpose of preventing the prisoner being able to see what the executioner was doing while also preventing the observers from seeing the agonised look on the prisoner's face as the rope tightened around his neck. A night cap was often used for this purpose, and was positioned at the last moment, hence the phrase 'pulling the wool over one's eyes'.

Worcester, 9 August 1753

At our Assizes (which ended Yesterday) two Prisoners were capitally convicted, amongst whom was John Morris the Younger, for the Murder of John Adney, he was found guilty on Tuesday, and agreeable to the late Act of Parliament, receiv'd Sentence to be hang'd, dissected and anatomoniz'd.

The other Criminal condemn'd was John Alcock otherwise Brown, (who is order'd for Execution) for stealing a Mare, the property of Mr. Stone, of Isbury.

Thomas Anderton, otherwise Andrews, for having two Wives, was burnt in the Hand, and order'd to remain in Gaol six Months – Job Watkins, for picking the Pocket of Mr. Thomas of Claines, was also burnt in the Hand.

Worcester, 23 August 1753

John Alcock, alias Brown, who was condemn'd at our last Assizes for stealing a Mare, will certainly be Executed on Wednesday next.

We hear that the Landlord and Landlady of the Rock Tavern, in the parish of Kinfayre are to be tried at the next Assizes.

Worcester, 30 August 1753

Yesterday John Calcott, alias Brown, was executed here for stealing a Mare, the Property of Mr. Stone, of Isbury. – He was to have been executed before, but it being expected he would make great Discoveries, (admissions) a Respite was obtain'd for him, but which had not the desir'd Effect, he rather growing more hardened and obstinate; for tho' (as he acknowledg'd himself) he had it in his Power to impeach a great Number of his Accomplices, sixteen of the most notorious of whom, he said might soon be taken, yet he could not be prevail'd on to do it; he, however, declar'd, that Morris, (lately executed here for the Murder of one Adney, of Pershore) with some others of the Gang, robbed a Person some Months ago near Sutton Coldfield, in Warwickshire, of 400 Pounds, afterwards murder'd him, and then buried his Body; but he would not tell who were the other Persons concern'd in the said Robbery and Murder: He likewise acknowledged he had for some Years past belong'd to a numerous Gang of Rogues, consisting of about 40 Highwaymen, Horse Stealers, &c. many of whom were Frequenters of the Rock Tavern, in Staffordshire; and there is some Reason to believe his obstinacy proceeded chiefly from their promising to rescue him at the Place of Execution, the vain Hopes of which, no doubt, prevented his impeaching them, who, however, deceived him, he remain'd to the last very obstinate and full of Resentment, particular against Mr. Stone, who, he said had best take Care of himself, insinuating, that the Gang would take an Opportunity of murdering him. Between Eleven and Twelve o'Clock he was carried to the place of Execution.

John Calcott and John Alcock, both having the same alias, were apparently hung for the same crime.

At this particular time, there were many reports in the newspapers of armed highwaymen on horseback robbing mail coaches, and passengers of their valuables.

Worcester, 13 September 1753
Susannah Bruford, of Mounton, near Taunton, was indicted for poisoning her Husband, and found guilty. She was sentenced to be burnt last Monday, at Wells. Upon the Trial it appear'd she had made the Attempt once before the fatal Time, by giving her Husband Arsenick in some ale; but he, perceiving it was gritty, drank but a little; however, he found himself extremely sick, but with the violent Perjuring and Vomiting, the Effects of the Poison were prevented: he then first suspected the wicked Design of his Wife. Some Time after, being order'd by an Apothecary to take Flour of Brimstone, his Wife took an Opportunity of mixing some Yellow Arsenick in it, and that in so large a Quantity as was sufficient to kill twenty Men. Her Husband did not take the Whole, but he was soon seized with Violent inward Burnings and great Torture, and continued four Days in the most extreme Agonies. She was but Nineteen, married only in March last, and committed the Fact in May. Her keeping Company with another Man, is thought, induced her to commit this heinous Crime.

Worcester, 20 September 1753
Susannah Bruford, of Mounton, near Taunton, was burnt at Cure Green, near Wells, for poisoning her Husband, who was a Farmer of good Repute. A little before her Execution, she declared that the Beginning of her Misfortune was a too near Intimacy with an Attorney's Clerk, who seduced her when she had been to see some Fire Works at Taunton. She behaved very penitently, and acknowledged the Justice of her Sentence. There was a prodigious Concourse of People to see the Execution.

This particular crime was classified as Petty Treason; it was applied to women who murdered their husband, master or mistress. High Treason, for coining (clipping of coins) silver or gold or counterfeiting, resulted in the same punishment. Burning was a common punishment throughout Europe for both heresy and witchcraft.

Worcester, 21 March 1754
George Steel, alias John Pilkington, who was executed on Thursday last, behav'd, to the last with great Hardiness and Obstinacy. – On his Trial he was remarkably bold and Insolent; for when the Judge had pronounced the sentence of Death on him, concluding with Praying the Lord to have Mercy on his Soul, Steel immediately cry'd out, And the Lord have mercy on your Soul, and every Body's here. He acknowledged he had formally belong'd to the noted Baxter's Gang and was principally concerned in Horse stealing, but could not be prevailed on to name any of the Accomplices, yet was so generous as to inform several Persons where they might find their Horses that had been stolen from them. On the Morning of his Execution two of his Acquaintances came to take their Leave of him, and at their going away were for shaking Hands with him, which he would not permit them to do till they had pulled off their gloves, which they happened to have then on. On his way to the gallows, he kept himself in View as much as possible, and often laught'd; and observing a Person crying of Hot Mutton Pies, he expressed an inclination to have one, and call'd out for that Purpose, but, upon recollecting himself, he thought it would be an useless Piece of Indulgence, and therefore had none. He said nothing material at the Place of Execution, but seem'd very impatient to be dispatch'd, and, as soon as the Rope was plac'd round his Neck, he threw himself off the Cart with a great Swing not waiting for its being drove away. After hanging about an Hour, he was cut down and his Body delivered to the Surgeons for Dissection.

Worcester, 28 March 1754

William Harrison, who was Executed here, on Friday last, for robbing on the Highway, behav'd with great Decency and Penitence. – Till the Wednesday Evening he was strongly persuaded within himself that he would be reprieved; but his coffin had a proper Effect, he betaking himself from that Time to a due Preparation for Eternity. – At the Place of Execution he seem'd to intimate he had been engaged in a Courtship with a young Woman, and that, in order to support the Character of a generous Lover, took to the Highway, as the means to supply himself with money for that Purpose.

Worcester, 1755

Laft Thurfday Evening Mr. John Webfter, of Salop, was robb'd by a Highwayman, on Stowerbridge Common of upwards of Twenty Pounds in money, his Watch, and Pocket Book, in which there were Bills to 171l. in Value.

On Saturday Night laft about 6 o'clock, Mr. Phillips the Stowerbridge Carrier, and a Boy were robb'd by two Footpads, one and a half miles from Birmingham, near Five Ways, one of whom had on a white Frock coat, on the road to Hales Owen, of what Money he had about him, and his Letters and Parcels and the Boy of about 18s.

On Saturday, Samuel Edwards, who was convicted of Robbing Mr. Phillips, the Stowerbridge Carrier, was executed at Warwick, he confeffed to the Robbery of a man afleep between Stowerbridge and Kidderminfter, of 9s. – a man at Kidderminfter, being drunk of about 3l. – Stole 3 horfes at Bilfton and 2 horfes at Leominfter, and many other crimes.

At the Affizes at Shrewfbury, Four Criminals receiv'd Sentence of Death, Edward Broom, for Sheep ftealing; Thomas Shelly, for ftealing a Mare; and Nichollas Lamb and Robert Edmonftone, for rape: The laft of which is repriev'd. – Rich Jones, Tho. Fieldhoufe, Catherine Shone, and William Row, (condemn'd at the former Affizes, but respited) are order'd for Tranfportation for 14 Years. – Tho. Copeftaff, for ftealing Rags, and Robt. Davies, charged with Burglary and Felony, are to be tranfported for feven Years. – Five were burnt in the Hand; three to be whipt.

Henry Pearce for breaking into the houfe of John Ofwold and taking thereout four Shirts, 10 Napkins, one Gold Ring, a Silver Spoon, a Pair of Silver Buckles, (Shoe Buckles) and about 4s. in silver. – is order'd for execution To-morrow 7-Night. [Se'nnight = seven nights' time]

Worcester, 3 April 1760

Monday se'nnight Thomas Kirby, Blacksmith, late of Upton, in the Parish of Shifnal, was executed at Shrewsbury, for the Murder of Samuel Bolton, of the same Trade and Place, and his Body was afterwards deliver'd to the Surgeons for Dissection. He absolutely denied the fact till he was convicted, but when he was taken back to Gaol, confessed that he was prompted to the Murder by Bolton's being a Rival to him in his Trade, and from his Opinion that by his Death he should have all the Business to himself; and that accordingly on Thursday Evening, the 22d of February, 1759, knowing that he was gone to a neighbouring Farmer's he determined on putting his Scheme in Execution, and went with an Iron Rod in his Hand to meet him, with which he knock'd him down, and afterwards with a Suck belonging to a Plough that Bolton had brought from the Farmer's, he gave him a Blow on the Head, which kill'd him; when hearing the Voice of two Men, who were coming that way, he remov'd him farther, and with a Cord that he had in his Pocket, hang'd him on a Tree, in which Manner he was found.

THE FATHERLESS BARN MURDER, HALESOWEN

BERROW'S WORCESTER JOURNAL, THURSDAY 19 APRIL 1759

On Friday last a most cruel Murder was committed on the Body of John Walker, at Joseph Darby's near Hales-Owen, where the Deceased and one Nathaniel Gower, as Bailiffs, were in Possession of the said Darby's Goods on a Distress for Rent: About Nine that Evening, the said Darby's two Sons, Joseph and Thomas, came into the House, and with a Broom Hook and Bludgeon fell upon the said Bailiffs, and Gower escaping, they cut and beat the Deceased till he was almost killed; then stripping him naked, thrust him out of the House, and with a Wagon Whip cut him almost in Pieces: Gower made the best of his Way to Hales-Owen, from whence some Persons went to the Deceased's Relief in a Close near the House, who found him weltering in his Blood, and with great Difficulty carried him to Hales-Owen, where he immediately expired. Upon searching Darby's House early the next Morning, he, his Wife and two sons were secured, but not without great Danger to the Apprehenders, one of whom narrowly escaped being killed with an Ax with which the old Man struck at him. They were all four on Sunday last committed by the Rev. Mr. Durrant to Shrewsbury Gaol. Upon full and sufficient Proof made of the Fact, and of old Darby's standing by, and all the Time encouraging his Sons in perpetrating this Scene of horrid Villainy. The Deceased's Coat, Waistcoat, and Breeches, were at the Time of taking the Murderers found in the said House, all bloody.

Worcester, Thursday 16 August 1759
Letter from Stourbridge, dated Tuesday 14 August:
Joseph Darby and his two Sons, indicted for the murder of John Walker, in the Execution of his Office of a Bailiff, at their House near Hales Owen, were, on Thursday last, [the day the Assizes ended at Shrewsbury] condem'd, and were hang'd on Saturday. The old Man's Body was given to the Surgeons in order for Dissection. His Wife was tried for being concern'd in the said Murder, but was acquitted. And Yesterday Morning, about Eight o'clock, the Bodies of the two Sons were brought through this Place, and carried to Hayley-Green, about a Mile from the Place where the Murder was committed, and hung in Chains, between Four and Five in the afternoon, in the view of a prodigious Number of Spectators. The Reason why they were not hang'd up till so late in the Evening, was, that a convenient Spot was not fix'd on to erected the Gibbet, and now it stands very close to the Common Road. As they, while living, were a Terror to their Neighbours, they may, probably, terrify them a long Time yet, their Faces not being cover'd, which render them very ghastly Spectacles. Since the Execution 'tis reported

that one of the Persons hung in Chains was not a Son of old Darby's, but was nurs'd in the Family from his Infancy.

At this particular time Halesowen was in the county of Shropshire, so the prisoners were tried at Shrewsbury.

Above: The road where the gibbet was erected was named Gibbet Lane, a grim reminder of what happened there. It was renamed Alexandra Road in recent times and no longer bears witness to the atrocious murder which was committed nearby, or the penalty paid by the perpetrators.

Below left and right: Newspaper report taken from *Berrow's Worcester Journal*, 19 April and 16 August 1759. Note: ſ is simply an old way of writing *s*.

WORCESTER, *April* 19.

On Saturday next will be held our ſecond Fair.

On Friday laſt a moſt cruel Murder was committed on the Body of John Walker, at Joſeph Darby's near Hales-Owen, where the Deceaſed and one Nathaniel Gower, as Bailiffs, were in Poſſeſſion of the ſaid Darby's Goods on a Diſtreſs for Rent: About Nine that Evening, the ſaid Darby's two Sons, Joſeph and Thomas, came into the Houſe, and with a Broom Hook and Bludgeon fell upon the ſaid Bailiffs, and Gower eſcaping, they cut and beat the Deceaſed till he was almoſt killed; then ſtripping him naked, thruſt him out of the Houſe, and with a Waggon Whip cut him almoſt in Pieces: Gower made the beſt of his Way to Hales-Owen, from whence ſome Perſons went to the Deceaſed's Relief in a Cloſe near the Houſe, who found him weltering in his Blood, and with great Diffi-culty carried him to Hales Owen, where he immediately expired. Upon ſearching Darby's Houſe early the next Morning, he, his Wife, and two Sons were ſecured, but not without great Danger to the Apprehenders, one of whom narrowly eſcaped being killed with an Ax with which the old Man ſtruck at him. They were all four on Sunday laſt committed by the Rev. Mr. Durant to Shrewſbury Goal, upon full and ſufficient Proof made of the Fact, and of old Darby's ſtanding by, and all the Time encouraging his Sons in perpetrating this Scene of horrid Villainy. The Deceaſed's Coat, Waiſtcoat, and Breeches, were at the Time of taking the Murderers found in the ſaid Houſe, all bloody.

Letter from Stourbridge, *dated Tueſday, Aug.* 14.

" Joſeph Darby and his two Sons, indicted for the Mur-der of John Walker, in the Execution of his Office of a Bailiff, at their Houſe near Hales Owen, were, on Thurſ-day laſt, (the Day the Aſſizes ended at Shrewſbury) con-demn'd, and were hang'd on Saturday. The old Man's Body was given to Surgeons in order for Diſſection. His Wife was tried for being concern'd in the ſaid Murder, but was acquitted. And

" Yeſterday Morning, about Eight o'Clock, the Bodies of the two Sons were brought through this Place, and carried to Haley-Green, about a Mile from the Place where the Murder was committed, and hung in Chains, between Four and Five in the Afternoon, in the View of a prodigious Number of Spectators. The Reaſon why they were not hang'd up till ſo late in the Evening, was, that a convenient Spot was not fix'd on to erect the Gib-bet, and now it ſtands very cloſe to the Common Road. As they, while living, were a Terror to their Neighbours, they may, probably, terrify them a long Time yet, their Faces not being cover'd, which render them very ghaſtly Spectacles.

" Since the Execution 'tis reported that one of the Perſons hung in Chains was not a Son of old Darby's, but was nurs'd in the Family from his Infancy.

THE MURDER OF FRANCIS BEST OF KIDDERMINSTER

BERROW'S WORCESTER JOURNAL, THURSDAY 13 JUNE 1771

Last Saturday Morning, between Nine and Ten o'clock, Mr. Francis Best, of Caldwall Mills, Kidderminster, a very substantial and reputable Meal man, was found murdered in the Ridd-Field near Kidderminster, having his Throat cut in so shocking a Manner that his Head was almost severed from his body, and his Scull so terribly fractured that his Brains were plainly to be seen. Mr. Best was going on Foot to Bewdley Market, and it was known by his Family that he took with him in his Breeches Pockets, about fourteen or fifteen Pounds, and in his Waistcoat Pocket he had a Bag containing about 8o*l.* which last Sum remained there when he was found, but the other Cash was missing. The same Afternoon John Child, of Kidderminster was taken up, on Suspicion of being concerned in this Murder and Robbery from the following Circumstances, viz. that, in the Forenoon, he came to Bewdley, and paid a Person some Money he had lately borrowed off him; that, in the Afternoon, he returned to Kidderminster, changed his Cloaths, bought a Pair of Breeches and other Things, and ordered a Horse to be got ready directly, and taken to the Turnpike, while he walked through the Town: But just as he was going to mount, the Constables seized him.

On his Examination the next Day, he made the following Declaration; viz. That, about three Weeks ago, it was agreed between him, and one Thomas Bourne, of Alverley, in Shropshire, to meet upon a Day then fixed on (being Saturday last) and to way-lay and rob Mr. Best; that they accordingly met, and went together to the place where they had agreed to attack him; that as soon as they had met and pass'd Mr. Best, Bourne turned about and knocked him down with a large Bludgeon, and cut his throat; and that then they rifled his Breeches Pockets.

Upon this Accusation, some Persons immediately set out to find Bourne, but he could not be heard of by that Name, having changed it to that of Steel; however, by a Description given of him as having lost one of his Fingers he was discovered to be in the Service, at Mr. Palmer's of Compton, in the Parish of Kinver, Staffordshire, and accordingly brought to Kidderminster for Examination, and Mr. Palmer attended on the Occasion; but it was clear on the Testimony of Mr. Palmer, that Bourne had been at Home the whole Day, it is pretty certain that this Murder and Robbery were committed by Child himself only. On his being searched, soon after he was taken, there was found upon him Money to the Value of about 12*l.* amongst which was a remarkable Nine-shilling Piece, which was proved to have been lately received, by Mr. Best's Son, off a Person at Kidderminster and afterwards paid by the Son to the Father; the identity of which Piece has been sworn to by Mr. Best's Son and the Person he received it off: The Bludgeon with which Mr. Best

was knocked down, has since been found, by Child's Direction, near the Place where the Murder was committed: And a conscious Guilt, since the Discovery of these Particulars seems to have filled his Mind with Horror and Distraction; for, on Monday last, while at Breakfast, being entrusted with a Knife, he suddenly started up, and stabbed himself in two or three Places in the Belly, but the wounds, it is thought, by the Persons who attend him, will not prove mortal. He continues under Confinement, with a proper Guard over him, in the Town Hall at Kidderminster, and is to remain there till he's fit to be removed to our County Gaol. And as to Bourne, he likewise remains in Custody; for, though he may justly be pronounced innocent, in respect to the Murder of Mr. Best, yet he frankly acknowledged his being well acquainted with Child, and that he had been concerned with him in divers Robberies, &c.

Worcester, Thursday 20 June 1771
On Friday last Thomas Bourne was brought to our County Gaol, being charged by John Child as an Accomplice with him in the Murder and Robbery of Mr. Best, near Kidderminster: But Bourne, most solemnly protests he is entirely innocent.

On Tuesday last the above John Child was likewise committed to the said Gaol: He was conveyed from Kidderminster between two Horses, who supported a Kind of Bier, with a Bed upon it, and on that he was placed full length, properly fastened down, and over him was a sort of tilted Covert; so that the vast Numbers of People who waited all the Way on the Road, and in the Streets of this City, to view him as he passed, were disappointed upon seeing him. He is kept in a Room by himself; and, to prevent a second Attempt to destroy himself, his Hands are stapled down to the Floor.

We are assured, that John Child, under confinement in our County Gaol, for the Murder of Mr. Best, begins to be properly effected with his unhappy Situation. He has recanted his Accusation against Bourne, declaring that himself only was concerned in that shocking Transaction. As this seemed to be the Reality of the Case, the Rev. Mr. Taylor, who has attended Child, was the more pressing and assiduous in order to bring him to an Acknowledgement of his false Charge against Bourne.

Worcester, 25 July 1771
On Thursday last John Child, for the Murder and Robbery of Mr. Best, near Kidderminster, was executed at our County Gallows, amidst a vast, Concourse of People; and the next morning his body was taken to our Infirmary for Dissection. He was very penitent and devout, he acknowledged the Crime for which he suffered, and desired the Spectators to take Warning by his untimely End. We are assured, that the famous Mr. Bourne, in his great Modesty and to shew particular Respect for his old Acquaintance, John Child, attended the Execution, and showed himself very conspicuously.

THE SHOCKING MURDER OF OBADIAH ROLLASON OF AMBLECOAT

BERROW'S WORCESTER JOURNAL, 1 JULY 1773

On Tuesday last was committed to the said Gaol (by Harry Long, Gent. Coroner) Walter Kidson, late of Amblecoat, in the Parish of Old Swinford, Labourer, he being charged by the Coroner's Inquest with the wilful Murder of Mr. Obadiah Rollason, of Stourbridge; the Particulars of which are said to be as follows:– About two o-Clock on Friday Morning last, the said Kidson went to Mr. Rollason's House, and called to him, as he lay in Bed, telling him that a white Horse was got into his mowing Grass; upon which Information Mr. Rollason got up, dressed himself, and went to examine his field with the said Kidson, as is supposed; when they had reached a Gate that overlooked the same; the Villain began to execute his wicked Designs; as appears by much Blood being spilt on the road and Bushes for many Yards. About Five o-Clock the Deceased was found thrown across the Road; with the back Part of his Scull beat into his brains; and mashed in a shocking Manner; a large Cut on the Side of his Neck, and several other visible Wounds. – As soon as the Body was found; the whole Town was alarmed; and Pursuit was made after Kidson, who had endeavoured to fled several People that had met him; however, he was taken about Seven o-Clock the same Morning and brought to a Room where the Deceased lay, some of the Gentlemen charged him with committing the Crime, which he denied with a bitter oath; they began to examine his shirt sleeve; which was stained with Blood that looked fresh; they then charged him again; when he trembled much, but would not confess: His house was then searched; where they found a bloody Smock Frock washed in places where any Blood appeared; and put out to dry. – This blood-thirsty Villain had an Intention of putting his Designs in Execution a Fortnight before, by calling Mr. Rollason in the Manner above mentioned, but he escaped then by not rising. The field was examined both Mornings, when it did not appear that any Horse had been in it; this certainly confirms the Villain's being the Perpetrator: He is a Man who had led a loose life, and bears a bad Character, and was tried at Worcester Assizes, last Summer, for stealing Hay but was acquitted:–

It is supposed that the Reason of his committing this Murder, was to rob Mr. Rollason of a Sum of money he took at Bromsgrove Fair the Day before, who, in his hasty Rising, changed his Breeches, by which the Murderer was disappointed of a good Booty. – He is a very lusty-well looking Fellow, but has rather worn a gloomy Aspect ever since his Commitment to Gaol. He still positively declares that he is entirely innocent of the Murder; that he has not been in Company with: nor seen Mr. Rollason for a Fortnight before he was brought to view the dead Body; that he was at Home, in Bed with his Wife, at the Time, and long after it was said Mr. Rollason was called up and supposed

to be Murdered. Being asked how his shirt, &c. became so bloody; he said he had been killing a Lamb the Day before, which had occasioned it:– He is much chagrined at being refused a Bed in the House instead of laying in the Dungeon with the rest of the Criminals; but when it is considered how dangerous it would be to admit him into the House, there was great Prudence and Propriety in not indulging him. – The following circumstances of great weight against this Fellow, we are told, arose in the Course of his Examination; viz; that when Mr. Rollason was called to get up, that both himself and wife concluded it to be the Voice of the said Kidson.

Worcester, 21 August 1773
The Trial of Kidson (who is to be executed Tomorrow, near the Spot where the Murder was committed, and afterwards hung in Chains) lasted near six hours, in the course of which above thirty Evidences [Witnesses] appeared against him, and such a Multitude strong, corroborating Circumstances arose, that not the least Doubt could remain of his being guilty of the Murder; though he positively denied the Fact when called to make his Defence, and seemed not at all affected when the Sentence of Death was passed upon him; and even when he was measured yesterday in the afternoon for his irons, [chains in which he had to hang on the Gibbet] he stood with the utmost Composure. – Had this desperate, inhuman Wretch escaped, many People in Stourbridge, and that Neighbourhood, would have been under the most terrible Apprehensions, he having thrown out many severe threats and Menaces against those who were instrumental in bringing him to justice.

Worcester, 28 August 1773
On Friday last Walter Kidson, for the Murder of Mr. Rollason, of Stourbridge, was executed near that Town (and afterwards hung in Chains) amidst a Concourse of at least twenty thousand People, and to the great Satisfaction of the whole Neighbourhood, to whom he was become a great Terror, being a most vicious desperate Fellow; and he remained to the last such an obstinate, harden Wretch, as to die in absolute Denial of the Fact. He was conveyed from our County Gaol in a Post Chaise [a hired travelling carriage, drawn by horses] to within about three Miles of the Place of Execution, and then put into a cart, which carried him through the Town of Stourbridge. It was a long Time before he expired, the Rope being very injudiciously fixed around his Neck, so as that his Head was near slipping through the Noose; and it is asserted, that he cried out, after he had hung near two Minutes, "O' Lord! I shall never die."

Walter Kidson was hung at Amblecote, close to where he killed Mr. Rollason; his execution was amateurish, the noose being incorrectly adjusted. He was probably 'dropped off' the back of the cart he was being conveyed on, which was an insufficient drop to break his neck; consequently he suffered a long, agonising death by slow strangulation, causing him to cry out 'O' Lord! I shall never die.' On being pronounced dead, he was then conveyed to Stourbridge Common, where he was hung in chains on a gibbet, possibly the gallows on which he was executed.

It will be noted that the County Gaol is mentioned here, whereas the City Gaol was mentioned previously. Worcester had two gaols, and later two police forces.

THE GUMMERY FAMILY MURDERS AT BERROW IN WORCESTERSHIRE

Before Harry Long, Gent. coroner, were the bodies of Edward Gummery, Elizabeth his wife, their daughter, aged nine years, and Thomas Sheen, brother of the said Elizabeth, who in the early hours of Sunday 7 May 1780 were barbarously murdered in their beds. The handbill on the next page refers to that event; it is also reported in greater detail in *Berrow's Worcester Journal*, dated 18 May 1780.

A near neighbour, by the name of Player, heard noises coming from the cottage as he lay in bed with his wife. He went to investigate and found the front and rear doors locked, but on hearing noises from within, he called out the names of the occupants, but received no answer. He then went and fetched his wife; on their return they found the front door open. On entering they saw blood coming through the gaps in the floorboards of the upper chamber, and dripping onto the floor below. On going upstairs, they saw two corpses on the floor covered in blood, which upset them so much they left to seek further help.

An immediate search of the area was made for the culprits, and six 'trampers' (tramps) were immediately found and apprehended; one had a blood-stained stick, some had bloodstains on their clothes and a child in their company said, 'It was not my Daddy that killed them, but two men who are gone to Tewkesbury.' It was thought an axe had been used in the murders. On searching them, no evidence could be found to link them to the crime. A search of the cottage revealed nothing was missing; it was a murder without a motive.

It was thought that Player had scared off the culprits, who were still in the house when he called out the names of the occupiers and attempted to get into the cottage.

The trampers were not charged with the murder, and were released, but were later apprehended, and charged with damaging enclosure fences at Malvern.

Twenty-nine years later, in 1809, an elderly man called James Taynton, said to be in his eighties, and described as a road labourer, was admitted to the Worcester Royal Infirmary with a broken leg. He was in a very serious condition, and at times delirious and rambling about being involved in the destruction of the enclosure fences. On being asked what he knew about the murders, he said the murderers were still alive and were as old as himself. On further questioning it seemed he knew more about the murders than at first thought. After further questioning by a nurse on what he knew about the murders, he replied, 'Aye, damn you, but you have not got hold of it yet,' and when asked what he took into the house, he replied 'bills' (bill hooks – sharp-bladed cutting tools, often used in hedging), which fitted the nature of the wounds on the bodies. He continually insisted that demons were coming to seize and torment him; it was, upon the whole, a most affecting instance of the power of conscience upon a guilty mind. Since his death it has been ascertained that he was one of the labourers employed upon the Link Enclosures, and bore a very bad character. He died shortly afterwards and no further investigation was made.

An Account of four People cruelly

MURDERED

In their Beds in the Parish of Berrow near Castle Moreton in Worcestershire, about Six Miles beyond Newent.

ON Sunday Morning last about 4 o'Clock, a person who lives at a small distance from the House where the Murder was committed heard as he thought a groaning, accordingly he went to the House of one Edward Gommery a labouring Man, finding the outward Door fast, he called to them, but receiving no Answer he returned Home, and told his Wife that he feared all was not right at Gommery's, as they did not answer when he called, he then desired his Wife to go with him to the House: He now found the outward Door open, for the Villains were just gone away, for they were in the House when he first came there, having got in at the back part of the House, had the fore Door been open and he had gone in, he would have fallen a Sacrifice to their Fury: But his coming disturbed them, and they left the House.

When they came into the lower Room they called, but receiving no answer they went up Stairs, but shocking was the Scene, for Edward Gommery was lying with one Arm almost sever'd from his Body, and his Bowels hanging out. His Wife, with the upper part of her Head chopp'd in pieces, and her Nose cut off: Her Daughter with her Throat cut, and a Wound on the back of her Head: Mrs. Gommery's Brother lay with his Head split open, and the Blood ran in Streams through the crevices of the Floor. The Alarm being given, a general search began, and three Men with some Women and Children were found in a field about a quarter of a Mile off. On one of them was found a bloody Stick, and some Blood was found on the Cloaths of another. They were immediately secured, and taken to the Place where the Bodies lay, In returning, says one of them "The Girl looks just the same as she did when she was asleep."

One of them is named Evans, and is a Basket-maker. Another of them used to sell Toasting-Forks about the Country.

May 9th 1780.

This handbill, printed 9 May 1780, is an account of the barbarous murder of a family of four in the parish of Berrow near Malvern.

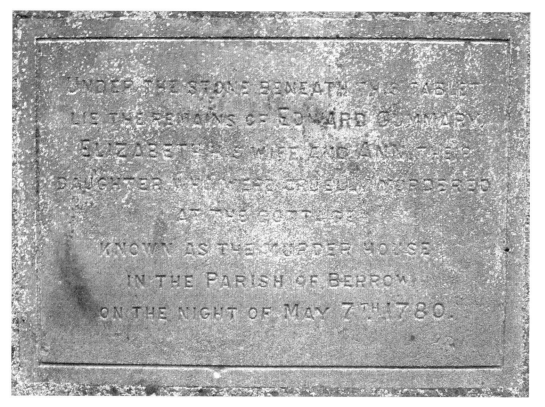

Above: A stone tablet in memory of the Gummery Family can be found on the outer wall of the parish church of St Faith and is shown above. The inscription reads: 'UNDER THE STONE BENEATH THIS TABLET, LIE THE REMAINS OF EDWARD GUMMERY, ELIZABETH HIS WIFE, AND ANN HIS DAUGHTER, WHO WERE CRUELLY MURDERED AT THE COTTAGE KNOWN AS THE MURDER HOUSE IN THE PARISH OF BERROW ON THE NIGHT OF MAY 7TH 1780.'

Below: A single-sided bill hook. The inner edge is razor sharp. A double-sided 'bill' would also have a cutting edge on the outer side.

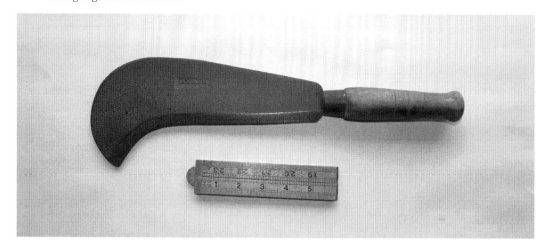

THE MURDER OF MARY HIGGS

BERROW'S WORCESTER JOURNAL, 25 OCTOBER 1781

Committed to our castle Catherine Higgs charged with the wilful murder of her daughter, two years old, by throwing her into a pool near the Bell-Inn in the parish of Bell-Broughton.

Worcester, 14 March 1782
On Tuesday evening Mr. Justice Nares and Mr. Jus. Heath finished the business of the Assizes here; at which Catherine Higgs, for the wilful murder of her own daughter, about two years old, by drowning her in a pool near the Bell-Inn in the parish of Belbroughton, was capitally convicted, and immediately received judgement of death, to be executed this day.

Worcester, 21 March 1782
Thursday last Catherine Higgs, for the murder of her own daughter, was executed at our County gallows, [Red Hill] pursuant to her sentence.

Mary Higgs was buried at Belbroughton and is recorded in the parish records as 'Mary Higgs a poor child of the parish of Bromsgrove, 2 years old, was drowned by her own mother Catherine Higgs in a stream at Bell End, and buried here October ye 11th. The said Catherine Higgs was executed at Worcester ye 14th March 1782.'

Belbroughton is historically known for its manufacture of scythes. It is situated on the Belne Brook, which rises at Clent and supported a number of water mills along its length. Most were used for scythe production, either as hammer forges, to make the blades, or blade mills for grinding them. There were two water mills at Bell End: the first was a blade mill at the junction of Hartle Lane and the Stourbridge–Bromsgrove Road, which was demolished to make way for the feeder road; the second, further up Hartle Lane and known as Galton's Mill, made gun barrels. Both had extensive pools.

THE BARBAROUS MURDER OF JOHN WEBB OF NORTHFIELD

BERROW'S WORCESTER JOURNAL, 20 MARCH 1783

Early on Friday morning the body of Mr. Webb, a farmer in the parish of Northfield, in this county, was found in a marl pit near the Bell Inn, Northfield. He had been at Birmingham market the preceding day, and in returning home late in the evening was robbed and murdered. His brains were dashed out, and his body otherwise barbarously mangled. The villain, supposed to have committed this cruel murder, was seen in company with Mr. Webb, on the road between Birmingham and Northfield, about seven or eight o'clock on Thursday evening. It is thought the wretch immediately after the horrid act stole a horse from Mr. Green of Rednal Green, which he rode to Lydiate Ash turnpike, there left him on Friday morning, and ran away. He was afterwards seen by several persons near Bell-Broughton. He is about five feet 10 inches high, stoops a little in the shoulders, has remarkable strong thighs and legs, and a large foot. He wore his own light-brown hair, had an old round hat, a claret coloured great coat, and light coloured ribbed stockings.

Worcester, 14 August 1783
At the assizes for this county Thos. Wardle was found guilty of the wilful murder, in March last of Mr. Webb, a farmer in the parish of Northfield, by beating out his brains, with a large stick, and afterwards throwing the body into a marl pit, on his return from Birmingham market. Immediately after his conviction the Judge, in a most awful and pathetic speech passed sentence upon him to be executed this day, and his body to be hung in chains on the further part of Bromsgrove Lickey, near Northfield.

Worcester, 21 August 1783
On Thursday last was executed, at Redhill, near this city, Thomas Wardle, for the murder of Mr. Webb, at Northfield, in this county. He appeared to be near 40 years of age, of a sallow complexion, and his behaviour betrayed a sullenness of disposition, and a seeming insensibility of his aweful situation, which was shocking to behold. At the fatal tree the clergyman repeatedly interrogated him with respect to the crime for which he was about to suffer, and pathetically expostulated with him on the enormity of launching into eternity with a lie in his mouth; but he continued inflexible and persisted in denial of the murder to the last. After hanging the usual time, his body was taken to the Lickey, and there hung in chains pursuant to the sentence.

At this time Northfield was in the county of Worcester, where Thomas Wardle was tried for the murder of John Webb. He was executed at Red Hill, where it appears he was hung from a tree. His body was later hung in chains at Bromsgrove Lock.

THE MURDER OF ELIZABETH DEAN OF CHESTER

BERROW'S WORCESTER JOURNAL, 9 SEPTEMBER 1790

On Tuesday last, at Chester Assizes, John Dean found guilty of the murder his wife and he was executed on Thursday near Stockport, and his body hung in chains. Seldom has the page of humanity been stained with a more horrible and ferocious murder than the above; and seldom have the solemnities of justice been marked with circumstances more shockingly aggravating than those evinced by the testimonies of several witnesses. It appeared that the culprit returned home, from a public-house, about the hour of twelve on Saturday night; that one Mary Bell, a lodger in the Dean's house (who lay in an adjoining room) was alarm'd by his oaths and threats, in saying he would murder his wife; to dissuade him from which, the tears and entreaties of his son (a boy about 14) proved to be ineffectual; Mary Bell, hearing a violent fall down stairs, arose from her bed, and perceived that the father and son had fallen, filial affection of the poor boy having impelled him to interfere on behalf of his defenceless mother, whose situation was more distressful from the consideration that she was in the seventh month of her pregnancy. To divert him from his avowed purpose, Mary Bell made use of some conciliatory terms, which served only to increase, if possibly, the obduracy of his heart; and he pursued her (the witness) up the stairs, swearing he would murder her also; which operated so forcibly on her mind, that she jump'd through a window (four yards high) into the street. She then went to the house of one Thornley, a constable, whose humanity on the occasion was honoured with the approbation of the court: This man, joined by one or two others, returned to Dean's house as speedily as possible; where they beheld the unfortunate woman lying stretch'd on the floor, one of her legs under the grate, her body uncover'd by any thing but the small remains of a shift, and presenting a picture of savage barbarity indescribably shocking! Indeed her body appeared to be one general wound! – The monster, fatigued with his horrid work, sat in a chair near her, his hands, waistcoat, breeches, stockings, and shoes, nearly cover'd with the purple marks of ferocity; The instrument of his cruelty lying at his feet; – whilst in this situation, seeing her body move, in the convulsions of expiring nature, the wretch exclaim'd, Damn thy foul Bet, ar'n't thou dead yet! – After much resistance the murderer was lodged in the dungeon at Stockport; and the dying woman put to bed immediately, when (Mr. Clerk, Surgeon, being sent for) every effort that ability and humanity could suggest, was made use of, but in vain; as Death (affliction's best friend) put a period to her miseries in less than three quarters of an hour. – The Cæsarean operation was performed on the body, and a lifeless child extracted from the womb; when it appeared that an internal rupture had happened, from the profuse quantity of extravased blood which was discovered.

MURDER MOST FOUL
OF HENRY YATES

WOLVERHAMPTON CHRONICLE, 3 APRIL 1793

The most bloody, premeditated, and diabolical murder and robbery, that perhaps ever disgraced the Christian æra, (with the most poignant reluctance we stain our paper by the record) was fatally effected in this town, on Monday morning last about seven o'clock, on the body of a worthy and industrious individual, Mr. Yates master of the Barley Mow public-house in Piper's Row, Wolverhampton. The unfortunate man, by trade a carpenter and joiner, had arose early in the morning, for the purpose of finishing some of his professional labours. At the usual hour of breakfast, his unsuspecting help-mate went to summon him, but, receiving no answer, went backwards to the work-shop, where, horrible, horrible to relate! She found her assassinated husband, lifeless, and his head almost severed from his body. In this awful delirium, she raised up the corpse, and for some moments clasped it in her arms, when, on an interval of fortitude and reason returning, she called to her assistance the commiseration of her neighbours. Every enquiry having been made, no one was known to have been that morning in company with, or assisting him in the shop; they at length traced footsteps by which they concluded, that some person must have entered by the rear of the premises, and come over a wall – a search having now taken place, about ten o'clock, the same morning, the keeper of our house of correction apprehended, in a public house in this town, Eben Colston, the corporal of a recruiting party belonging to the 31st regiment of young Buffs, upon the strong presumptive proofs of having in his possession the watch of the deceased, and, "murder has many mouths," the sight of some blood upon his clothes. The wretched culprit who but the moment before had been indulging himself, even in the headless merriment of singing several songs, now struck with returning reason, and conscious guilt, made a voluntary confession of the dreadful deed. – On the Saturday proceeding it appears that the deceased, who had frequently employed the prisoner at his leisure hours, had required his assistance – they had worked together about half an hour, on terms of the greatest friendship, when, by a momentary impulse, (he says) unprovoked and unpremeditated, he struck the deceased on the side of the head with a hammer, and afterwards cut his throat from ear to ear. – Mr. Yates had been married for a very few years, and has left a deplorable widow, and two infant children. – The wretched delinquent, who is a very likely young man, about 21, is now a prisoner in the house of correction, and apparently labours under the most excruciating stings of agonising conscience.

Ebenezar Colston was hung at Stafford Gaol on 17 August 1793. He was the first person to be executed at the gaol; previous executions were held at Sandyford Meadow.

THE MURDER OF WILLIAM PARKER OF SWINDON, WOMBORNE

BERROW'S WORCESTER JOURNAL, 10 DECEMBER 1807

Mr. Parker, of Swindon, in the parish of Womborne, Staffordshire, a Gentleman of considerable fortune, and universally respected, was poisoned on Tuesday se'nnight; this gentleman was in the habit of taking a cup of camomile tea every morning; and on the above day it was brought to him by William Hawkeswood, but before he had drank much of it, he perceived so unpleasant a taste that he declined taking any more, and was soon after taken ill; he immediately suspected that he had been poisoned. The surgeon who attended desired Hawkeswood to bring the cup to him in which he gave his master the tea; upon tasting the little liquid that adhered to it, he discovered that arsenic had been mixed with it. Hawkeswood was then asked if he had tasted it himself upon his master's discovering the disagreeable taste; he said he had, and that it made him very sick.

William Hawkeswood was born at Pedmore, and baptised at St. Peter's church, 4 February, 1787, by Richard and Hannah Hawkeswood. He was employed by Mr. William Parker, of Swindon, Womborne, and lived in his house, where he was treated like a son. He often went home at weekends to his father's house at Pedmore, returning to his Master on Monday morning, occasionally calling at Stourbridge to purchase items for use on the farm, which he did on Monday 23 November, and bought poison on the pretence of treating sheep for scab.

Realising he was suspected of carrying out the wicked deed, and conscious of his guilt, he decided to go home to his father's, where he hid until the Coroner's Inquest had declared him to be the murderer. The next day he went with his father to Worcester, and caught the mail coach to Bristol, and enlisted under the name of John Gilbert, on board a ship and received a bounty of 10 guineas.

Meanwhile, a Sheriff's officer of Worcester, named Mark Guier, caught the next coach from Worcester to Bristol, where he found Hawkeswood, dressed as a sailor. He secured him and brought him back to Worcester, from where he was transferred to Stafford Gaol.

STAFFORD ADVERTISER, SATURDAY 9 APRIL 1808

STAFFORD ASSIZES – TRIAL OF WILLIAM HAWKESWOOD, AGED 20,
For the wilful murder of Mr. William Parker, of Swindon, in the parish of Womborne, Staffordshire.

Before the Hon. Baron GRAHAM.

This indictment charged the prisoner with wilfully poisoning and murdering the deceased, by administering white mercury in camomile tea on Tuesday the 24th day of November last, which the deceased took down into his stomach, and languished until the Sunday following, when he died.

Sarah Sheldon was first called. She deposed that she was a servant to Mr. Parker. On the 22d of Nov. (Sunday) the prisoner went to his father's at Pedmore, and returned on Monday the 23d. Stourbridge is betwixt Pedmore and Swindon. The deceased was in the habit of taking camomile tea each morning before he came down, which she always made, in a white teapot. The tea had been made close to Tuesday, the 24th; she sometimes took it up, but not on Wednesday.

On Monday and Tuesday the deceased was very hearty and well, she saw the deceased betwixt 6 and 7 o'clock on Wednesday morning; he was sick and vomited; he spoke and asked her what tea she had given him, and said he was poisoned. She drank some of the tea, which had no taste of camomile and was very hot in the mouth, brackish and not like anything she had ever tasted before; it made her sick and she was not well the whole day after. She saw the prisoner at 10 o'clock the same day. The deceased was then ill and gone to bed. Prisoner came into the kitchen where they were talking about the deceased. Prisoner said he had taken some of the tea; that he had a cold and had heard that it was good for one; that he did not like the taste and went out, drank some water and brought it up. She had never heard the prisoner mention a cold before and did not perceive that he had one; on Tuesday morning the tea was in the same place it always was. Deceased continued very ill on Wednesday and Thursday; prisoner was about the house, but on Friday morning he was not to be found. Prisoner was in the habit of being in the kitchen with the witness and saw her take the tea upstairs every night. White mercury was not kept in the house for any purpose. In her cross-examination she said, that the prisoner was received and treated as a friend by the deceased and that she never knew of any difficulty between them, the prisoner was in the habit of going home on a Sunday.

Elizabeth Cartwright deposed that the prisoner took up the tea of the deceased in a cup about half full, which was the normal amount. The deceased went to bed about 8 o'clock in good health; she took up his tea before he went to bed; it was put on a chest of drawers at his bedside. The prisoner was up at five on Tuesday morning; being more than before his usual time. The witness corroborated the evidence of the proceeding made to the good understanding that existed betwixt the prisoner and the deceased.

Mr. Caltern deposed that he was a druggist at Stourbridge; that he knew the prisoner, and formally lived within two miles of the prisoner. On Monday the 23d November, prisoner came to his shop and asked for a quantity of white mercury, the proper name is corrosive sublimate. At his cross-examination he said, that the prisoner was well known to him, and had frequently come to his shop for similar drugs; his brother was a beast leech, had bought it there for several years; it was used to care for his beasts, and for the switter, a disease in lambs. He knew the prisoner from a child and could speak to his general character, but never heard anything amiss of him. – The prisoner made no secret in buying it.

Edward Higgins deposed, that he was waggoner to the late Mr. Parker and slept in the house. On Tuesday the 24th November, he went at 4 o'clock, into the kitchen. He went out and returned in about an hour. On his return he saw the prisoner in the kitchen by himself, he was sitting on the screen. There was room for three to sit on the screen, and asked which was the teapot? The prisoner came behind him with a view to prevent

him using it. The prisoner was not in the habit of rising till between 6 and 7 o'clock. Never heard of any white mercury being kept in the house.

On his cross-examination he said, that he believed there had been some sheep bought lately at Dudley fair.

Mr. Thomas Wainwright deposed, that he was a surgeon at Dudley, on Wednesday 25th Nov. he was called to Mr. Parker's, and got there between one and two o'clock. Mr. Parker was very ill in bed, had a weak trembling pulse, cold extremities, countenance bloated, and was evidently much exhausted. – The deceased said, that he was well the day before, and had had a good night; had drunk some camomile tea, but finding it uncommonly nauseous, did not drink so much as usual. He had been taken with a violent pain in his stomach, and vomiting and afterwards perjuring. Witness enquired what he had taken the day before. He replied that he was poisoned & attributed it to the tea. Witness drank some of the tea and knew that there was corrosive sublimate in it by the taste, which was like that of copper, but more pungent. Witness administered the usual medicines to Mr. Parker, who vomited while he was in the room, and threw up blood; left him weak but his sickness was less, and he was better. – Saw Mr. Parker again on Saturday, who was then in a dying state, did not believe he would live the night out. He was in a state of extreme debility; swelling of the stomach, a decided symptom of death in cases of poison, and that fluttering pulse; exactly such effects as he should expect from the effect of the corrosive sublimate: his salivary glands were likewise effected. Mr. Parker died on Sunday morning. His body was opened in the presence of Dr. Morrison of Wolverhampton, and Mr. Causer.

The stomach was exactly as might be expected from the poison; the lower part of it was corroded to the size of half a crown and in smaller spaces.

Mr. Joseph Wainwright, father of the proceeding witness deposed, that he was a surgeon at Dudley & had been in great practice for many years. He saw the deceased Mr. Parker on Thursday the 26th Nov. He judged that the state in which he found him was due to the effects of poison, taken internally. He tested the tea and recognised instantly and absolutely on its being impregnated with corrosive sublimate. He examined the prisoner on the occasion. Prisoner denied knowing that any poison was in the house; said he knew what white mercury was but not by the name of corrosive sublimate; his father used it for cattle. Prisoner said that he drank half a spoonful of the tea but would not drink more it was so bitter. Witness gave him a half penny to taste, and prisoner denied that there was any resemblance in the tastes. Prisoner said the tea had made him sick and he vomited over the fold wall into the fold, and that two thrashers saw him. He was immediately asked who the men were. He then instantly denied saying that two men had seen him. Witness said he was astonished that he should tell such a direct untruth, as his son heard him likewise. Prisoner perceived in his denial of the words, and when he was asked to show the place where he vomited, said it could not be seen as the cattle had trampled upon it. He said that a boy saw him vomit by a bridge; believes he said the boy's name was Sutton. Witness said that the sublimate would overpower the bitterness of the tea; he tasted it; it had a nasty brackenish taste, and left a great heat in the throat; and that the taste was very similar to that of a half penny. Prisoner had no cough that the witness could perceive. Witness left the deceased in such a state as might be expected from the operation of the poison; and his constitutional powers were yielding fast to its effects. – Did not see him again till after his death; when opened his stomach was much inflamed and corroded.

In his cross-examination he said, that he believed it might be the morning before that the prisoner said he had tasted the tea; that it was about poison that he questioned the prisoner, and not white mercury.

Judge. Did the boy know what corrosive sublimate was? No.

Judge. Did he know what white mercury was? Yes.

Dr. Morrison deposed, that he was called in to Mr. Parker on the Saturday – found his pulse low – complained of dryness in his throat, attended with such other symptoms as would follow the taking of corrosive sublimate. – Witness tasted the camomile tea and had no doubt of it having corrosive sublimate in it – was present at the opening of the body – appearances of the stomach, &c. were such as would be occasioned by taking the poison – the state in which he appeared before and after death was such as left no doubt as to the means by which he died.

Samuel Chambers deposed, that he had heard that the house keeper had locked out the prisoner at Swindon wake – that it was not long before the death of Mr. Parker; who never saw the prisoner sick.

Sarah Dale deposed, that she lived next door to the deceased. She said to the prisoner that the master (the deceased) was very ill. She had been down but he was so ill that he could not attend to the business on which she went; and the women had very ugly talk in the brew-house; they were saying that somebody put poison in the camomile tea. Prisoner said yes, they did, & that it put him in a tremble to think they should say so. He then went away, but came again and said that old Dr. Wainwright called him into the parlour about the stuff in the tea, and asked him if he knew what brown hellebore was. He said, no: he asked him if he knew white mercury, and he said, yes; his father used to dress sheep with it.

Mr. John Parker Wilson deposed, that he was the nephew of the deceased, and lived in the parish of Enville, about four miles from his uncle; his uncle had turned over his land to him and was to live with him. Witness slept at his uncle's on Tuesday the 24th; being a general custom previous to going to Wolverhampton market on the Wednesday. His uncle went to bed in good health. In the morning before he was up he heard his uncle vomiting; he got up to see what was the matter, and found him dreadfully sick on the chair. Prisoner was servant to the witness; his brother married the prisoner's sister. – Witness saw the prisoner; went to him in the fold and found him all of a tremble, asked him what bothered him. Prisoner said that the Doctors were more against him than any other of the family. Witness told him not to be daunted, for if he was innocent all the world could not hurt him. Prisoner asked the witness if he thought the Doctors would enquire at Stourbridge whether he bought any poison or not. Witness said he could not tell. Prisoner said that he thought they could tell whether it was poison or not in the tea pot, and he would fetch Dr. Causer to see. Witness advised him not to go, and he said he would not.

In his cross-examination he spoke to the partiality of his uncle to the prisoner, & said that he had bought sheep lately. On the wake morning he was in the field with the prisoner. A little wool on one of the sheep's back stood up. They drove them up in a corner and caught it, but it had nothing like any scab on it. The wool was "congealed up" by something being put on it to cure maggots. The prisoner had the care of the sheep.

Here the evidence closed.

At his trial he was called upon for his defence; he handed over a written paper making a full confession, admitting he had put poison in the camomile tea, not intending to

poison Mr. Parker, but to spite Mrs. Sheldon, who was the long standing housekeeper, with whom he was not on very good terms. He had previously seen her drinking some of the tea; thinking it would make her vomit, but not seriously harm her.

Several people were now called who spoke in general terms to the good character of the prisoner for his honesty, sobriety and humanity.

The Judge in summing up the evidence took a view of the relative situation of the prisoner to the parties concerned; the difficulty of conceiving the prisoner to be ignorant of the qualities of the drug, from his having been so long accustomed to seeing it used. What could be his business with the drug? The complaint of the sheep did not require it. Had it been for the design of playing the housekeeper a trick, the quantity used was too great to suppose him ignorant of its power. Would he not in that case have employed another means; or have taken other opportunities to have put it in the house-keepers tea? But there was nothing in their quarrel that could warrant such revenge. If he were ignorant that the camomile was for the deceased, so he must be ignorant that it was for the housekeeper. The judge then noticed the equivocating conduct of the prisoner; his pretending that he had drank the tea, and that it had made him sick, with a view to give a reason for his ignorance of it; and his stating that two men saw him sick, and when he was asked what men, he denied that he had said that anybody did see him. The motives of human conduct were frequently difficult to conceive. He could not say what may or may not be lurking in the prisoner's mind in respect to the death of the old man; the short remainder of his life might be hanging over some cherished prospects of the prisoner, from a consideration of his affinity to the family, and to remove this lingering obstruction might be the prisoner's object. The judge then commented on the defence of the prisoner, and submitted it to the Jury how far the prisoner's conduct might be due to the effect of ignorance and wantonness, or whether the poison was not prepared and destined solely for the old man?

After a few minutes consultation the Jury returned a verdict of – GUILTY; but recommended the prisoner to mercy.

The Judge then proceeded in a manner peculiarly awful and impressive to pass the sentence of death. He spoke of the prisoner's youth, and the kindness and indulgence, which he had always experienced from the deceased. What could be the wicked impulse of his heart might remain a secret to everybody but himself; he had been found guilty by a Jury of his country, and it was his severe and painful duty to pronounce the sentence of the law; namely, "That you will be taken to the place from whence you came, and thence on Wednesday morning next, taken to the place of execution and there be hung by the neck until you are dead, and may the Lord have mercy upon your soul."

During the sentence the prisoner, for the first time, discovered some emotion. He was conveyed from the Court, and executed agreeable to his sentence, on Wednesday, about a quarter before twelve. He made no further confession; said that he had told his father, and should say no more. Prisoner was a stout and muscular young man; with very high cheek bones, and rather dark complexion.

William Hawkswood was publicly executed on the roof of the Old Gate House of Stafford Prison on Wednesday 6 April 1808.

On 31 March 2007, family descendants came from New Zealand and visited the church and the locality to find out more about their infamous ancestor.

THE MURDER OF MR. ROBINS OF DUNSLEY

BERROW'S WORCESTER JOURNAL, 24 DECEMBER 1812

Daring Robbery and attempt at Murder. – On Friday evening about 5 o'clock, as Mr. Benjamin Robins, of Dunsley, was returning from Stourbridge market, he was overtaken by a man who walked and conversed with him for some distance; but when within less than half a mile of Mr. Robins's house the villain drew behind Mr. Robins and discharged a pistol at him; the ball, it is supposed, struck Mr. Robins on the back bone, which caused it to take a direction round his ribs to near the belly; from the place it entered to where it was found, was from 14 to 16 inches. The villain, as soon as he had fired, demanded Mr. R's. money, who said, "Why did you shoot me first? If you had asked me for it before, you should have had it." Mr. R. then gave him two 10*l* notes, a 1*l* note, and 8*s* in silver. The rascal then said – "Your watch;" Mr. R. said – "if you demand it, take it;" when he took the chain in his hand, he trembled to such a degree that Mr. R. thought he could have taken him, had he not been so badly wounded, and the idea of not being able to get home to his family operated upon his mind. As soon as the villain had possession of the watch, he either presented the same pistol or another, and desired Mr. R. to proceed or he would shoot him again; Mr. R. replied – "You scoundrel, you have already shot me enough; you have taken my life from me." He then walked home. The villain made towards Stourbridge. Mr. Causer, jun. and Mr. Downing, surgeons, of Stourbridge, were immediately sent for and soon extracted the ball; it was of a large size, and appeared to have been lately cast. Mr. Robins, is not yet pronounced out of danger. A man is under confinement at Stourbridge on suspicion.

Worcester, 25 March 1813
Murder of Mr. Robins. – at Stafford Assizes, yesterday se'nnight, William Howe, alias John Wood, was charged with the wilful murder of Mr. Robins, of Dunsley, near Stourbridge, on the 18th December last. On being asked if he wished to challenge any of the Jury, the prisoner did not object to any particular person, but generally to any who might reside in the neighbourhood of Stourbridge. One of the jurymen only was found to come from that part of the County, who accordingly left the box, and was replaced by another person, Mr. Pearson shortly opened the case and was succeeded by Mr. Jervis, who stated the particulars of the murder, which agreed with what is already before the public, and concluded by giving the following, which occurred since the prisoner was apprehended:– "a man he knew while at Ombersley came to see him, he dropped a letter and asked him to give it to his wife, to give the prisoner's wife it was directed 'Mrs. Howe,' who took it to a woman named Hodgson, who read it to her, then she burnt it,

but not before, an extract had been made by Mr. Vicars, 'that she should go to a rick near Stourbridge to search for something.' Vicars and Aston went to the rick, and in a hole as if made by a hand, found three bullets, and in another a pistol, the fellow to that found in the box, and acknowledged by Howe. Another fact is that during the prisoner's confinement he entered into conversation with another prisoner charged with stealing fowls. I cannot tell what, not knowing how it took place, but I can say what happened in the consequence of that conversation a watch proved to have been that of the deceased was found to have been pledged by the prisoner, at Mr. Power's, of Warwick; Power is here; he will state that the prisoner is the man who on the 21st December, three days after the murder, sold it, – he offered to pledge it – Power offered £1, he wanted £2. and would sell it, but as a family watch wished to have it again; said he had had it repaired at Mr. Gammon's, late Brown's of Birmingham: When watch-maker's repair watches they generally put in a paper with their name. Mr. Robins had had it repaired there – this is a sufficient proof. It will be proved by the family of Mr. Robins that the watch was his; the bullets found in the chest, the bullet mould, and also the bullets in the rick, and the bullet extracted, proved the same sort."

Witnesses to the number of thirty were then examined, who satisfactorily proved the guilt of the prisoner by a long train of circumstantial evidence. Mr. Justice Bayly then summed up the whole of the evidence with the utmost perspicuity and impartiality. The Jury conferred together for about seven minutes and brought in a verdict of guilty. The learned Judge then addressed the prisoner in a very pathetic manner, and pronounced the dreadful sentence of DEATH, and his body to be hung in chains, near the spot where the murder was committed. The prisoner heard the dreadful sentence apparently without dismay. He did not call a single witness to his character, and on being taken from the bar exclaimed, "My heart is innocence."

THE EXECUTION. – About 11 o'clock on Thursday, the unhappy criminal was conducted to the new drop in the front of the County Gaol. He trod with a firm and steady step, and preserved his fortitude unshaken till the last. He freely confessed to the murder of Mr. Robins; he went to Stourbridge for the purpose of committing a robbery, supposing it probable that he might attain a considerable booty being the old market; he did not know Mr. Robins, and any other person who he might have met at the time would have shared the same fate. He deplored the "badness of his heart," which had led him to the commission of his dreadful offence, prayed most devoutly for the forgiveness of the Almighty, and entreated the prayers of the surrounding multitude. He then submitted to his fate with firmness and composure. He was 32 years of age. The dead body (enclosed in a case of ribbed iron) was conveyed to Wolverhampton the next day, and from thence to Stourbridge, on Saturday, when it was hung in irons, near the spot where Mr. Robins was shot, about 2 miles from Stourbridge. So great was the curiosity excited on this occasion that it is supposed no less that 40,000 persons visited the place on Sunday.

The lane is now known as Gibbet Lane and the wood in the surrounding area as Gibbet wood; it is a grim reminder of what happened there almost two hundred years ago.

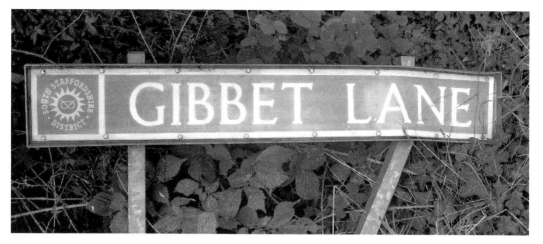

The road sign at Dunsley, Kinver, is a reminder of the murder of Benjamin Robins, by William Howe, which took place in this lane. Howe was convicted and hung at Stafford, and his body hung in chains on a Gibbet near the same spot he murdered Mr. Robins.

Dunsley Hall, originally the home of Benjamin Robins, is now known as Dunsley Hall Hotel.

THE MURDER OF RICHARD COOKE, THE WATCHMAN, WOLVERHAMPTON

WOLVERHAMPTON CHRONICLE, 27 MARCH 1822

On Thursday morning, John Platt, Thomas Ramsall, William Ramsall, Thomas Holmes, William Harris, John Meek, and Jeremiah Roberts, were charged with the wilful murder of Richard Cooke, at Wolverhampton, were placed at the bar.

MR. RUSSELL, in addressing the jury for the prosecution, said that he trusted they would give the grave and serious charge against the prisoners their most minute and deliberate attention; and begged them to dismiss from their minds everything he should lay before them in his statement of the case, which did not appear to be fully supported by the evidence. There could be no doubt that Cooke the watchman had interfered, as was his duty, to suppress a breach of the peace, and it was clear, that in the execution of that duty he had been resisted by means likely to cause his death. The indictment charged that Platt threw the stone, but it was immaterial to fix the throwing on any particular person, as all were implicated. He concluded by observing that the prosecutors, although expecting a verdict of guilty, if the crime was brought home to the prisoners, would feel happy if, upon the evidence, the jury could conscientiously, pronounce a verdict of acquittal. The following witnesses were then called.

John Geary is a collier; on Sunday night the 20th January was looking for lodgings in Dudley-street, Wolverhampton, about 9 o'clock, when he met the two Ramsalls, and immediately after all the other prisoners, who recommended him to the Hen and Chickens, where they went together; after they had been drinking some time, a dispute arose about a glass which had been taken away, in consequence of which the landlord went out and returned with Cooke, who he said was the watchman, and desired the prisoners to pay for the glass; which they did. They were all there but Platt, who had gone away, and he soon returned with another watchman, named Hand, when the glass was taken out of Platt's pocket, the money returned, and the dispute settled, the watchmen then left. Thomas Radford is the landlord of the Hen and Chickens, public-house, in Dudley-street, Wolverhampton; recollects Geary coming on Sunday night the 20th January, to ask for lodgings, and all the prisoners at the bar came in immediately afterwards, and they remained together from half past 9 till about 12 o'clock, and had four jugs of ale; the watchmen wore large flannel coats, which is the usual dress, and had lanterns and large sticks with them. Soon after witness heard a noise, and on looking out of the windows upstairs, saw by the light of the gas lamp, 5 men engaged in an affray in Bilston-street; one of them came to the end of the street and called out, when several other men ran from Dudley-street into Bilston-street, and the watchman followed. A rattle was sprung in a few minutes after, and seemed to sound from the end of Bilston-

street near Piper's-row. The prisoners were not drunk but a little elevated. Platt had a white hat on.

Watchmen were the equivalent to the parish constable, but patrolled the streets at night, keeping law and order. The description given above, of him wearing a grey greatcoat, carrying a lantern and a staff, fits other known descriptions. The staff was usually a stick about 4 or 5 feet in length, rather like a club, which could be used as such if necessary, while the rattle was rather like a football rattle and could be 'sprung' to summon help if required, as it was here. The 'Watch House' would be an early form of police station, complete with lockup or cell(s). Watchmen and parish constables were often known as 'Charlies' and were figures of ridicule.

Ephraim Webb is a collier; on Sunday night the 20th January he was at the Hen and Chickens, where all the prisoners were drinking together; they left about twelve o'clock, and the witness at the same time; Meek and Holmes went into Bilston-street, and the others, all of whom he (Webb) knew by name, except one who was called Backsticks, and he now is known to be William Ramsall, went along Dudley-street, and witness went after them; heard a noise from corner of the street directly, and the men who had gone along Dudley-street, ran back into Bilston-street, followed by Cooke, the watchman; witness also followed, heard them cursing and swearing, and when he got into Bilston-street, they were scuffling together just above Bradshaw's shop. The seven prisoners were there, two tradeschaps, and Cooke, the watchman. Witness saw Meek and Roberts hit the same tradeschap, and knock him down, and went and begged of him to go home, but he said he would stand and be killed on the ground first; Harris then knocked him down, and Cooke asked if they meant to kill him; he was afterwards knocked down by another of the colliers, and Cooke said he would not stand it any longer, he saw they meant to kill him, and sprung his rattle. Witness did not see the tradeschaps afterwards. Two watchmen soon came up, and the row ended, and Hand, the watchman took Harris into custody, and the other watchman, whose name witness did know, seized Meek, and they proceeded with them towards the watch-house, Cooke walking at the rear and keeping the others off, witness followed, and when they came to Piper's-row one of them said "D--n their eyes lads, here's friends," he then saw several of them run across the street to a heap of paving stones, to which they more than once returned, and heard the bibbles [a Black Country expression, meaning pebbles] bounce upon the pavement as though they had gone passed the watchmen, who then went away, and witness saw the prisoners, and Meek at liberty among them, going towards their home along Bilston-street, saying how they had mastered the watchmen. Heard Holmes say what a big stone he had thrown, and saw a pale in Thomas Ramsall's hand, which he had pulled from a garden fence.

John Hand, is a watchman of Wolverhampton; whilst on duty about a quarter past 12, on Sunday night the 20th January, heard a rattle spring in Bilston-street, and on going there saw some men, and Cooke in the midst of them, who desired him to catch hold of any of them, and witness seized hold of one man; soon after Heath came up and took another into custody, whom Cooke pointed out as one of the worst; they then proceeded towards the watch-house, Cooke keeping the other men off, and when they came to the corner of Piper's Row, the man witness had in custody being too strong for him, gave a sudden spring and broke away; at this time the stones began to fly; 20 or more were thrown from a heap which lay ready for paving, and one struck Cooke a blow on the forehead, which made him reel, put his head against the wall, and cry "O Lord!" witness

then called to Heath to loose his man, or they should all be killed, which he did and then took Cooke between them to Heath's house.

Thomas Gardiner lives in Wolverhampton; was in Bilston-street, a little after 12, on Sunday night the 20th January, and saw Hand and Heath with each a man in custody, going towards Piper's Row, and Cooke acting as guard; when they came to the corner of Piper's Row, the man whom Hand held broke from him; several other men were endeavouring to effect the rescue of Heath's prisoner, but failed. A heap of paving stones lay on the other side of Bilston-street, and two men, one wearing a white hat and another in a dark velveteen dress, went to them, and one of them said, "now lads, here's friends," another in a flannel frock at the same time broke a pale from a garden fence; they then returned together across the street to within about four yards of the watchmen, and the rest of the party went and supplied themselves with stones. Witness then saw the men in the white hat and the velveteen dress in the act of throwing in an over hand manner, and it appeared as if one stone met something in its way to stop it, and then fell upon the pavement; the man with the pale in his hand was in the position to strike a blow, and the others threw stones. At this time witness heard Hand call out to Heath "loose him or we shall all be killed," and the watchmen went away. The colliers then set up a great noise and went off along Bilston-street.

Isaac Wilding was apprehended, and has been in custody on the same charges as the prisoners; he was drinking with them at the Hen and Chickens, on the night in question, till they left, when he went off another way; in a short time, heard a watchman's rattle and a great noise in the direction of Bilston-street, where he went; and saw three of four watchmen going down Piper's-row, with their prisoners, whom he joined, as they went witness heard William Ramsall say he had thrown a stone, and that Meek got off that minute. On the next night, witness was at the house of a person named Cranage, in company with Roberts, Meek, and Platt, when Meek said he heard the watchman was very ill, and he and Roberts said they must be off, or they should be taken to. Platt called witness up at 12 o'clock, the same night, and they went together to Ashton-under-Line, where witness left Platt and went to Duckenfield, and was apprehended there. Platt afterwards surrendered himself in Wolverhampton.

John Tomkys apprehended Holmes, Harris and the two Ramsalls in South Wales, near Pontypool, working in the mines; and Benjamin Sollom took Meek and Roberts in Derbyshire.

Edward Hayling Coleman, surgeon to the Wolverhampton Dispensary, who attended Cooke from the Tuesday after until he died, described the nature of his wound, and stated his belief that it had been the cause of his death.

John Warrilow produced the stone that struck Cooke, which he received from Heath, the watchman, who identified it.

A great number of respectable persons came forward and gave all the prisoners excellent characters; after which his Lordship carefully recapitulated the evidence, laying down the law upon the subject in much the same terms as it had been stated by Mr. Russell, and commenting upon the parts as they applied to the various prisoners, except Meek, against whom, being in custody during the time of the affray, no charge could be made out.

The Jury after deliberating an hour and a quarter, returned a verdict of Guilty against all the prisoners except Meek; and the Learned Judge proceeded to pass sentence upon them nearly as follows:–

You, John Platt, Thomas Ramsalls, William Ramsalls, William Harris, Thomas Holmes, and Jeremiah Roberts, are severally found guilty of the crime of Murder, and I do not believe there is anyone in this assembled Court, possessed with the least degree of human feeling, who does not experience most painfully, and distressing sensations of seeing six fine young men like you, all of whom had previously borne good characters, reduced by one act of intemperate, and fatal violence, to the awful situation in which you now stand. This country has long been governed by statutory and wise laws, and it has hitherto been our boast that those who have been appointed to take a share in the administration of them, have been almost uniformly treated with a proper degree of difference and respect. It has been deemed necessary to make strict enactments for the protection of all peace officers, and if it were not so there would be no safety for the community; freedom and social order would be at an end, and in the land would be one continued scene of violence and bloodshed. You young men, heated perhaps in some degree by liquor, had involved yourselves in an affray, for which it was fit you should be taken into lawful custody, and if you had submitted, a moderate punishment would have sufficed, and you would have been restored to your friends. Instead of this you resorted to measures, which must produce mischief; the large stones, which were thrown by you, if they did not chance to kill, were almost certain to maim and severely injure those with whom you were engaged. What can be interposed to save you from the fate, which awaits you all, I know not. Your Jury, who have paid the utmost attention to your case, paused long, as was their duty, in order to sift every particle of the evidence, and in pronouncing their verdict of guilty against you have recommended you in a most humane and proper manner to mercy, on the ground of your previous good character, and the probable absence of any intention in your minds at the time to commit the fatal act of which you stand convicted. It however only now remains for me to finish my painful duty of passing the sentence of the law upon you, which is – that you be taken hence to the place from whence you came, and from thence on Thursday next to a place of execution, and that you be hanged by the neck till you be dead.

On Wednesday morning the prisoners were again conducted into Court, when the Learned Judge (Mr. Justice Richardson) addressed an admonitory speech to them, and said that owing to the recommendation of the prosecutors and the Jury, their general good character, and apparent contrition, he had been induced to recommend them to mercy, and held out hopes that their lives would be spared. They have consequently been reprieved. The convicts on hearing the address of his Lordship, seemed overwhelmed by the excess of their feeling. On Tuesday during their long trial, they had no sustenance, and they could take none after condemnation, when they were replaced in the caravan next morning, so far were their senses disordered, that they expected they were going to be executed; and it was a long time after they returned to prison before they recovered from the shock they had sustained.

It seems strange that a verdict of wilful murder had been proved, for the killing of a law enforcement officer, and the death sentence passed, that a plea for mercy should be recommended, and given, and that the culprits should receive a reprieve, but they do not seem to have received any alternative form of punishment at all for their wrongdoing – nothing can be found in later newspapers suggesting a lighter punishment.

THE MURDER OF SAMUEL WHITEHOUSE? HALESOWEN

WOLVERHAMPTON CHRONICLE, 24 APRIL 1822

Inquest at Hales Owen.
Prior to the inquest of Samuel Whitehouse, a reward of £100 was offered for information leading to the apprehension and conviction of the murderer.

The Coroner's Jury summoned to enquire into the circumstances attending the death of Mr. Whitehouse, re-assembled on Saturday morning at the Beech Tree Public-house, on the Hales Owen road. Much additional evidence of the circumstantial nature was brought forward, and the proceedings occupied the attention of the Jury until evening, when a verdict of wilful murder against Joseph Downing, brother-in-law of the deceased, was returned. Being in attendance he was immediately apprehended, and committed, on the Coroner's warrant, to Salop County Gaol, to await his trial at the next assizes. Downing was taken through this town on Sunday.

Wolverhampton, 7 August 1822
THE TRIAL OF JOSEPH DOWNING – SHROPSHIRE ASSIZES
The trial of Joseph Downing for the murder of his brother-in-law, Mr. S. Whitehouse, of West Bromwich, commenced on Saturday.

Mr. Puller opened the case to the Jury by stating that it was one which required their most serious attention; that the parties concerned were in different situation in life to the generality of similar cases brought before a Jury, both the prisoner and the deceased being persons of respectable and considerable property, and what was a most painful circumstance, their being so nearly related. He concluded by saying that they were near together at the time the deceased met his death, and that the prisoner had with him the instrument which the surgeon says was most likely to have occasioned his death, and that it was next to impossible he could have passed the deceased in the lane without seeing him, but he still wished the Jury to give due consideration to all inclination in the prisoner's favour, and then to determine if he was the person who gave the wound.

The first witness called was Thomas Fox, a blacksmith, living in Beech Lane, on the road from Birmingham to Hales Owen; he deposed that the deceased was a courier at West Bromwich, five miles from his house; the prisoner, Downing, a cow leach lived in the parish of Rowley, four miles off; that Downing and Whitehouse each married a sister of the other; Whitehouse had a small estate near the Beech Lane, which he sometimes came to see; that on Wednesday 3d April, Whitehouse came to his house about eight o'clock in the morning, and Downing about ten; the latter brought a colt with him to be shod, and a gun barrel to be widened in the breach; they both rode;

they went out with the witness into the Light Woods shooting, and returned about three o'clock, when they took some refreshment; about four they all walked out to see Mr. Whitehouse's farm, and again returned about six, and had some more eating and drinking; that Downing and Whitehouse paid for the ale, which was had from a public house; they had in all twelve quarts, of which witness's man, son, and wife, had about two quarts, and the rest was nearly equally drank by Whitehouse, Downing, and himself; that while they were drinking a wager was laid of a pound between himself and Downing, and the stakes 2l. were given to Whitehouse; the deceased had other money, but witness did not see it, and a watch. About nine o'clock they set off home, it was a clear and moon-light night; Whitehouse mounted his horse first, and witness gave him his gun, which he was sure was then entire; they were all fresh, but Whitehouse did not sit on his horse very well; Downing then got on his horse, and took the colt to lead with his right hand; they went across the turn-pike road and through a small gate opposite the house; there is another gate opposite that, about thirty yards, over a piece of new enclosure; witness went to the second gate with them, when Downing sent him back for his gun barrel, which he had forgotten, and requested Whitehouse to wait, or he should lose his way through the wood, as he had done a month before. [On the other side of this wood, about 500 yards away, is a gate, through which is a lane leading both to Rowley and West Bromwich.] Witness immediately returned with the gun barrel, and found that Whitehouse had left Downing, and gone on by the Trig road through the wood; he does not know how far, as he could not see him; gave the gun barrel to Downing, and returned home to bed. About twelve o'clock he was called up, and went to the Beech Tree public house, and found Mr. Whitehouse there badly hurt; waited while young Mr. Bloxam dressed his wounds and then went to Mr. Downing's on Mr. Whitehouse's mare; called Downing up, and told him that Mr. Whitehouse was badly hurt, and had lost his money. Downing answered he was very sorry, and wondered which way he could have gone, for, he never saw anything of him on the road; that he had waited there, while the mare (which had not had much during the day) was fed; that he had been told by his wife where Whitehouse was found, and that they looked at the place as they came by; Downing and witness went to the Beech Tree, and saw the deceased, who appeared to know the witness; about eight o'clock it was agreed to fetch another doctor, and Mr. Downing went to fetch Dr. Badderley; about ten or eleven o'clock witness and Downing went again to the place where Whitehouse was found, and witness saw Downing find the spring off Whitehouse's gun pan in the rut close by. – Witness, in his cross-examination, said that the deceased and Downing were in the habit of coming to his house to go shooting, and that they were upon terms of the greatest friendship. Downing had four or five children; Whitehouse, who had none, adopted Downing's eldest daughter, and sent two of his other children to school; they were talking upon the subject during that day, and Whitehouse expressed himself how happy they were such good children. Whitehouse's mare was skittish, and witness understood had once thrown him; Whitehouse had expressed himself, in witness's hearing, afraid that the mare would at sometime kill him.

The next witness, Richard Aston, is an apprentice to a shoe-maker, close to Fox's; he was returning on the evening of the 3d of April from Oldbury; there are two roads high up the lane leading from the wood, one leads to Oldbury and West Bromwich, the other to Rowley; about twenty minutes past nine o'clock he met a horse galloping up the lane, he stopped it, and took the horse to Ezekiel Deirne's house who lives in a

cottage on the lane side, then rode him towards Fox's, and found the deceased lying in the lane about twenty yards from the wood gate, on his right side with his face towards Fox's, and his gun about two yards off; he got off the mare, took the gun, which was afterwards found broken, and led the horse to Fox's; that he returned with Mrs. Fox and others to the spot where the deceased lay in the lane; that before they got to the lower gate some person hollo'd out as though from the spot where the deceased lay; the witness answered, and immediately he heard a horse gallop away; he found the deceased moved – and now lying on his back – his waistcoat ripped up; he had no money in his left hand pocket, but two pound notes in his right, and his watch was gone; that Mrs. Fox went for more assistance; they carried the deceased round the lane to the Beech Tree public-house; that Mrs. Fox returned through the wood, when he called out to her from the lane "Mrs. Fox," three times – this was about a quarter past ten o'clock; that witness went for Mr. Bloxam.

Ezekiel Deirne, a nailer living by the lane side, saw Mr. Whitehouse, and afterwards Downing, go in the morning up the lane; that in the evening he saw Downing return about nine, leading the colt; that five minutes after, two men passed, and soon after Whitehouse's mare galloped by; he thinks Downing could not have returned without his seeing him.

Mr. Bloxam, Jun. surgeon, of Hales Owen, was then examined as to the nature of the wounds on the deceased. There was a cut about 2 inches long across the back part of the head, and two small grazed wounds on the left temple; that the scalp was separated upwards about 2 inches; and that the skull was considerably fractured; that the deceased was quite insensible, and remained so till he died. Witness thinks that the wounds on the back of the head could not be occasioned by a fall or kick from a horse, but from a blow from some heavy flat instrument like the breach end of the gun barrel produced. – In his cross-examination this witness agreed that at a proper striking distance, a kick from a horse might occasion all wounds.

Mr. Bloxam the elder, father of the above, who had been a surgeon in Hales Owen many years, corroborated the testimony of his son.

Thomas Taylor who lives about 300 or 400 yards from the spot where the deceased was found, heard about 20 minutes after nine, someone call out in the wood three times, "Fox," and something fall. – John Taylor, his father, also stated the same. – Benjamin Hill was called to prove the time of Taylor's clock with Fox's.

Benjamin Grainger, High Constable of Hales Owen, stated that he was the prosecutor on the 13th April, he rode Whitehouse's mare through the wood, and laid the reins of the bridle on the neck, and she took and kept the middle of the Trig road through the wood gate.

The deeds relative to some property belonging to the deceased were produced and partly read, proving that it would devolve to the prisoner or his children, in the case of the death of Whitehouse and his wife without children.

This ended the case for the prosecution and the Judge seemed to think a defence was not necessary, but the Counsel for the prisoner called on their side Samuel Hodgetts, to prove the mare had before thrown Mr. Whitehouse; and Thomas Biggs, a servant of Mr. Whitehouse, who stated the mare had thrown him also, and was skittish, and a kicker.

Mary Biggs, servant to Mr. Downing, stated that her master came home after ten, put up his horse, turned out the cows, and went to bed.

Mr. J. Badderley, the family surgeon, saw the deceased and thinks it more probable that the wound was occasioned by the kick of a horse than a gun barrel.

Mr. Winter, a surgeon of 14 years' practice, from the circumstances thinks it more probable that the deceased met his death from the kick of a horse.

Mr. Evans, a surgeon of Shrewsbury had been present during the whole of the trial, and thinks it much more probable that the wound was occasioned by a kick rather than a blow.

The brother of the deceased was called, and said he never recollected their relationship being other than friendly.

The learned Judge (Bayley) in addressing the Jury, stated that this charge was of the highest crime that could be committed towards a subject, and that there should be a reasonable degree of certainty to convict the prisoner, not conjecture and belief only; that where the evidence was only circumstantial it ought to make the case as clear as though you were really present; their experience gave them instances where no human eye could see, but the probability of circumstances were such, as they could come to but one conclusion; that he would only further make a few short remarks: He (the learned Judge) thought that the prisoner might with the greatest ease have passed the deceased in the wood, who might have got out of the direct Trig road, and that in case the prisoner did not pass him in the lane he could not be the murderer. That if the minds of the Jury were not entirely free from doubt on the subject he would go through the evidence and make his observations on the particular points.

The Jury, without hesitation returned a verdict of not guilty.

The Judge again addressed the Jury, and said he thought it right to say, before the prisoner and the persons present, that if the deceased came to his death by any violent hands, the evidence of the case was sufficient to satisfy him that it was not the hands of Downing.

The prisoner seemed much affected, and said "Thank you, My Lord – thank you."

The trial lasted from seven till nearly three o'clock; and the Court was very much crowded.

Shrewsbury, 18 August 1824, Murder and Robbery
On the 3rd April 1822, John Felton was returning home when he came across the body of Mr. Whitehouse, lying at the side of the road. Being an opportunist, he turned him over and went through his pockets, relieving him of his watch and £10 in notes. The watch was found in his possession in June last. The wife of Mr. Whitehouse, stated her husband had taken the watch with him when they went out shooting. Felton was apprehended in Birmingham and was in possession of the watch, which he could not give a satisfactory account for. The watch was identified as that of Mr. Whitehouse. On that evidence he was charged with robbery and murder. He appeared at Shrewsbury Assizes in August 1824. On the evidence of Richard Aston, who originally found the body at about 9.30 in the evening, lying on its right side, who then went for help, and returned to find the body had been moved, and was now lying on its back and the pockets rifled. The prisoner denied murder but admitted he had taken the watch and money. Since he had been previously imprisoned on the charge of murder, the Judge considered that the circumstances against him were very slight.

The Jury returned a verdict of Not Guilty.

THE MURDER OF SARAH NEWTON, BRIDGNORTH

WOLVERHAMPTON CHRONICLE, 26 MARCH 1823, SHROPSHIRE ASSIZES

Trial of John Newton, for the Murder of his Wife, Sarah Newton, at Severn Hall, near Bridgnorth.

Counsel for the prosecution – Mr. Pearson, Mr. Russell, and Mr. Ryan. For the prisoner – Mr. Jervis, Mr. Serjeant Peake, Mr. Curwood.

Mr. Pearson opened the case in a very able and humane manner, stating the material parts, contained in the evidence, so as to bring the leading points in a clear view before the Jury. It would then be for them to say whether it was under that momentary impulse which would make it manslaughter or in such a premeditated and deliberate manner as would constitute to the full extent the foul crime of murder with which he stood charged.

George Edwards is a tin man and brazier in Bridgnorth, and has supplied the prisoner with articles from his shop; on the 22nd of January last, witness went with a bill to the house of Newton, Severn Hall, and found him at home; on delivering the bill, prisoner asked him into the parlour, and after some time remarked upon one item that he had given his wife money to pay for it, that she had frequently played him some tricks and run him into debt at different times, and he would give her a good threshing; he went and called his wife in; and asked her if he had not given her the 3s. to pay for the lantern; witness does not think she made any answer, but seemed to admit he had given it her; she then walked out of the room, and Newton asked witness to have a jug of beer; the prisoner seemed much hurt at the lantern being put in the bill, and said he would thresh his wife; witness advised him not to, and ridiculed the idea of beating her for such a trifle, and said if he would give him the bill he would erase it, sooner than he should have any words with her about such a simple thing. Witness went about half-past two to Newton's house, and remained till near eight; while there he once passed through the kitchen where Mrs. Newton was nursing a child, she appeared well but low, and witness shook hands with her and told her to keep her spirits up. Witness got Newton to promise he would not beat his wife when he left. The prisoner came out with him, and in passing through the kitchen witness did not see Mrs. Newton, but called out, "good night, Mrs. Newton," and the prisoner said he supposed she had gone to hide herself as she knew what she was to expect; they walked into the garden together, and there witness again begged the prisoner not to beat his wife, and said he would never speak to him again if he did; they shook hands and parted. Between one and two o'clock on the following morning witness was called up, and after getting a light and opening

his door found the prisoner who told him a bad job had happened, for his mistress was very ill; witness said "good God! Mr. Newton, I hope you have not been doing anything wrong," and he answered no, it was not from his striking her, but from the way she was, alluding as witness supposed, to being with child, which Newton had told him she was in the course of the afternoon. Prisoner then enquired how he could find Doctor Hall's back door, to which witness accompanied him, and he then left him and went to bed; and did not see him again until the day of the funeral. Witness was not examined at the Coroner's inquest.

Mary Jones was a servant in Newton's family, and had lived there about three years; remembers the evening her mistress died; about four o'clock in the afternoon of that day witness was sent by her mistress on an errand across the Severn; she was not then ill but in low spirits, she was in the family way; witness crossed the Severn and at about 8 o'clock on her way back; the river is six fields from her master's house; when within four fields witness's attention was particularly attracted by a noise in the direction from it, and she distinctly heard one of the children cry "O dear, daddy, donna." Witness then ran till she got home, and in the kitchen found her mistress and little John, a child eight years old; Mrs. Newton was on the house floor with a deal of blood about her, witness went to her and raised her up, and she continued bleeding. Julia Oliver soon after came in, and the two lads William Bach and George Littleford; her mistress shook hands with Bach, and said "God bless you;" the prisoner came in sometime after and asked his wife which was the rogue she or him; he brought with him Sally Lloyd whom he had fetched from Bridgnorth, and she with Julia Oliver and herself carried her mistress to her bedroom and put her to bed; afterwards whilst witness was warming her master's bed, she heard him go into the room where her mistress was and abuse her. Doctor Hall's assistant came before Mrs. Newton died. After her mistress was dead, Sally Lloyd went to her master's room to tell him, and witness went with her, but does not recollect any answer he made; he got up, came downstairs, and said he would go for a doctor at Bridgnorth; does not know how long he was away, but no one came back with him. Witness recollects a Coroner's Jury meeting at Newton's afterwards, and the prisoner had told her not to tell the gentlemen she heard the child cry when she was four fields off the house, but she did tell them; afterwards her master sent for her upstairs and asked her what she had said, when she told him, he said "what did you tell them that for, did I not tell you not to say so?" she did not make any reply but went away. – On her cross-examination, witness said her mistress was five or six months gone with child, and had been hard at work brewing and baking that day.

Wm. Bach, a lad about 16, was waggoner to the prisoner; on the night Mrs. Newton died saw her about six o'clock, when she was pert enough, went to bed at eight, and soon after heard one of the children cry as if someone was whipping it; witness then went to sleep till his master came to the bottom of the stairs and called him to come down directly to his mistress; he went and found her on the house floor, and she said to him "God bless you, Will, I take my leave of you." Has never heard his master say anything of the matter since, except that he would give all the world for her again.

Sarah Lloyd is a widow, lives at Bridgnorth, and attends sick persons, and had been often at Newton's and attended Mrs. Newton at her lying-in [a rest period after childbirth]. On the night the prisoner's wife died, he came to her house about nine o'clock, called her up and told her his mistress was very ill in the same way she had been before. Witness dressed herself and went with prisoner, who said on the road that if he

had such bills as those brought in he could not pay his way. Witness described the state in which she found Mrs. Newton when they got to the house, and said she assisted in putting her to bed. When prisoner was going to bed he came and asked how his wife was, and witness said very ill, to which he replied "she may thank herself for that, for having such bills brought in;" witness told him what he had got to say he had better tell in the morning, and go to bed. Witness had before told prisoner there must be a doctor, and he said he could not fetch one; she then sent Wm. Bach to Bridgnorth, and Mr. Barber, an assistant to Mr. Hall came and desired vinegar and water to be applied to stop the bleeding, he left a draught to be taken, and some time after went away. Witness, in consequence of what Barber had said, went to prisoner's room and asked him what he did with it and he replied with his hand; did not tell him what Barber had said to her. When Mrs. Newton was dead witness went and told prisoner, who jumped out of bed, and seemed greatly alarmed, and exclaimed, "Lord have mercy upon me, she is not dead, she has fainted away, or is in a fit;" but witness replied "she is dead to true to make a lie of it." He then went downstairs and said he would go and fetch a doctor. Witness assisted to lay out the body, and when washed perceived various marks of violence, which she described. The clothes, which she in part washed, had a great deal of blood upon them, and the gown was ripped across the arm, but she did not observe any marks of soil upon it.

George Littleford was cow-boy to Newton at the time his wife died, and recollects being in the kitchen that night after her death, when his master came in, but does not know whether he spoke. Witness afterwards went with Bach to fetch Mrs. Ward, and on their return met the master in the fold-yard, who asked them if the mistress was dead, when Bach answered she was, and the prisoner said he gave her two or three blows, but no violent blow to kill her. Ann Jones is mother of the witness Mary Jones; was present with her daughter when she went to her master after the coroner's inquest, and corroborated her evidence. On another occasion was with prisoner in his kitchen when his little boy was present, and said to her "Nancy, my mam lay down here after my dad beat her," when the prisoner said, "hush, hush don't talk about your mam."

James Barber was an assistant to Mr. Hall, of Bridgnorth, at the time of Mrs. Newton's death, and was called to her. Witness found her in a very weak and dangerous state, from the loss of blood; gave her laudanum, ordered some brandy for her, and desired vinegar and water to be applied to stop the bleeding, but did not examine the cause from whence it proceeded; he then went home, and between one and two in the morning the prisoner came to Mr. Hall's house, at Bridgnorth and wished him to go and see his wife, as she was dangerously ill. Witness gave the prisoner a bottle of medicine, but neither Mr. Hall nor himself went, as he thought she must die, and he had done everything he could for her. When he left her, at half-past eleven o'clock, he considered her in a very dangerous state – that there was no chance of helping her, – her pulse was at 30, and she appeared fast sinking into the grave. Witness was afterwards present at the examination of the body, with Mr. Coley, and described the marks of violence, which were found in various parts of it. Witness, when before coroner's inquest, deposed that the deceased died from loss of blood; but did not add that it was not in consequence of any violent blows or kicks. – (The Learned Judge remarked strongly upon the want of attention and humanity in this witness towards a person in the desperate condition, which Mrs. Newton was.)

James Millman Coley, a surgeon in extensive practice at Bridgnorth, examined the body of Mrs. Newton on the 27th of January. He described the numerous cuts and

bruises which appeared in various parts of the body, and must have been produced not by one but many blows or kicks; and clearly proved that the death of the deceased, who was in an advanced state of pregnancy, was occasioned by the violent assault which had been made upon her. Had witness been called in to the deceased, he should have thought it was his first duty to ascertain the cause of the bleeding.

This closed the case for the prosecution: but a great part of the testimony of several of the witnesses and of the surgeons, as to the nature of the brutal and horrid assault, is of necessity withheld being totally unfit to meet the public eye.

The prisoner being informed that this was the time for him to make his defence, said that his wife insulted him first, struck him violently, and that he was in liquor.

Witnesses were called for the prisoner to establish a plea of insanity, viz.

John Hewitt, apothecary to the gaol, deposed that when the prisoner was brought to prison he appeared in a low way, that on the third day he became violent, and remained in an incoherent state several days, and appeared to have a predisposition to insanity.

William Proud, of Bridgnorth proved that he attended the brother of the prisoner, who was insane, in 1820, who was afterwards sent to a lunatic asylum.

John Newton, of Sedgley, uncle to the prisoner, proved that three of his relations, on the mother's side, had been in an insane state, two of whom had died so; but said he had known the prisoner from his infancy, and had never known a single instance from which insanity could be inferred, before the present unhappy circumstance.

Many other witnesses were then called to prove various acts of the prisoner, as walking and talking to himself, squaring his fists at a looking glass and opposite a wall, and swimming his horse across the Severn when it was dangerous to cross.

The evidence on the part of the prisoner being concluded:

Mr. Colley was recalled – he attended Newton's family from 1813 to 1821, during which time he had very frequent opportunities of conversing with the prisoner, and never saw the slightest symptoms of insanity in him.

His Lordship in his summing up, during which he capitulated the whole of the evidence, said there could be no doubt that the deceased came to her death in consequence of acts done by the prisoner, and, as the learned counsel had stated, they would have to determine whether it was under circumstances which constituted the crime manslaughter or murder; and further, whether the prisoner was under the influence of insanity. If a person under the impulse of violence of momentary passion, and before reason has time to resume her seat, by a blow or the use of any deadly weapon about him, caused the death of another, then the law allowing for the frailty of human nature, and leaning to the side of mercy, calls the crime manslaughter. But was that the case in the present instance? Or had not they evidence that the prisoner had several hours to reflect, and had even given a promise that he would not ill-use his wife? And yet, in a very short period after, she was found in the dreadful state described by the witnesses. They had heard the body of evidence with regard to the plea of insanity. They had certainly heard stated many strong instances of eccentricity, oddity, rashness, and unbridled passion, but not of insanity. The jury, after a short consultation found the prisoner guilty.

The Learned Judge then pronounced sentence upon him nearly as follows:– John Newton, you have, on clear and most satisfactory evidence, been convicted before an intelligent and humane jury, after a long and patient hearing of the dreadful crime of murder; an offence so foul we are called upon expressly to punish it. "Who so ever

Severn Hall, once the home of the Newtons, is now a large farm. It is said that Admiral Lord Nelson once stayed here.

sheddeth man's blood, by man shall his blood be shed." If it were possible for such a crime to be aggravated, it is so in your case as it was perpetrated upon one it was your duty to protect and cherish, merely because you deemed her to have misapplied the trifling sum of three shillings. It was not done under the influence of momentary passion, for if anything could have checked your brutal disposition, it would have been the interference of a good-natured and kind-hearted man, who offered to lose the money rather than it should be the cause of quarrel between you and your wife, and who extorted a promise from you not to ill-treat her. After having more than four hours to reflect, you took the opportunity, as soon as he had left, to put your threat into execution; you threw her upon the ground, and beat and kicked her in a manner the most likely to produce the effect it did. In any state, but particular in her situation – far advanced in pregnancy with a child of which you were the unnatural father – one would have thought the brutal ferocity of a savage would then have been disarmed; but when afterwards you were desired to fetch a doctor, you refused to do so; and when your wife was laid on the floor, and in her bed, you tauntingly insulted her. During my long experience of more than 30 years, I have never met with a case of such horrid barbarity as yours. On this side of the grave you can expect no mercy; but the fountain of the Almighty's mercy is open to all who seek it by sincere repentance, and to obtain it you will have the assistance of those who are better able to advise you than I am. By the law you have but one clear day to live, and I trust you will pass it in devout preparation for another, and, I hope, a better world. It now only remains for me to pronounce the sentence of the law upon you, which is – that you be taken hence to the place from whence you came, and thence, on Monday next to the usual place of execution, and that you be hanged by the neck until you are dead, and that your body be given for dissection; and may the Lord have mercy on your soul!

The prisoner did not, during his trial, evince any signs of contrition, and it was only on the conclusion of his sentence that he seemed to feel his awful situation; when he appeared to be nearly convulsed with passion, and to be meditating either an attempt of escape or revenge.

The prisoner, towards the latter part of the sentence, began to betray uneasiness, and endeavoured to get away from the bar; but when the sentence was concluded he would not leave it. Being very stout and powerful, he threw himself down, and several men were called to carrying him away. He was removed with great difficulty, and he cried, in a piteous tone, "Dona' kill me, dona' kill me!" – the trial lasted upwards of seven hours and so anxious was the crowd to witness it, that the Judge committed two persons who forcibly rushed into Court.

The unfortunate culprit after being taken to his cell became calm and resigned.

He suffered the sentence of the law at twelve o'clock on Monday. Newton was about 44 years of age, was married in 1813, and has left four orphans, for whose fate in his last moments he expressed great anxiety.

THE MURDER OF ANN SPENCER, AT GORSE COTTAGE, BUSHBURY, WOLVERHAMPTON

Edward Spencer, a road worker, lived with his wife Ann at Gorse Cottage, on the Turnpike Road from Wolverhampton to Cannock. They were an elderly couple living on their own. On the morning of 22 December 1824, Edward kissed his wife goodbye and set off to his workplace. About 3 o'clock in the afternoon he received an urgent message to go home. On reaching his cottage he found a number of people standing around, and his wife lying dead upon the bedroom floor, her head knocked to pieces, and his coal hammer and potato fork lying nearby. Various articles of clothing were missing, and were later recovered from a pawnshop in Darlington Street, Wolverhampton, where they had been deposited by a certain Thomas Powell. Powell was identified by Ann Moore, the owner of the pawnshop, who lent 17 shillings on them. Several other people had also seen Powell on the day in question, on the road from Gorse Cottage, with a bundle under his arm. Thomas Powell was arrested and tried on 15 March at the County Hall, by Mr. Justice Littledale, for wilful murder of Ann Spencer.

WOLVERHAMPTON CHRONICLE, 16 MARCH 1825

TRIAL OF THOMAS POWELL

Assistant Constable Richard Diggory produced the clothes, delivered to him by Mrs. Moore, who identified them as those, pledged to her by Powell.

Edward Spencer examined the clothes, and knew the coat by two hooks and the make of the pockets; but he had not had it a great while, because he bought it after they stripped his house last June; the breeches and the other articles he proved to be his property; the fork he had had 14 years, the hammer more than 20 years; the fork was much bent in forcing the door, and the point of one of the prongs was broken.

Mary Spicer lives about 300 yards from the Gorse cottage; Ann Spencer came to witness's house on the Wednesday before Christmas day; she staid to have a bit of tobacco, but said she had a cake in a pot over the fire and must not stay long, and in a while went away; soon after she left, witness saw John Beech running, and went with him to Spencer's cottage, in consequence of what he said; saw a badge of blood on the kitchen floor, which appeared to have been wiped up, and going upstairs streaks of blood on the left hand wall; at the top of the stairs was Ann Spencer's body which lay on the floor, her head towards the bed staff and her heels towards the stairs; her neck handkerchief was thrown over her face; witness turned her head with her hand which became full of blood; she was quite dead but warm; and had a great wound on the back part of her right ear and bruises on her forehead and cheek; there was a potatoe fork in the kitchen and a hammer lay on the floor; over the fire was a pot with a cake in; the key

was outside the door in the lock; the staple was burst off; the door had been burst open by the potatoe fork, the prongs of which fitted the marks on the door.

Mr. W. Jones had compared the fork with the marks on the door, which it fitted; there were no marks of blood on it, nor on the hammer.

Mr. John Fowke, surgeon, of Wolverhampton, examined the body of the deceased on Thursday the 23d of December, on the left temple were several severe bruises and the skin broken, and immediately beneath the bruises the jaw was fractured; the fracture extending to the socket of the eye and down to the upper jaw; behind the right ear was a lacerated wound an inch or more in length, and the skin round was much bruised; there were bruises on each shoulder, the pit of the stomach, and on the back of her right hand; on the ensuing day, the 24th, witness opened the head, and between the brain and the membrane which covered it, found a quantity of extravasated blood just beneath the wound at the back of the right ear; the injuries about the head were sufficient to cause death almost instantaneously; he should judge the bruises on the temple must have been inflicted by some heavy blunt instrument, and might have been the hammer; they were round, particular that on the back of the hand; the blows on the temple must have been repeated; the bruise behind the ear might have been occasioned by a pointed instrument and must have been done at a thrust; the prongs of a fork might have produced it. On his cross-examination he said that if the injuries had been produced by the hammer and the fork, it would not necessarily follow that they must have marks of blood upon them.

This closed the case on the part of the prosecution; and the prisoner being asked if he had any defence to make, said "I am quite innocent of the job, and if I had done anything amiss I had plenty of time to get away." He then told a story about Diggory, and concluded by saying, "I suppose he had done this for spite, and I hope the law will reward him for it. I am quite innocent of the job." He did not call any witnesses but said he expected the trial would have been yesterday, when they were here but they were now gone away.

His LORDSHIP then, in a most elaborate summing up which occupied an hour and a half, took a general view of the whole evidence; and the jury after a quarter of an hour's deliberation, returned a verdict of – GUILTY.

Mr. Justice LITTLEDALE immediately proceeded to pass sentence as follows:– Thomas Powell, prisoner at the bar, you have been convicted by a Jury of your countrymen of the wilful murder of Ann the wife of Edward Spencer. No person was present when you perpetrated the foul and barbarous deed, and it appears that this murder was committed with a great deal of barbarity and cruelty. The old woman could have given you no provocation, and your only motive in taking away her life must have been to destroy the possibility of her giving evidence against you. There are scarcely any cases of murder towards which any mitigation of punishment can be extended; but yours is one in which I can not flatter you with the slightest hope. Your life, must in a short time, be taken from you. Whether you will obtain forgiveness of your sins, it is impossible for any human being to know, but I entreat you earnestly to apply yourself for the short time you have to live in seeking pardon where only it is to be obtained. It now only remains for me to pass upon you the awful sentence of the law, which is that you be taken hence to the place from whence you came, and thence, on Thursday morning next to the place of execution, and that you be hanged by the neck till you be dead, and that your body be dissected and anatomised, pursuant to the statute; and may God, of his infinite goodness, have mercy upon your soul.

Powell is 32 years of age, of stout make, and ruddy complexion; was dressed in a blue frock coat, yellow silk handkerchief, and coloured waistcoat, and had the appearance of a respectable farmer's servant. While the trial was proceeding he seemed to pay a good deal of attention, but did not during any part of it, even when the instruments were produced with which he executed his fiend-like purpose upon his aged and hapless victim, evince the slightest emotion, and he continued unmoved during the passing of the sentence.

STAFFORDSHIRE ADVERTISER, 18 MARCH 1825

EXECUTION OF POWELL

This unfortunate man, upon being taken to his cell, after his trial, on Tuesday evening, appeared much depressed; he trembled excessively, his countenance was pale, and a cold perspiration spread over his body; but the consolatory ministrations of the Rev. Mr. Langley, the Chaplain, had the effect of soothing his troubled mind. During that night, however, he slept but little, and often exclaimed "Oh Lord, where am I going!" at an interview with his brother on Wednesday morning, he was much affected at first, but he soon recovered himself and talked in a firm voice respecting his family. Throughout the whole of Wednesday, he was occasionally attended by the Rev. Chaplain, who continued his pious exhortations until late in the evening. During the night, which was his last upon earth, the wretched man was very restless, and appeared to be in a state of great alarm; he would not allow the person who attends him to leave his side for a single moment. At an early hour on Thursday morning, he was again waited upon by the Chaplain, and after a while spent in prayer he received the holy sacrament with Mr. Brutton, the Governor; his hand trembled much while the cup was in it, and he shed tears, but soon resumed his former firmness. Upon being urged to unburden his mind by confession, by the Governor and the Chaplain, both before and after receiving the sacrament – he solemnly denied all participation in the robbery or murder; but acknowledged that he had committed several other robberies, and that he had led a very wicked life. He said "that the man who had been apprehended at Liverpool told him that he knocked the old woman down, but he did not know whether he had killed her; and that a 'Codsall Will' brought the clothes to him [Powell] to pawn." At a quarter before eight, the Under Sheriff arrived and at ten minutes past eight the procession ascended the platform. Powell shook hands with all the officers, and returned thanks to them and the respected Governor of the prison for all their kindness; then turning towards the spectators, he exclaimed "God bless you all!"

When the rope was adjusted he said "Let me say my prayers;" he appeared to pray, and then, the cap being over his face, kicked off his shoes; and while he was requesting Wm. Dibb, one of the turnkeys, to visit his little child, the signal was given by the Governor and the executioner drew the fatal bolt – he struggled a little, and was quite dead in two minutes. After hanging the usual time, the body was cut down, and carried in a shell to the County Infirmary to be dissected and anatomised. – Powell was a fine strong-built man about five feet four inches in height. He had been married, and has left one child; his wife died lately in Stafford Infirmary. He formerly lived in the service of two or three respectable tradesmen in Stafford and has been through his life, well known in this neighbourhood.

Most county towns and cities had a Guildhall or Shire Hall, or similar, in which courts were held to try their miscreants, and also a gaol, usually in the form of a castle, to provide secure accommodation, where they could be housed before trial and for punishment afterwards, and also to provide a site for public executions. The drawing above is a pencil sketch of the Stafford Gaol Gate House, known as the Lodge Gate, *c.* 1900. Public executions were carried out on the flat roof up until 1817, when they were brought down to ground level and carried out on a mobile gallows, which was wheeled into position in front of the gates when required; it made for better viewing for the large public gatherings that assembled here, which were normally associated with such events, depending on how infamous the victim was. Prisoners for execution were brought out through the gate with their arms pinioned. They mounted a short flight of steps onto the platform of the drop and were positioned beneath the noose. The area in front of the gallows, including the front gardens of houses opposite, was often used by enterprising persons for the erection of spectator stands, where a better view might be obtained at a cost of half a crown, or a standing in a window might be preferable at a price ranging from eighteen pence up to half a guinea, depending on the quality of the view, and how notorious the culprit was!

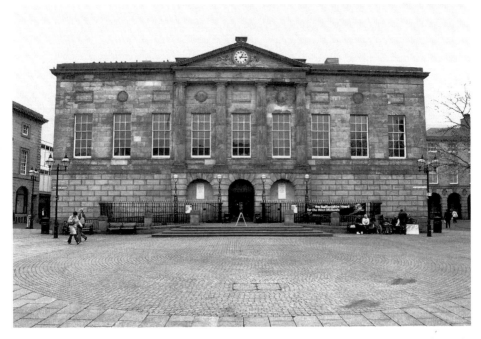

There have been at least three Shire Halls in Stafford over the past 800 years, all approximately on the same site, the first dating back to Norman times. The present Shire Hall, shown above, was completed about 1798; in the basement was the guardroom, to accommodate the prisoners while they awaited trial at the assizes, and to where they returned after sentencing.

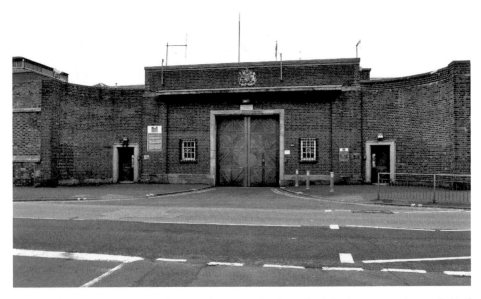

The Stafford Prison gatehouse, in Gaol Road, as it is today. It was built by the prisoners in 1952, behind the original stone gatehouse, which was then demolished on its completion. The doorway on the right opens into to a reception area, where there is a small display of photographs of the old gate house, together with records of many of the prisoners executed here.

THE KILLING OF JOSEPH PARSONS, ROWLEY REGIS

BERROW'S WORCESTER JOURNAL, MARCH 1827

Dreadful occurrence. – On Thursday, an Inquest was held at Rowley Regis, upon the body of Joseph Parsons, a nailer; he lived with Elizabeth Parsons, who passed as his wife, but they were continually having angry words, and on Tuesday, both of them being at work in the same shop, they were quarrelling from ten in the morning till three in the afternoon, using the most provoking language to each other, till they came to an agreement to separate, after which the man said something so irritating to the woman, that she swore "if thee sayest another such word to me, thee shall either kill me or I'll kill thee," lifting up at the same time an iron, with which she was at work on, as if to strike him, the man also picking up a missile to throw at her, and moving his hand in a menacing attitude the woman still holding the iron, and repeating "if thee dost – if thee dost," still adding "I'll be sure to do it," she thrust the iron, which was sharp pointed and nearly red hot, into the body of the man, who, reeling to the opposite side of the shop, the blood gushing down his bosom, gasped for breath three times and died instantly, without uttering a single word! The Jury returned a verdict of manslaughter against Elizabeth Parsons, who was committed to the county gaol. The prisoner had been married to the deceased, but her former husband, whose name is Edward Willetts, is still living, and is now confined in Stafford gaol under sentence of transportation for life for a felony.

George Taylor, constable, produced the iron with which the wound was inflicted, and Daniel Shaw, surgeon, proved it was such an instrument as might have inflicted the wound; the iron had entered between the first and second ribs, past the left lobe of the lungs, and through the heart; the cavity of the chest was full of coagulated blood; it would cause almost instantaneous death. Guilty. – Imprisoned Two Months. Willetts was also tried for bigamy, in marrying with Parsons, her former husband Edward Willetts being alive, and found – Guilty.

WOLVERHAMPTON CHRONICLE, 6 AUGUST 1828

William Steventon or Stevenson, a miner, aged 31, was indicted for the wilful murder of John Horton, at Hales Owen. It appeared that on the 31st March Inst, the prisoner and several of his companions were drinking at a public-house at Oldbury, when the deceased, who was an officer of the Oldbury Court, entered. The prisoner said that he knew that the deceased had an execution [warrant for his arrest] against him, but

the deceased made no reply. After being pressed upon the point several times, he said he had an execution against the prisoner, and asked him what he intended to do. The prisoner requested two or three days' time to send to his wife, but Horton said he would not agree to that, and as soon as he had finished his pipe he meant to take the prisoner with him. The prisoner then asked leave to go home and put a clean shirt on, and the deceased consented; they then left the house together; the prisoner returned in about ten minutes with a long knife in his hand, and when the deceased approached him and urged him to settle the matter, he pulled the knife from under his coat, jumped up and placing his hand on the deceased's eyes, and ran the knife into his body, and it passed through his liver; he died shortly after. – The Jury found the prisoner guilty, and he was ordered for execution on Monday, and his body to be dissected [see p. 66 for the execution of William Steventon].

Murder, in these times, followed by conviction, followed by execution, provided a steady supply of corpses for dissection by doctors and medical students to aid medical research. Although it seems it was unable to provide sufficient bodies for all medical purposes. Dead bodies were valuable. Ten pounds per body was a typical price, which was a lot of money in those days. This led to certain sections of the criminal fraternity realising that burying dead bodies was a waste of money, which led to a spate of associated crimes, such as 'body snatching', by exhuming, at night, the bodies of people recently buried from churchyards, and selling them to the medical profession, who were happy to buy them without many questions being asked. This in turn led to further murders. Burke and Hare were two enterprising Irish men, living in Edinburgh, who realised the potential of this lucrative crime, and developed a thriving business, but like many successful businesses, demand outstripped supply. So to satisfy their clients' needs, they supplemented their supply by obtaining additional bodies, by luring people into their homes, plying them with drink, until senseless, and then smothering them, or 'Burking' them, as it became known, which looked like natural death. They then sold the bodies. After killing more than sixteen people they were caught and tried in 1829. Hare turned King's evidence, and Burke was publicly hanged in the square at Edinburgh before a crowd, said to be upwards of 24,000 individuals, and his body was used for dissection. It was due to the activities of Burke and Hare that the Anatomy Act was introduced in 1832 forbidding the dissection of bodies of those executed.

Most of their victims were elderly – they put up less struggle – and many would have been described today as alcoholics, and/or of no fixed abode, who would not have been easily missed.

'Burke' and 'Burking', meaning to stifle, became new words in the English dictionaries.

THE MURDER OF JAMES HARRISON OF DRAYTON

WOLVERHAMPTON CHRONICLE, 6 AUGUST 1828

Joseph Pugh, John Cox the younger, and Robert Cox were severally indicted, charged with the wilful murder of James Harrison, on the 17th of July, 1827; and John Cox the elder, and Ann Harris, as accessories before the fact, with inciting the said Joseph Pugh, John Cox and Robert Cox, to commit the said murder.

Mr. Richards, in opening the case for the prosecution, said that in the early part of last year considerable depredations took place in the neighbourhood of Drayton by a gang of sheep-stealers, who proceeded to such an extent as to attract the attention of everyone. In consequence of some information that was given by the deceased James Harrison, a man of the name of Thomas Ellson was apprehended and committed to gaol. The apprehension of Ellson with some further information that was expected from Harrison, would, it was supposed, involve the prisoner John Cox, if not the rest of the family. The elder Cox, the principal at the bar, was the father of the prisoners John and Robert Cox, and Ann Harris was the mother of Ellson. As the trial of Ellson was approaching, it became necessary that Harrison, who was the principal evidence against him, should be got out of the way, in order to prevent his conviction and any further discoveries. When the trial came on, Harrison was not forthcoming and it was rumoured that he had been made away with. It was not till Ellson had been again taken up, that any clue was obtained to unravel this mystery; but in consequence of some information that was then obtained, the prisoners Joseph Pugh and Ann Harris were taken into custody. In consequence of information given by Pugh the body of Harrison was found in a field called Hocknell's Field and the other prisoners were immediately taken into custody. Harrison, at the time of his disappearance, lodged at the house of Pugh's father; and the last time he was seen was with the prisoner Pugh, whom he went out with for the purpose of stealing some bacon; and the Jury would hear that a crime, heretofore unknown in England, had been committed, a sum of money having been paid for the murder of Harrison, in order to prevent his appearing as a witness against Thomas Ellson.

The first witnesses called were Henry Holt, of Drayton-in-Hales, who (on the place being pointed out by Joseph Pugh) caused Hocknell's Field to be dug, and the body of Harrison was discovered; the father of the deceased and others, who described the state in which the body was found, and identified it; George and Ann Pugh, the parents of Joseph Pugh, who proved that Harrison left their house in the middle of the night of the 14th of July, 1827, with young John Cox, after a loud whistle had been heard.

Thomas Ellson (the witness alluded to by Mr. Richards in his opening) said, I come now from Shrewsbury gaol. Last year I was in Stafford gaol. I was taken there the day before Good Friday on a charge of stealing some potatoes. From Stafford gaol I was taken to Shrewsbury gaol on suspicion of sheep stealing. I remained three months in gaol till the assizes were over. I married the daughter of the prisoner old John Cox. The two young Cox's now at the bar are his sons, and my brothers-in-law. The prisoner Ann Harris is my mother. After my liberation from Shrewsbury gaol I went to old Cox's at Drayton, and there saw the two young Cox's. Old Cox and his two sons went with me to the Star public-house; where we had some beer together; Robert Cox said to me in the presence of his father and brother, "If it had not been for me and Joe Pugh, you would not have been here now." My mother, Ann Harris then came in, and I went home with her. While I was at my supper in her house that night, Robert Cox came in and said to my mother, Ann Harris, "D--n your old eyes, if you don't give me some more money, I'll fetch him and rear him up against thy door." – The next morning at breakfast time Robert Cox came again, and my mother gave him 2s. and desired him "never to come bothering her any more." Some time after this I saw Joseph Pugh and young John Cox at my house. Pugh said he was the man that freed Harrison out of his (Pugh's) father's house under the pretence of going to steal some bacon; he then took him down the town-field by the pen-fold, and when they got by Dale's barn, told him they were too soon to steal the bacon, and he must go and lay down by Cartwright's stack. John Cox and Robert Cox were waiting at the stack at this time. Pugh said he then caught Harrison by the wind-pipe, and Robert Cox took him by the legs, and John Cox was digging the grave the while. The last words Harrison said when he was dying were – "Oh, Lord, spare my life, and I'll not hurt Shooter" (meaning the witness, that being the nick-name he was known by). Pugh said they killed Harrison in the mowing-piece, took him into the next field (a ploughed piece) to bury him. I remember being confined in the lock-up house at Drayton about some fowls. While I was there, Old John Cox came to me about twelve o'clock at night, and said to me if I would say nothing about the murder, he would employ a lawyer and counsel for me at the sessions. I saw old John Cox give Robert and John Cox 6d. a-piece. I had some conversation with my mother, Ann Harris, on this subject and she told me she had given 50s. and Old Cox had given 50s. to have James Harrison murdered. [The witness was strictly cross-examined by Mr. C. Phillips and Mr. Bather.]

A great number of other witnesses were examined, by whom the facts detailed by the Counsel for the prosecution and the statement made by Ellson were fully proved, as well as by the confessions of Ann Harris and some of the other prisoners. John Pugh acknowledged to Henry Holt, who had him in custody on the 30th of June, that he took Harrison down the Wiper-lane, and there he met John Cox the younger and Robert Cox. He then knelt down upon Harrison, and the young John Cox put a twisted string around Harrison's neck, and pulled it till he was dead. Robert Cox, he said, stood by, but did not assist, and he and John Cox buried him. He also made a similar confession to the Rev. D. Edwards, of Drayton. John Cox also acknowledged to Joseph Taylor, who apprehended him at Newcastle, that it was he and Pugh who killed Harrison, but his brother had nothing to do with it. The confession of Ann Harris stated that when her son, Thomas Ellson, was taken to Stafford gaol, she went to old Cox, and told him they were both done, without Harrison would go off with her Jack, and he had said he would take and throw him into a coal-pit. Old Cox said, "D--n him, if Trunkee Pugh has his

freedom, he would cut his throat in a wagon; but Harrison said he would not go off with Jack without Joe Pugh went off with him, and Joe said he would not go away, as he had done nothing amiss." Bob Cox asked if she would give him 2*l.* to get him out of the way, and in a few days after Bob came to her and said, "D--n your eyes, you old b-----; give me the money." She afterwards met him at his father's, and gave him three half-crowns, and sent her father some meat. Cox said he did not care about her son being hanged, but it was a hard thing that his boy should suffer. The Wednesday after her son came out of gaol she said to the Cox's, "Pray God, Harrison may come back alive;" and Robert Cox said he had taken him to Gloucester and listed him. Old Cox told her she should get some poison to poison Harrison.

The case for the prosecution being closed, the prisoners were called on for their defence, who all declared they were innocent of the charge, and the Learned Judge having summed up, the Jury, after a short consultation, returned a verdict finding Joseph Pugh, John Cox the younger, and Robert Cox, Guilty, after a few minutes' consideration, found John Cox the elder, and Ann Harris Guilty.

Mr. Justice Gazelee having expressed a wish that the Jury would again reconsider the case of John Cox the elder, and read over the evidence effecting him, – John Cox the elder called out, "My Lord Joodge, My Lord Joodge, I'll speak, I'll speak now I wool; and that there lawyer chap (pointing to his attorney) and that Counsellar there, they n'kept my witness out a court, and would not call them. They would not; and I have them to call."

Mr. Justice Gazelee then addressed the prisoners, and said –

"Joseph Pugh, John Cox the younger, and Robert Cox, you have been severally convicted of the crime of murder; and you, John Cox the elder, and Ann Harris, have been severally convicted as accessories before the fact. It is impossible for any one who has attended to the evidence to have any doubt of the propriety of your conviction. The Jury have taken into their consideration your several cases; they have had their attention called to the evidence, which applied to each of you; and after the most serious consideration have found you guilty. The crime of murder at any time appals the heart of any one; but no man, when he considers the circumstances of this murder, and that the object of it was to defeat the ends of justice, can hesitate to say that it is of a description unparalleled in the annuls of crime. I need hardly offer any observations to you on the subject, as I cannot hope that they can have any effect on those who have been guilty of such an offence. With regards to you, Pugh it does not appear that you had any interest to preserve, any relation to protect, or any feeling of revenge to justify you in the sacrifice of this unfortunate man, yet, having him in your house, and under the protection of your paternal roof, you tempted him out under the pretence of committing an offence, according to your own statement (which whether true or not, he would not, have attempted without your solicitation and assistance), and having gotten him into your power, you put an end to his existence without allowing him one moment for preparation. Let me implore you all to reflect how much more indulgent the law is to you which affords you the time to supplicate the mercy of the Almighty, than you were to your unfortunate victim, whom you sent out of the world without a moment's time being given to him to reflect upon the past, and endeavour to make peace with his Maker.

The Learned Judge then concluded by passing sentence of death on all the prisoners, and ordered Joseph Pugh, John Cox the younger, and Robert Cox, to be executed on Monday, and their bodies to be dissected.

It was altogether a most revolting case. Pugh, the father, was called to convict his son, Ellson to convict his own mother and father-in-law and brothers-in-law. His wife corroborated his evidence against her own father and brothers; and the evidence of Mary Bateman, the daughter of Ann Harris, tended to confirm the testimony, which fixed the guilt on her mother.

EXECUTION AT SHREWSBURY

On Monday morning, Joseph Pugh and John Cox two of the principals in the horrible murder at Market Drayton, and William Steventon, for the murder at Oldbury, underwent the last dread penalty of the law in front of the county gaol. Robert Cox, the third principal in the first mentioned atrocious deed, who was to have suffered at the same time, received a respite on Monday morning. Steventon lamented much the course of life he had pursued, which he mainly attributed to the pursuits of bull-baiting and cock-fighting, and the practices of sabbath-breaking, drunkenness, and debauchery; and he was especially anxious that his brothers and children should be warned as to the mode of life that they ought to pursue in order to avoid offences and their punishments.

The drop was erected at an early hour on Monday morning; at about nine o'clock it became known that Robert Cox had been reprieved; and it was sometime after communicated to him that his life would not that day be forfeited. The chaplain, with the Rev. John Richards who had engaged with the several culprits in the last sad offices, having succeeded in bringing the unfortunate men to a satisfactory state of mind, and administered the consolation of religion according to their sacred office, Steventon, Pugh, and young John Cox, were conducted to the place of ignominious exit. They ascended the scaffold calmly and deliberately, but neither of then addressed a word to the immense multitude then before them; but, while the ropes were adjusting, they continued to pray for mercy at the Throne of Grace and in this most becoming state they were launched into eternity! – They died instantly. After they had hung the usual time the bodies were cut down; and permission being requested that the hand of the deceased should be drawn over several individuals suffering under the affliction of wens, that operation was performed!! The bodies of Pugh and Steventon were then conveyed to the Salop Infirmary for dissection; and body of Cox was taken to Market Drayton for a like purpose.

A wen is a form of tumour on the skin, especially the scalp. The treatment here mentioned is probably a superstition, or an old wife's tale – it is not a recommended treatment!

Of the interest that had been excited to the murders for which they suffered, some idea may be formed when we state that about five thousand persons are believed to have been congregated in front of the prison at the moment of execution; and every place from which a view of the drop could be obtained, was crowded with spectators.

The execution of John Cox the elder, and Ann Harris, is expected to take place on Saturday.

FROM THE *SALOPIAN JOURNAL*

CONFESSION AND EXECUTION OF ANN HARRIS

Ann Harris, convicted at our late Assizes of maliciously inciting Joseph Pugh, John Cox the younger, and Robert Cox, to murder James Harrison, underwent the dreadful sentence of the law in the front of our County Gaol, on Saturday last; and as no female had been executed in this County for twenty-five years previous, the number of spectators was immense – probably five thousand were in view of the fatal scaffold.

On Friday the daughter of this unhappy woman came to take leave of her condemned parent; on which occasion Ann Harris evinced much fortitude, observing, that it was better for her to go out of the world than to continue in it, for it was too likely that if she remained she might relapse into a state of crime. She expressed her firm hope that the life of old Cox would be spared, to afford him time for repentance, and that he might, as far as was in his power, atone for his former course of life, which to her knowledge had been very wicked in many transactions, besides that for which he was now in prison; and for all of which she prayed that the Almighty would forgive him. (Old John Cox, aged 60, was respited.)

On Saturday morning the Rev. John Richards visited her at an early hour, and prayed with her. – Mr. Griffiths afterwards visited her; and on this occasion she stated that she was a very wicked woman, and very guilty – that she was going out of this world, and would not tell an untruth; that old Cox was the first promoter of the murder of James Harrison, but that she very willingly consented to. Such is the unreserved statement of this then dying woman; and, as she has now undergone the sentence of the law, we may without impropriety advert to some portions of the confessions of Joseph Pugh and John Cox, jun. (executed on the 4th inst.) Pugh stated, that, as Harrison slept with him, Ann Harris had, as one means of murdering him, proposed that he should cut Harrison's throat in the night, and immediately leave the house and come to her dwelling; and if any suspicions had been excited, she was to have come forward and sworn that he (Pugh) had been all night in her house.

After Ann Harris had made the confessions above recited, the Chaplain arrived at the prison, and preceded to the performance of the duties of his ministerial office, in which the culprit joined with an appearance of real penitence. After attending the last duties in the chapel about a quarter before twelve o'clock, a slight faintness came over her, but she rallied, and proceeded to the fatal platform with a degree of firmness greater than could under all circumstances, have been anticipated. She was assisted up the ladder by Mrs. Kitson, and another female, and then, without addressing a word to the multitude in front of the gaol, she uttered a few sentences of prayer, and while thus engaged was launched into eternity. Life was immediately extinguished, but, as in most cases of ignominious exit in this way, muscular convulsion was observed for several minutes. – After hanging one hour the body was cut down; and on Sunday morning it was buried in St. Mary's Church-yard. – Ann Harris was 50 years old.

THE MURDER OF ANN COOK
AT LYE-ON-THE-WASTE

On 24 August 1829, Michael Toll, a travelling hawker, and Ann Cook were walking back from Cradley to Stourbridge, a distance of about 3 miles.

Around 7 o'clock in the evening, they were about halfway up Hayes Lane, and turned onto a footpath known locally as the Lime Kilns, which led to a coal pit where they were later seen sitting. They sat for a while, having a heated discussion. Suddenly, Toll struck Ann a heavy blow on the head with his walking stick, which was a heavy, club-like instrument. Ann screamed out 'Murder' and Toll pushed her into the pit. About 8.30 the same evening, Toll made a number of enquiries, asking numerous people if they had seen Ann, his wife, saying that he had last seen her near Dudley. He went away for the next five days and on his return he was told her body had been found. Her body was found by T. F. Higgs and taken to the Swan public house in Lye Waste, where her body was examined and the inquest held. Mr. Higgs stated there was no fence around the pit to prevent anyone falling in. Thomas Homer said he had seen the couple together on the evening of 24 August, and mentioned it to the prisoner when they met at the Swan. The prisoner, in a show of affection, wrung his hands and kissed the dead body and said, "Why did you leave me, why did you leave me?"

The Swan public house was in Lye Waste opposite the Talbot and Talbot Street.

BERROW'S WORCESTER JOURNAL, 3 SEPTEMBER 1829

CHARGE OF MURDER. – Michael Toll was this day lodged in our County Gaol, having been committed by Mr. Hallen, Coroner, on the charge of causing the death of Ann Cook, by pushing her into a coal pit, at Lye-on-the-Waste, near Stourbridge. The parties were seen sitting together near the pit on Monday se'nnight. The body was found on Friday.

Worcester, Thursday 11 March 1830
WEDNESDAY, MARCH 10
CHARGE OF MURDER. – Michael Toll, aged 29 (a native of Ireland,) was charged with the wilful murder of Ann Cook, by throwing her into a coal pit (18 yards deep,) at Oldswinford.

Oldswinford should not be confused with the present-day Oldswinford. The murder mentioned here took place in Lye, at the Hayes, which was in the parish of Oldswinford, and while Lye did have a church in 1830, built by Thomas Hill in 1813, it was only a chapel of ease, i.e. an annex of St Mary's church, Oldswinford. Lye church was dedicated as Christ Church in 1839, splitting Lye from Oldswinford to form the parish of Lye.

Mr. Whateley and Mr. Scott conducted the prosecution; Mr. C. Phillips and Mr. Carden the defence.

Mr. Whately then called witnesses, who proved the facts stated in the opening speech.

Joseph Bellingham said, that at about half-past seven in the evening he saw deceased and prisoner close to the edge of the pit; she sitting, he standing.

John Westwood proved, that about eight in the evening I heard a women cry "murder" once, in the direction of the pit.

Mark Tench, who keeps the Anchor, at Stourbridge, stated, that the prisoner called at his house between eight and nine in the evening, and enquired for his wife saying she was to meet him there. – Ann Cox also saw the prisoner at the Anchor; he said that he and his wife had parted near Cradley, and that something might have happened to her – and that she might be dead; he seemed much agitated and cried.

From the evidence of Jane Cook, the sister of deceased, it appeared that the prisoner had manifested great anxiety to find the deceased; and she told the prisoner at Kidderminster that the body was found, he went with her immediately to see it, and cried when he saw the body, saying "my dear Ann, why did you leave me at Stourbridge?" He made no attempt to escape. [Oldswinford parish burial records, dated 2 September 1829, state that Ann Cook, found dead, was 18 years old.]

The prisoner's measuring stick was also produced; it was rather thicker than such sticks generally are; the person (Mrs. Bucknell) with whom Toll left the stick, thought there was a mark of blood upon it, but neither the Learned Judge nor any other person could discover such a mark. – A female, named Harper, deposed that on the 26th of August, two days after Toll professed to have missed his wife, he called at her house, and said he had left his wife "at the top of the town" (Stourbridge).

Mr. W. B. H. Freer, Surgeon, Stourbridge, described the injuries, which the deceased had sustained; there was a wound above the right eye, which did not appear to have been inflicted by falling down the pit; but he admitted on his cross-examination that it might have been occasioned by a sharp stone projecting from the side of the pit. There was an injury on the hip, which he thought was inflicted while the deceased was alive. He thought death was occasioned wither by her falling or being thrown into the pit. The deceased was in the family way.

A written defence was put in. The prisoner protested his innocence. Several witnesses gave him a good character; Anne Willey, of Kidderminster, said Toll always appeared to behave kindly to deceased, who, on the Sunday before her death, told witness that she wanted for nothing, which Toll could give her.

Mr. Justice Littledale, in summing up, said that this was a case deserving the most serious attention of the Jury, and they would have to say whether the deceased was pushed into the pit by the prisoner, or whether she threw herself into it or fell in accidentally.

The jury having returned a verdict of GUILTY, the learned Judge addressed the prisoner, in an impressive manner, and passed SENTENCE OF DEATH on him, ordering the execution to take place on Friday next.

Worcester, 18 March 1830

EXECUTION. – On Friday at the usual hour, Michael Toll was executed in front of the County Goal, pursuant to the sentence passed upon him on Wednesday for the murder of Ann Cook, by throwing her into a coal-pit at Oldswinford. The prisoner being a

Roman Catholic, was attended by the Rev. Mr. Tristram, the officiating clergyman of the Catholic Chapel in this city. On reaching the foot of the gallows, nearly ten minutes were occupied by the culprit in joining the Rev. Mr. Tristram in intercessions for mercy at that tribunal before which he was so shortly to appear. During this time he was firm and collected; and suffered himself to be bound and the rope adjusted without betraying any violent emotion. About eighteen minutes past twelve, the signal was given, the drop fell, and in a few seconds afterwards he was a lifeless corpse. It is not known whether the culprit made any confession of his guilt. The concourse of persons assembled to witness the melancholy scene was considerable; a large proportion consisted of women and children. The prisoners in the Gaol, as is usual on these occasions, were drawn up in the front yard to witness the execution. After hanging the usual time, the body was conveyed to the Worcester Infirmary, to be anatomised, as directed by the sentence. Upon opening the body it was found that Toll had swallowed (probably on the day before his execution) some pieces of blanket, we fear with the intention of committing suicide. The stomach was so inflamed that he could not have survived many days.

'The Lime Kilns' was a historical footpath from the Hayes to Hayes Lane, often used as a shortcut. In early times it led to fields (which contained pits for the mining of coal, clay and limestone, used in the manufacture of bricks) where three murders were committed. The Lime Kilns footpath still exist, as shown in the above picture, but now only leads to factory units, and is known as the Hayes Business Park. It was said years ago that on certain nights the crying of a young child could be heard, and many people would not walk the path after dark. It was probably only rumour, or the wind in the trees!

THE DREADFUL MURDER OF LITTLE SALLY CHANCE AT LYE

BERROW'S WORCESTER JOURNAL, 29 JULY 1830

Charge of Murder. – We mentioned in our last, that Charles Wall had been committed to our County Gaol, under the warrant of Thos. Hallen, Esq. Coroner, charged with the wilful murder of Sally Chance. Wall is 22 years of age; he is a nailer at Lye Waste, near Stourbridge. The deceased was four years of age only, and is stated to be the child of a female to whom the prisoner was about to be married. Her body was found in a lime-stone pit, into which the prisoner is charged with having thrown it. The pit is situated at Oldswinford and is but a short distance from that in which the body of the female was discovered, for whose murder Toll suffered at our last Assizes.

The Lye Waste was an area historically known for its mud houses, often built by their occupants, who were mostly nailers, men, women and children as young as 8 years of age, who worked the daylight hours in their small garden workshops forging nails. The monotony of life was broken only by regular visits to the numerous public houses that existed in Lye at this time.

Once again this murder took place at the Hayes in Lye, Lye being in the parish of Oldswinford.

Trial – Wednesday July 28th 1830.
Charles Wall, aged 23, was charged with the wilful murder of Sally Chance, in the parish of Oldswinford, in this county.

Mr. Whateley stated the case for the prosecution. The learned counsel begged to call the particular attention of the jury to the important charge he was about to put under their consideration, as on their verdict depended the life of the prisoner.

Noah Stephens – I am a miner; on the 19th of May I was at work in a lime-stone pit at Hay's Hill; I remember the signal being given for breakfast; it is by thumping the scaffold at the top of the pit; when I heard the noise I ran from the break to the bottom of the shaft; I saw a bundle lying in the water; I thought it was my breakfast that had fell in; I got a stick and dragged it up, and saw it was a child; I was startled, and let it drop again into the water; I then called the other men to my assistance; one of them jumped into the water and brought the child out; the water several days before was higher than on the day when the child was found; the shaft of the pit was 240 feet deep; there are pieces of lime-stone sticking out of the sides of the shaft.

Cross-examined by Mr. Carrington. – Most of the children about the parish were dressed in check frocks.

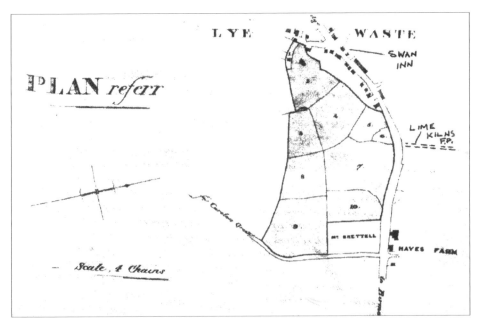

The map above is dated 1850 and shows the Hayes Farm and crossroads, the Swan Inn, where the bodies were taken and the inquests held, and the Lime Kilns footpath; the pits were close to this foot path.

Maria Pearson – I know a little girl called Sally Chance; she was lost on the 16th May. I saw her in the evening near the house of John Brooks; she was playing on the road-side with two other children. I know the prisoner; at this time he came up to the child and said "Sally, your mother is gone home;" she said "Is her," and then walked away towards her mother's.

The house of John Brooks, in the Waste, was called 'Ivy Dene'. It was a very distinctive house of red and yellow brickwork, with terracotta work to the central arched doorway and window heads.

The prisoner came out of Saml. Knowles house; he followed the child; I never saw her again alive.

Mr. Davis stated, in answer to a question by Mr. Carrington, that there was no fence around the pits, and if the slide was withdrawn, a person might fall in by accident.

William Newey – I know the prisoner; I saw him about a quarter before nine on Sunday, the 16th May; he was then near the Anvil public house. The deceased was walking about two yards before the prisoner; when I met him, he dropped down his head, and was walking with his hands in his pocket. I know the mother of the child; she came to my house about half-past nine to make enquiry after her; I said, "Mary, the last time I saw your child was with Charles Wall." The prisoner was present and she asked him if he had seen her; and he said, "he had not;" they then went away. The prisoner called me up at one o'clock, and said, "Wm. Squirrel (a nick-name), did you see me with the child?" I said, yes he then called me a d--- liar. I saw the prisoner again about

five o'clock; a man named Joseph Hunt was with him; he again asked me if I had seen him with the child, and on my saying yes, he again called me a liar.

Mary Chance. – I am the mother of the child; I live at the Lye Waste; I am a single woman, I know the prisoner. On the 16th of May I was at Samuel Knowles's house, from four o'clock to nine; the prisoner was with me; he left about twenty minutes before nine. My child was in the house about a quarter after eight o'clock; she asked me for a half penny, to buy apples, which I gave her; she asked leave to go out to play; before she did so, she brought the apples to me; the prisoner was then present. Before I left Knowles's house I went in search of the child, but could not find her; about half an hour afterwards I met the prisoner, and asked him if he had seen Sally; he said, "No, not since she brought you the apples." The prisoner went with me in search of the child until about one o'clock, when he said he would go home and go to bed. I went to Newey's house; his wife told me that her husband saw Charles Wall take Sally up the road; the prisoner was present and denied it. I had not been at Church that morning with the prisoner; he was courting me, and we were asked in Church the first time that day. Wright Rubens was the father of the child. On the Sunday evening she was dressed in a light pinafore, and had no cap or bonnet on. I never saw her alive again.

Cross-examined. – The prisoner used to call "Sall-y," I never knew him walk out with her before the day she was lost. I have another child about three years old.

Thos. Kendrick – I know the prisoner; saw him about a quarter before nine o'clock on Sunday, the 16th May. I know it was about this time, as I heard the clock shortly afterwards strike nine. He was near the Anvil public-house; the roads divide at that place, and the prisoner was taking the one leading towards the fields; the child was a few yards behind him; he called to her, and told her to come forwards; the child made haste, and ran after him; I then saw him get over the stile, but saw nothing of him again that night. About five o'clock the next morning, I went to the prisoner's house; he was in bed; I told him to get up; the constable was with me at this time; when he got up, I asked him if he had seen the child and he said no, not since eight o'clock. We then took him to the pit, where we supposed the child was.

William Baker – I live at Brettell Lane, near Oldswinford. I was at the Swan Inn, Lye Waste, on the 16th May. I left about ten minutes before nine o'clock; I went up the Birmingham road until I got near the lime pits, when I met Charles Wall; a young girl was with him; the child was in his arms; I did not know the prisoner before, but I am sure he was the man; I pointed him out at the inquest from amongst 13 or 14 people. When I met the child she was crying, and wanted to go home and get some victuals. He said, "don't cry my child, and I will get you some flowers," I got over the stile first, and the prisoner went towards the lime pits. I watched him down 30 or 40 yards; the child was still with him, and making a cry. I saw him within about a hundred yards of the lime pits. I took particular notice of him, on account of the child crying so very much.

John Round – I saw the prisoner a little after nine o'clock on the 16th of May; I was in the Hay's Lane, between the stile leading to the pits and the Birmingham road; no one was with him at this time.

The author lived in upper Hayes Lane for over twenty years, and well remembers the footpath, known as 'The Lime Kilns', having walked it many times. It ran from Hayes Lane and came out, below the Hayes, between the electrical substation and Brown's scrapyard, almost opposite Wood Street.

Ann Southall – I live at the Hays; my husband is clerk to the owner of the lime pits; on Sunday morning, the 16th of May about ten o'clock, the prisoner came to my house, and asked me if the road through a field leading to the coal pits was stopped, I said no, the road is not stopped, but the people are, as they do so much damage; he then asked me if I knew which of the pits was knocked off; I said that I had not heard my husband say a word about it; I then asked which he meant; he put up his hand and said, either that or that; I said, do you mean the lime quarry pits, and he answered yes that was the one in which the child was afterwards found; no one was with the prisoner at the time he made these enquiries.

John Yardley. – I am the constable of Oldswinford; I went to the prisoner's house on Monday morning to apprehend him; he was in bed; I told him the charge on which I took him in to custody; he said he had not seen the child since a quarter after 8 o'clock.

Wm. Westwood. – After the Coroner's inquest, the prisoner was in my custody; he said "last Saturday I was very well off; I did not think it would have been in this way. I shall surely be hung for this crime."

Mr. Freer – I am a surgeon at Stourbridge; on the 19th of May I examined the body of a child; the head was fractured there was a very extensive lacerated wound on the scalp; it certainly was a wound such as might have been inflicted from the child being thrown down the lime pit, and was quite sufficient to cause instantaneous death.

This was the case for the prosecution.

Mr. Carrington, the prisoner's Counsel, then called the following witnesses;

Benj. Robins – I am a nailer, and have known the prisoner 10 or 12 years. The prisoner always appeared to be very fond of Sally Chance; he was very kind to her and other children. I know the pit where the body was found; it is situated in a field where it is very common for children to play. I saw several children playing there about 7 o'clock on the 16th of May; Sally Chance was amongst them.

Mr. Justice Park – Take care man, what you are saying; pray be careful.

Cross-examined – I saw the prisoner and Mary Chance about 6 o'clock; I was smoking a pipe near the pit; Sally Chance stood by the side of me nearly the whole time; I left her there when I went away about 7 o'clock, with my eldest wench.

Josiah Hunt – I have known the prisoner 15 years; I knew the child from its infancy; the prisoner behaved more kind to her than I can do to mine; my children and others used often to play near the lime pits; I saw Sally Chance playing there on the 16th of May.

Thomas Bolton – I live at the Lye Waste; I have known the prisoner 5 years; his treatment towards the deceased child was very kind; he treated her better than I can do my children; it was very common for children to play near the lime pits.

This closed the defence.

Mary Chance re-called. – I never walked with Charles Wall towards the lime-pits on the Sunday my child was lost.

Mr. Justice Park minutely recapitulated the evidence. His lordship said, he was at a loss to know what earthly motive the prisoner could have had for committing so diabolical an act as the one imputed to him; but motives could not be judged by an earthly tribunal, they were open only to that Eye that knew all secrets, and from whom nothing was hidden. If they were convinced the prisoner threw the child down the pit, they must suppose it was from a malicious motive arising from some cause or other; and

it would be their painful duty to find him guilty. But if, on the other hand they thought she fell in by accident, they would then return a verdict of acquittal it had been proved by several respectable witnesses, that the prisoner was seen with the child going in the direction of the pit, about the time it was lost; and it was also proved that he returned without it. His counsel had called witnesses to raise a presumption that the child might have fallen into the pit by accident.

One of the jury wished some of the witnesses to be asked whether or not, on Sunday, the 16th of May, the pit was covered over; because if such was the fact, it would be impossible the child could fall in by accident.

Two witnesses were re-called, who stated that the mouth of the pit was left open.

Mr. Justice Park. – Gentlemen, on my summing up I have all along presumed that the pit was left open, for if it had been shut, it would only prove that the child had been thrown in by some wicked person or another, but it would not at all prove that the prisoner was that man.

The Jury then retired, and in about ten minutes returned in Court with a verdict of Guilty. The most death-like silence at this moment reigned throughout the Court.

The prisoner appeared unmoved, not a muscle of his face exhibited the least agitation, and he seemed stupidly indifferent to the awful situation in which he stood.

The jury, when they delivered their verdict, said it was their unanimous wish to recommend the prisoner to mercy.

Mr. Justice Park. – In a conviction for murder, Gentlemen, I can receive no recommendation for mercy; there can be no mercy in this world.

The Learned Judge then addressed the prisoner, expressing his perfect acquiescence in the propriety of the verdict. The finger of Providence had pointed out his guilt as strongly as if the deed had been witnessed by human eyes. If the child had fallen into the pit by accident, her playfellows would have immediately given the alarm. It was, indeed, difficult to imagine his motive for such a crime as depriving an unoffending child of life; but God alone could know motives. His was a crime, which admitted of no mercy. He had behaved most cruelly to the woman whom he was about to make his wife – he had behaved most cruelly to her innocent child. "I entreat you, therefore, during the short time the law of England allows you to live, to spend it in prayer and supplication for mercy. You have committed a crime for which, in a few hours, you must be cut off from the land of the living. You have but a few hours to live; let me beg of you, then, to ask for mercy; be earnest in your entreaties, and you may yet find it. Knock with penitence at the gates of Heaven, and they may still be opened to you, for with God there is plenteous redemption."

It is at this point that the black cap (a square of 9 inches of black silky material) would be placed upon the Judge's head. Execution would follow within days of this sentence.

"It only now remains for me to pass upon you the dread sentence of the law, which is, that you be taken to the place from whence you came, and on Friday next, the 30th of July, be taken to a place of execution, and there be hung by the neck until you are dead; and that afterwards your body be given to the Surgeons for dissection, and may the Lord God of Mercy have mercy on your soul."

The prisoner was then removed from the bar.

BERROW'S WORCESTER JOURNAL, 5 AUGUST 1830

EXECUTION – The execution of Charles Wall, aged 23, convicted of the murder of Sally Chance, aged 5 years, by throwing her (on the 16th of May) into a lime stone pit at Hay's Hill, in the parish of Oldswinford, took place at six o'clock on Friday afternoon. We lament to say that up to the latest moment of his existence Wall exhibited an obduracy of the most painful kind. The Chaplain (the Rev. Mr. Hadley) was incessant in his endeavours to produce some religious impressions upon his mind – and to induce him to confess. His efforts were seconded by the Rev. Thos. Waters (the Baptist Minister) – but all in vain! The unhappy being seemed alike destitute of religious and natural feelings. – Though he could not be brought to confess the crime of which he had been convicted, it was observable that whereas he positively denied guilt after his conviction, he remained silent upon the subject when it was urged upon him just previous to his execution. Mr. Lavender used every effort to induce a confession. A more obdurate criminal we never heard of. – The body of the wretched being was very properly given to Mr. Downing, surgeon, Stourbridge, in order that it might be dissected in the immediate neighbourhood where the crime was committed. The body was most skilfully dissected by Mr. Hill and Mr. Hayes, two of Mr. Downing's pupils, and immense crowds of both sexes and all ages came from the Lye Waste and all the surrounding places to see the body. We hope the effect will be salutary. It is a melancholy fact that this is the second execution within six months for murders committed in the same neighbourhood, and under similar circumstances. – Upon the trial much surprise was expressed that the prisoner appeared to have committed the crime without any motive.

But after his conviction it became known that Wall had been engaged in many robberies, with which the child (whose mother Wall was about to marry) was acquainted, and had mentioned them to some persons. Wall, therefore, to get her out of the way, had recourse to the dreadful crime for which he as justly forfeited his life, – Wall acknowledged that he never went to a place of worship, nor never even heard that there was a Redeemer!

The pit where the body was found was at the Hayes, in Lye, where the body of Ann Cook was also found, but not necessarily in the same pit. The Swan Inn in Lye Waste was where both bodies were taken. The Hayes (from the word Hay, or Haga, a Saxon term for boundary or artificial enclosure) has been an important crossroads for many years; it was on the boundary of Lye and Cradley, which was also the boundary between the ancient parish of Oldswinford and Cradley parish. The area in 1699 was owned by the Foleys, who were followed by Doctor Richard Phillips, a surgeon and apothecary of Droitwich, who was the principal landowner in the area in 1782. Harry Court's map of 1782 shows the 'Hayes Farm' with other buildings nearby. The road running east to west was originally cut through a hillock of limestone, which was excavated and used for building and other purposes. During the late nineteenth and early twentieth centuries the area was occupied by Mobberley & Perry, brickmakers, who sunk various pits in the area to obtain coal, clay and limestone.

THE WILFUL MURDER OF WILLIAM HIGGINS OF COVENTRY

On Tuesday 22 March 1831, Mary Ann Higgins attempted to buy twopenny worth of arsenic to destroy rats, but was refused because she did not have a witness with her. She then went to another shop, but received the same answer. In the street she met a friend, who agreed to accompany her to the druggist where she obtained the arsenic. She then went home and administered the poison in some pea soup to her uncle, who died during the night. Edward Clarke, her boyfriend, denied all knowledge of the poison, or of it being administered to the old man.

WOLVERHAMPTON CHRONICLE, 17 AUGUST 1831
(WARWICK ASSIZES)

Murder of Uncle by his Niece

On Tuesday, Mary Ann Higgins, aged 19, and Edward Clarke, aged 21, were indicted for the wilful murder of William Higgins, at Coventry, on the 22nd of March last, by administring to him three drachms of arsenic. In a second count of the indictment, the prisoner Higgins was charged as the principal and Clarke as accessory.

Upwards of 40 witnesses were called, and the investigation lasted from nine o'clock in the morning until an advanced hour in the evening; the material facts of the case, however, may be thus stated:–

William Higgins, the deceased, was a man in a humble station of life, who had saved a little money, upwards of 100*l.* of which he had placed out at interest. Upon the death of his only brother, who left four or five children behind him, the deceased, himself being unmarried, took one of the children (the female prisoner) to live with him, and reared her as he would his own child, intending also to leave her the little money he possessed at his death. About the beginning of the present year, a courtship commenced between the girl and the prisoner Clarke, who was an apprentice at the watch factory of Messrs. Vale & Co. at Coventry, in the course of which he eventually acquired considerable influence over her mind. He was observed within the last few weeks to be in possession of more money than usual, including one or two golden guineas, a denomination of coin which the deceased's savings were supposed principally to have consisted; and he boasted on more than one occasion, that he had only to go to the old man's house whenever he wanted money. Several witnesses gave Clarke a good character; but none appeared on behalf of Higgins.

The Jury, after deliberating for about six minutes, returned a verdict, acquitting Edward Clarke, but finding Mary Ann Higgins, guilty.

The learned Judge then, in the usual form, sentenced the wretched girl to be executed at Coventry on Thursday, and her body to be dissected.

She wept all the time sentence was passing upon her, and cried piteously on being led from the bar. Her youthful appearance, and the dreadful situation in which she then stood, as being about to expiate, in the brief space of forty-eight hours, the dreadful crime of which she had been convicted, excited powerful emotions in the breast of every person present. The women in Court sobbed aloud, and the Jury and several other persons shed tears when the sentence was pronounced.

Wolverhampton, 17 August 1831
EXECUTION AT COVENTRY
On Thursday the awful sentence of the law was carried into effect on Mary Ann Higgins, convicted of the murder of her uncle, William Higgins of that city. She frequently asserted that her fellow prisoner, Clarke, participated in the murder and that it was done by his instigation. About twelve o'clock the unhappy criminal was brought out, attended by the Under Sheriff and his Officers, and the Rev. S. Paris, jun. Her eyes appeared swollen but her colour was ruddy. She then stepped into the cart with great firmness, and placed herself on the coffin, the Rev. Gentleman seating himself beside her, and endeavouring to engage her attention in prayer. The cart, attended by the executioner and an immense number of people, then moved on to Witley Common, where from 15,000 to 20,000 persons were waiting her arrival. On her way to the place of execution she seemed to pay great attention to the admonitions of the clergyman. At half past twelve the procession arrived at the spot where the drop had been erected. A circle was formed, and all persons were commanded to retire forty feet from the gallows while sentence of death was carried into execution. The unhappy criminal ascended the scaffold with great firmness. The Rev. Mr. Paris, then read, at her request, a prayer appropriate to the occasion, and this being finished, the Rev. Mr. Franklin recited a short prayer. The clergymen then shook hands with her and left her. The executioner took off her bonnet, and replaced it with a cap, which covered her face; her arms were afterwards pinioned, the rope adjusted round her neck, and a cord was tied loosely round her ankles. [The hands were usually pinioned together in front of the culprits, to enable them to pray.]

Everything being ready, the executioner descended, and in a short time, the signal being given by the wretched girl dropping a white handkerchief, she was launched into eternity. The body, after hanging an hour, was cut down and placed in the cart, and conveyed to the Old Bridewell for the purpose of dissection.

THE KILLING OF
JOSEPH HOLMES AT DUDLEY

BERROW'S WORCESTER JOURNAL, THURSDAY 18 MARCH 1832

CROWN COURT, Tuesday 6 March 1832

Jonas Woodall, 18, and John Poole, 19, chimney-sweepers, were charged with killing Joseph Holmes, by compelling him to enter and remain in the flue of an engine-house belonging to Mr. Grazebrook, at Blower's Green, near Dudley. The first witness was Benj. Holmes, a boy about 13, the brother of the deceased. He stated that the deceased, himself, and the two prisoners, worked for a chimney-sweeper named Jones, at Dudley. On the 12th November, they went to Mr. Grazebrook's furnace; witness went into the flue first; it was hot; Woodall went in after; witness remained in about an hour and a half; when he came out, he fainted. When he recovered, he heard his brother cry out in the flue, "O Lord; O Lord; I am being burnt to death;" Woodall said "Damn your eyes, go on, if you don't I'll cut your head off;" his brother asked for a scraper, and Woodall again told him to go on; he and Poole afterwards got him out, but he was dead; he had been in the flue about an hour and a half. – On his cross-examination this witness stated that his mother had said to him, "If you come back without hanging them, I'll murder you." – Benj. Brownhill was at the furnace when the accident happened; he saw somebody give Joseph Holmes two taps on the feet with the shovel, the boy not liking to go in, as his brother had fainted. He lived a minute or two after he was brought out. On his cross-examination he stated that the flue was 2 ft. 15 in. at the beginning, and afterwards 2ft. He never saw a flue swept before by sweeps; it is always done by the engineer, whose duty it was to see that the flue is in a proper state. – Wm. Danks stated that he was near the flue when the deceased was crying out that he should be dead, and the prisoners were swearing at him, and would not let him come out. On his cross-examination he stated that the boiler was tapped over night. – Mr. Roberts, surgeon, of Dudley, examined the body of the deceased; there was a burn on the back and another on the chest, and also on one of his elbows; the inner surface of the windpipe was completely lined with soot, which had also accumulated under the tongue. He had no doubt that the boy died of suffocation. – Mr. Justice Littledale, in summing up, said there did not appear to have been any intention on the part of the prisoners to injure the boy who had died, and that from the testimony of the medical gentleman who had examined the body of the deceased, they were led to understand that his death was occasioned by suffocation from inhaling the soot, and not from any foulness of air in the flue. Therefore he did not see how manslaughter could apply in this case. – The Jury, after a very short deliberation, returned a verdict of Not Guilty.

THE MURDER OF MR. PAAS OF LEICESTER

BERROW'S WORCESTER JOURNAL, 16 AUGUST 1832

At Leicester, on Wednesday James Cooke, the wretched murderer of Mr. Paas, was put to the bar. During a reading of the indictment he was engaged in reading the New Testament, and when the usual question was put to him he pleaded Guilty. When the Judge warned him of the consequences of that plea, he said he was aware of them. Sentence of death was then passed upon him, and his body was ordered to be hung in chains. He says, that he had the murder in contemplation a week previous to committing it; that on Mr. Paas coming into his workshop he shut the door after him, and that he then paid him a small account, but denies that he struck him while writing the receipt; that Mr. Paas soon after took up a book that lay on the press, and while examining the binding, he walked behind him and immediately struck him on the back of his head (his hat being off at the time;) that Mr. Paas immediately put both his hands to his head and staggered towards the door, and as loud as he was able called out "Murder!"; that he (Cooke) again struck him another severe blow on the top of his head, and finding it not quite sufficient he dealt out a third, which brought the poor creature to the ground. He then locked the door and left. On returning in the evening, he commenced the work of cutting up the body, and was so little discomposed by what he was doing, that he could have gone on with, the horrid work longer than he did, if there had been any necessity for it. He then also stated that pride was the cause of his crime, as he wanted to get some money to embark for America. Cooke was executed yesterday evening at 5 o'clock, he threw out a white cambric handkerchief and the drop fell. His conduct on the scaffold became his situation; his last words were, "Lord! Remember me when thou comest to Judge the world." When the drop fell, he struggled violently for two minutes, during which he gave some terrible convulsive heaves, dying very hard. It is calculated that 40,000 persons were present.

Worcester, 30 August 1832
Hanging the Body of James Cooke in Chains. – The body, after hanging the usual time was taken into the gaol infirmary, and was laid upon a plank, and two bricks placed under his head, his clothes on, and his head was shortly after shaved preparatory to being tarred. On Saturday afternoon, the culprit was put on the gibbet. His face was covered with a pitch plaister, and over it was placed the cap he suffered in.

James Cooke of Leicester was the last man to be hung in chains or gibbeted – the practice was abolished in 1834. Gibbeting was considered to be an additional punishment, as people believed they could not go to heaven without a body.

THE MURDER OF MARK COX AT CRADLEY

WORCESTER HERALD, 14 MARCH 1833 (WORCESTER ASSIZES)

Samuel Winnall, aged 29, nailer was next placed at the bar to answer to the indictment charging him with having wilfully murdered Mark Cox, at Cradley near Stourbridge. Mr. Lea appeared for the prosecution, and Mr. Godson for the defence. It appeared that on the night of the 3rd of November last, the deceased Cox, the prisoner, two brothers, named Blizzard, and several other men, all being nailers, were drinking at a small public-house by the side of the road leading from Hales Owen to Stourbridge. A dispute arose between the prisoners and one of the Blizzards over a game at all-fours [an old American card game played with a normal pack of 52 cards]. The prisoner challenged the latter to fight, and the party left the house for the purpose; but no fight took place. However, the prisoner continuing to be very quarrelsome, the landlord asked the other men to assist in turning him out of the house, which they did. The prisoner then went into a lane near by, and stood against the hedge. Whilst all this was passing, the deceased Cox was asleep in the public-house; however, he afterwards awoke, and joined the party. Winnall was then again challenging anyone of them to fight, and invited them to come to him in the lane. They proceeded towards him, Cox being the last, when as he (Cox) was in front of him, the prisoner drew from behind him a large hedge stake, and grasping it with both hands, struck the deceased a violent blow on the back of the head, which felled him to the ground. The stake broke in two from the force of the blow, and the deceased survived the injury he sustained but a few days. In addition to the above facts, expressions used by the prisoner previous to, and after the night the blow was struck, was proved in evidence, which went to show feelings of malice, and the case, at one time, bore a serious aspect against him; however, subsequent testimony, both as regards the character before borne by the prisoner for humanity, and general good conduct, and the deceased, it being proved, having before his death stated his belief that the prisoner did not intend his death, but mistook him for Blizzard, placed the case in a more favourable view, and under the direction of his Lordship, the Jury acquitted the prisoner of the murder, but found him guilty of manslaughter. The learned Judge then directed that the prisoner should be transported for seven years.

Samuel Winnall was transported on 29 January 1834, bound for Van Diemen's Land (Tasmania), on board the *Moffatt*. A Winnall family of nailers lived at Careless Green; their surname was used for the naming of Wynnall Lane.

THE MURDER OF JONATHAN WALL AT BROMSGROVE

Robert Lilly, aged 50, was a button-maker of Bromsgrove. He was a mild-tempered man and inoffensive, but had a nasty temper when provoked or under the influence of drink. He was an ex-army man who had served time in India and was said to have received a serious head wound, which affected his temperament. On the night of 5 November 1833, he called at a public house on his way home, where he had three pints of beer. Having left the public house, slightly inebriated, he was set upon by a group of boys who threw fireworks and mud at him. Being a Catholic, he took this as a personal insult. On reaching home about 8 o'clock, he verbally abused his wife and stepdaughter, who set his supper of bread and cheese before him, which he ate, using his pocketknife. He became more abusive, cursing his wife and threatening her, causing her and her daughter to run out of the door shouting 'Murder'. Jonathan Wall was a friend and neighbour and also his landlord; he went to see what the fuss was about, and was immediately stabbed in the stomach. By now James King, a police constable, arrived and tried to calm him down and was threatened with the knife, at which he drew his staff and struck him two blows, which brought him down and the knife fell from his hand. Meanwhile, Wall was taken to a doctor, but died later.

Berrow's Worcester Journal, Thursday 18 March 1834

MONDAY MARCH 10 – Before Justice Park.
WILFUL MURDER. – Robt. Lilly, was charged with the wilful murder of Jonathan Wall, at Bromsgrove, on the 5th of November last. The verdict of the Coroner's Jury was "manslaughter," but the grand Jury returned a bill of wilful murder.

Mr. Alexander having opened the case called Anne Wise, the daughter of the prisoner's wife. This witness stated that his back was all over mud when he came in, and complained that mud had been thrown at him, and appeared in a great passion [rage or temper] and called his wife a whore, saying he would stick her, and held up a knife.

Charlotte Gill, saw Wall run up stairs, which he did with a view to induce prisoner to be quiet; two minutes later he came down, the prisoner coming down behind him; Wall cried out, "Oh, somebody take me to the doctor – I am a dead man." Witness said to the prisoner, "you villain, you have killed him." He replied, "damn you, if you come within reach of this knife, I'll serve you the same."

James King, constable, deposed, that he arrested Lilly and produced the knife, which was a common pocket knife; it was covered with blood. King stated that Lilly was very quiet when sober, but very violent when in liquor.

Mr. Horton, surgeon, deposed, that Wall was wounded on the left side of the belly; the wound was 5 or 6 inches deep, and the intestines were exposed; the knife produced, might have caused such a wound; Wall died of the wound 35 hours after it was inflicted.

Mr. Lee, on behalf of the prisoner, pleaded provocation, and should be deemed manslaughter only.

Mr. Sanders stated, that the prisoner had been in his employ since 1825, as a button-maker, and had borne the character of a quiet, inoffensive man.

In his charge to the Jury, the Learned Judge said, the prisoner at the bar stood charged with wilful murder in having caused the death of Jonathan Wall. The Coroner's Inquest had charged the prisoner with manslaughter; but he had stated before the Grand Jury, that this must be murder or nothing.

A defence had been made, and very properly, by the learned counsel, and some cases had been referred to, to prove that this might be only a case of manslaughter. His Lordship wished that he could find anything on the face of the evidence, which could justify him in so directing the Jury. A great deal had been said on the subject of malice aforethought, but he must tell the Jury, that every putting to death of a fellow-creature was murder, unless the party accused could show any circumstances of aggravation or defence; this he must show by his own witnesses, or must deduce from the evidence of his accuser. The indictment charged the prisoner with malice aforethought; no one from the evidence could infer that there was malice before hand in this case; but any man guilty of murder, by giving a wound with some deadly weapon, was to be considered as influenced by hostility against the whole race of men – it is therefore malice – not aforethought in this case indeed, the deceased himself released from any ill will to him. But the question that arose was, whether there was not malice, which might be deduced from the acts of the prisoner. The prisoner, in his defence, said he had been drinking, and the constable had said that though quiet when sober, he was outrageous when in beer. But his Lordship could not find in law that this was any excuse.

The Jury deliberated for about ten minutes and then returned a verdict of Guilty.

The Judge then assumed the black cap, and proceeded to pass sentence in the following terms.

The next part of the proceedings was known as the 'Admonitory Speech'; it was known by the criminal fraternity as the 'Dismal Ditty'.

"Robert Lilly, after a very long and very impartial trial, and assisted as you have been in your defence by a very able counsel who has argued every point, that could possibly tend to further your cause, the Jury have come to the conclusion, that you have been found guilty of murder, in taking away the life of a fellow-creature. If the Jury had found any other verdict it would have astonished all who have heard the evidence, and however painful it must be for them, that verdict is perfectly satisfactory to me, as it is in accordance with that which justice demands. I should indeed have been pleased, if I could have found any ground on which to recommend any other course. A kind, peaceful neighbour comes into your house, with the most anxious and kind intention to compose your differences, and in a moment you stab him with a mortal weapon, not in madness or fury of a man who is not conscious of his actions, but you dealt out your blows on every hand, and called upon every one to come on and you would serve them the same.

This is a case of direct and wilful murder, and how the Coroner's Jury could bring in a verdict of manslaughter I cannot conceive. There must have been some misdirection by the Coroner, for the principle he laid down is subversive of all law; it supposes that there must be malice aforethought, or there would be no murder; but where life is violently taken away, the law supposes malice, unless some circumstances can be brought forward to justify or alleviate the act. No such circumstances have been produced, and in your case I dare not hold out to you the slightest hope of mercy, for God hath said nothing can cleanse the land from blood that is shed but the blood of him that shed it. I dare not, as I respect the laws of God and man, afford you the hope of pardon from an earthly judge, but I can direct you where you may find that mercy which an earthly judge dare not vouchsafe, from the God you have offended, even through the merits and mediation of his adorable Son. Your time must be very short, and I therefore exhort you to apply to some spiritual instructor, and with earnestness of soul seek for that forgiveness – from God, which cannot be extended to you by man. Ask and it may be given you, seek and you may find, knock I entreat you at mercy's door and it may even now be opened to you, and it shall be my fervent prayer for you that it may. (Here the venerable Judge was deeply affected, and paused, overcome by his feelings.) The sentence of the Court is, that you, Robert Lilly, be taken back to the place from whence you came, and on the 12th, Wednesday, be taken to the place of execution, and there be hanged by the neck till you are dead – your body afterwards to be buried in the ground contiguous to the place of execution, and may God in his great mercy have pity on your guilty soul!"

Execution was often carried out within two or three days of sentencing, and generally on market days, in order to attract a larger crowd.

The solemn address of the venerable Judge, and deep emotion which he exhibited, while passing the sentence, caused a strong feeling throughout the Court. The prisoner was firm, but shed tears while the sentence was being passed, affected apparently more by the Judge's manner than by the fear of death. Throughout the trial he was composed, and there was nothing in his countenance, which betokened a man capable of deliberately shedding the blood of a fellow creature.

EXECUTION OF ROBT. LILLY. – This malefactor was executed at the drop over the entrance of the County Gaol, at 12 o'clock this day. After his condemnation, he expressed himself perfectly resigned to his fate adding that he truthfully forgave all who were concerned in prosecuting him. He also said that he had been on bad terms with his wife, but he bore no enmity to her. His wife visited him on Monday. – His whole demeanour was very becoming. Being a Roman Catholic, he has not since coming to the prison attended the chapel, but has had the assistance of the Rev. Mr. Tristram, Pastor of the Catholic congregation in this City, who has closely attended upon him, and yesterday administered the sacrament. At the above hour, Lilly attended by Mr. Tristram, left his cell and ascended the scaffold. When all the preparations were made, the drop fell; he did not appear to suffer much. After hanging the usual time, the body was buried, without funeral rites, in the ground adjoining the gaol. The crowd was very great and as usual, there was a majority of females.

Women were the highest proportion of onlookers. Children were often lifted onto parents' shoulders so they could get a better view!

The dreadful act for which Lilly suffered was committed when he was in a state of intoxication; it appears that though a very quiet, unoffending man while sober, he was, after having a small quantity of liquor, a mere madman; this violent effect is attributable to an injury on the head he sustained while serving in the army in India. Upon the night of the murder his passion was peculiarly roused by boys pelting him, as a Roman Catholic, and it being the 5th of November.

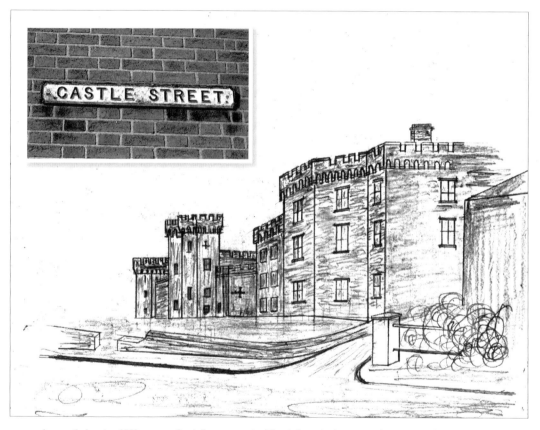

A pencil sketch of Worcester Gaol (known as the 'Castle'), with the iron railings normally mounted on the dwarf wall removed. The name of Castle Street ensures the gaol will not be forgotten.

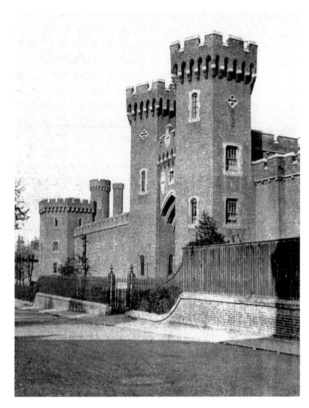

Left: The gatehouse was the main entrance to Worcester Gaol.

Below: Shire Hall, Worcester, where Queen Victoria still proudly reigns, was built in 1835 by Charles Day and Henry Rowe at a cost of almost £37,000. Most of the Assize courts were later held here after moving from the Guildhall.

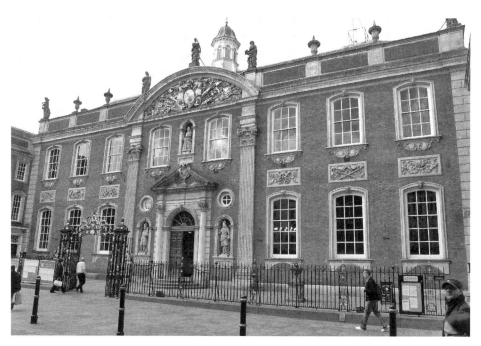

The Guildhall, Worcester, was built in 1724 and served as the town hall, and also as the site of the Assizes until about 1835, when the county courts were moved to the Shire Hall. The cells, which resemble dungeons, still exist in the basement.

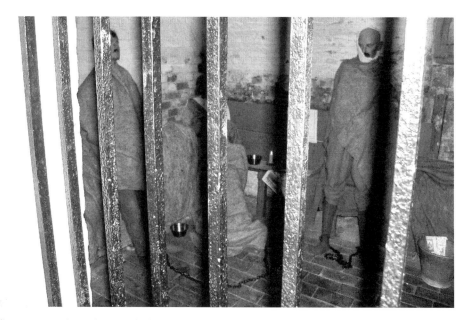

The prisoners shown here in the basement cells are awaiting their trial in the courtroom above their heads; some may have already received sentence and are pondering over their future, and that of their families. The date of this reconstructed scene is the late eighteenth century. Note the shackles on the prisoners' ankles.

THE MURDER OF JOSEPH HAWKINS
AT ARELEY KINGS

Joseph Hawkins owned a small grocery shop; he had not been seen since Thursday 8 September, so the local police officer was informed. Having obtained a ladder, he entered the house and found the building had been ransacked. On entering the brewhouse he found the body of Hawkins on the floor, covered in blood. He had a gunshot wound to the stomach and his brain was protruding from his skull. On the floor lay a coal hammer and a leg broken from a table, both covered in blood and hair. A local man named William Lightband was known to own a shotgun and had recently been to Stourport, where he had purchased powder, shot and caps. On this information William Merrefield, Inspector of Police, searched his house, and found a percussion gun barrel which smelt of powder, as if it had been recently fired. He likewise discovered, in a basket, a roll of tobacco, a bag of raisins, a bag of currants and some sugar. Subsequently he searched the suspect and found on him two sovereigns, one half sovereign and seven shillings in silver, and a watch, for the presence of which he could not give a satisfactory account.

BERROW'S WORCESTER JOURNAL, THURSDAY 9 MARCH 1837

TRIAL OF WM. LIGHTBAND FOR MURDER.
WEDNESDAY MORNING.
The Court was thronged at an early hour this morning, great anxiety prevailing to hear the trial of William Lightband for the wilful murder of Joseph Hawkins, at Areley Kings, in this county.

Shortly after nine o'clock MR. BARON PARKE took his seat on the bench, and the prisoner was placed at the bar. He did not appear to feel his awful situation; and when called upon to plead to the indictment, he threw up his hand with the utmost confidence, and lowly explained "Not Guilty."

Justice Baron Parke was known as a 'Hanging Judge'. Criminals to be tried by him could expect little or no mercy.

Mr. Lee and Mr. Beadon were council for the prosecution, Mr. Curwood appeared for the prisoner.

Mr. Lee opened the proceedings.

Mr. Kendrick Watson the surgeon, stated that he had extracted 12 shots from the stomach of the deceased and that his ribs were fractured and his breastbone broken and his liver lacerated. He said the cause of death was concussion of the brain, although

either the laceration of the liver, or the wound from the gun, would eventually have occasioned death.

William Merrefield, Inspector of Police, Kidderminster, described his visit to the prisoner's house and what he found there. He then detailed, in the most clear and satisfactory manner, the prisoner's confession, which was put in and read to the court.

"I, William Lightband, do declare, in the presence of Wm. Merrefield and Wm. Dickins, that I bought half an ounce of powder on Monday evening, at Mr. Griffin's, in York-street; the shot I had at Mr. Broadfield's, opposite the Market-house; the powder and shot cost me 2d. From there I went to Mr. Busby's, and bought a halfpenny worth of caps; I then had 2½d. in my pocket left. I watched my opportunity, and at about half-past six o'clock I went into Hawkin's with the gun, and asked him to serve me with half a pound of cheese; and while he was weighing it I put the gun across the counter thinking to shoot him, and the cap went off; it miss fired; he considered it as a joke, and laughed at me. On the Thursday morning my wife asked me if I was going to work; I said yes; she told me I should be too late. I left to go to work – she left to go hop picking; I concealed myself, and returned to the house to work on the gun stock, and finished it, I drew the charge that was in it, put it all together, and reloaded the gun with about two thimbles full of shot. About a half past five o'clock the same evening I went to Hawkin's and asked him for half a pound of sugar, and while doing so I shot him he fell. I afterwards struck him with the stock of the gun on the head, when the stock broke; I afterwards dragged him to the back room, and he made a little noise; I found a coal-hammer, and struck him twice on the breast; I was then going to leave him and he began to groan; I took hold of the leg of the table that has been produced to-day and with that struck him in the same place that I had struck him with the gun stock. I laid hold of him and turned him over and then left him. I went into the shop; I took about 2s. 6d. in copper, and some silver; in all, copper and silver, about 20s. 10d. I fastened the door with the key, and came out. On Friday morning I went in again, about a quarter past six o'clock, and found him dead; I then went upstairs and opened his box, but found nothing; but in an old basket in the room, in removing some old rags, I found five sovereigns and a 5l. note; the things that were produced by Mr. Merrefield were taken by me from the shop, I mean the currants, plums, sugar, and tobacco. I declare in the presence of God that what is here is all true, and I am the only person concerned. The gun stock I burnt."

During the reading of the above horrible detail, which was heard with breathless attention and anxiety by the whole court, the prisoner alone stood unmoved; he displayed no symptoms of feeling or contrition, but leaned with his hands on the front of the dock, and stared around him like an unconcerned spectator.

Two or three questions were put to Merrefield by Mr. Curwood as to the sanity of the prisoner. – Witness stated however that he never had to deal with a more cool and collected man in his life.

Mrs. Meredeth was returning from Kidderminster Market on the 8th of Sept., and had passed the house of the deceased about 160 yards when she heard the report of a gun; it was about half-past five in the evening.

William Bickerton, watchmaker, knew the prisoner, stated that on the 10th September he enquired about the prices of some watches; he purchased one at 25s., for which he tendered two sovereigns.

Matthew Grainger, an assistant to Mr. Yates, Stourport, said the prisoner, on the 9th September, purchased a hat at 4s. 6d., in which witness wrote "William Lightband." The prisoner also purchased other articles, to the amount of 14s.

John Parsons, clerk to Mr. Winnall, Stourport, had waited upon the prisoner several times for rent that was due; on the 9th of September he called at the office of Mr. Winnall, and paid three sovereigns, leaving due 1*l*. 17*s*. 6*d*.

This closed the case for the prosecution.

Mr. Curwood briefly addressed the Jury on behalf of the prisoner, observing that he had not wasted the time of the Court by any cross-examination, because he considered it would be doing the unhappy man no service; he thought it the most discreet course to leave it in the hands of the Judge.

Mr. Baron Parke summed up, and while his Lordship was addressing the jury the prisoner occasionally drew a heavy sigh, and seemed to feel his situation very acutely; tears flowed profusely down his cheeks before his Lordship concluded.

The Jury, after a few minutes' consultation, returned a verdict of Guilty. The prisoner when asked why sentence of Death should not be passed on him, gave no answer. – The Judge then put on the black cap, and in a most solemn tone pronounced the awful sentence, remarking that he had never during the whole course of his life heard of a more deliberate and cruel murder than that of which the prisoner had been found guilty.

His Lordship concluded, "You will return to the Goal from whence you came, and then be conveyed to the usual place of execution, there to be hung by the neck until your body be dead; and may the Lord have mercy on your soul!"

Worcester, Thursday 30 March 1837
EXECUTION OF WILLIAM LIGHTBAND
On Thursday last, soon after twelve o'clock, this culprit was executed in front of the County Gaol, for the murder of Joseph Hawkins, at Areley Kings. He acknowledged that his sentence was just. From the time of his condemnation the Rev. J. Addlington, the chaplain and the Rev. John Davies Rector of St. Clement's gave him the utmost religious instruction and consolation. The prisoner said he was not afraid of that death that kills the body, but of that which cometh afterwards, and kills the soul. On entering the prison he was ignorant of the alphabet; but before his execution he was able to read a chapter in the Bible. The Rev. J. Addlington, preached on Sunday se'nnight the condemned sermon, taking his text from the 32nd chapter of Numbers, part of the 23rd verse: "Be sure your sin will find you out." The discourse, which was a very impressive one, greatly affected the unhappy man. In quitting the room, to be delivered up to Mr. Under-sheriff Gillam, who was in attendance, he shook hands with the governor of the gaol – "Good by, and may God bless you for your kindness to me!" He tottered on, shedding tears profusely and accompanied by the Under-sheriff and his officers, to the portal of the gaol. The prisoners in the meantime were drawn out, the debtors in the yard on the right, and the felons on the left, to be spectators of the distressing scene which was approaching. At the portal of the gaol, during the process of being pinioned, his emotion and trembling were such that he was near falling, when the Rev. J. Davies approaching him, whispered some words of spiritual consolation, and he recovered his firmness. He then shook hands with two of the turnkeys, and steadily ascended the steps to the top of the building. When he was on the scaffold, while the fatal noose was being fixed, he trembled violently, crying out "Oh Lord! Oh Lord! Have mercy upon my soul," and shed a profusion of tears. He shook hands convulsively with a friend who had visited, and paid many attentions to him while in prison, and said "God bless you!" The cap was then drawn over his face; the Rev. Chaplain read the solemn and impressive

service for the occasion, and in a few minutes the fatal bolt was drawn. He fell apparently dead, but in about half a minute a convulsive movement of his whole frame excited a cry of horror from the crowd, which covered every visible spot of ground. A few struggles, as if gasping for breath, followed, and in a few minutes he ceased to live. – Wm. Lightband was about 20 years old, and of rather short stature. There was a wildness in his look and nothing ferocious about it. He was by trade a carpenter, and he told his reverend attendant and also one of the visiting magistrates, that he could obtain near 30s. per week by his labour, but having fallen in with profligate and vicious associates, he was seduced into the habits of intemperance and idleness that he left his own fire side and family to be in the companion of the drunkards in the ale house; and having thus imbibed a disinclination to follow his regular labour, the dreadful idea of committing the horrid deed for which his life had been forfeited entered his mind – was there fostered by the degeneracy into which he had fallen step by step and he was induced to spend the last money he possessed in the world, (5d.) in purchasing the shot and powder with which to murder his helpless victim Hawkins, and the rest (2½d.) on a pint of ale.

Such is the lesson he has left behind him. May it be a lasting and useful one to those who are following a similar course of life, in rioting and drunkenness!

Church House, built 1536 to hold celebrations known as 'Church Ales', was restored in 2006. The parish church of St Bartholomew and its churchyard, seen in the background, is where Joseph Hawkins was buried, 13 September 1836, aged seventy.

THE MURDER OF JOHN ORCHARD OF STOURBRIDGE

BERROW'S WORCESTER JOURNAL, THURSDAY 19 JULY 1838

Worcester Assizes, Thursday morning at Shire Hall before Lord Abinger.

Ann Orchard, aged 50, widow, and Maria Orchard, aged 27, single woman, were placed at the bar, the former charged with the murder, at Stourbridge, on the 3rd August last, of John Orchard her husband, by stabbing him with a skewer in the left breast, and the latter with having aided and abetted in the committal of such murder.

The indictment was read by the Court; and the prisoners pleaded not guilty –

Mr. WHATELEY, for the prosecution, said he was certain that the very circumstances stated in the indictment would induce the Jury to give this most lamentable and awful case their most serious attention. The learned gentleman then detailed the facts of the case:– It appeared that, for some years, the prisoner and the deceased lived very unhappily, on account of some suspicion that an improper intercourse existed between his wife and a person named Smith. On the evening in question, Smith was at the deceased's house, the Woolstaplers' Arms, Stourbridge. He went up the yard, the prisoners were observed to follow him. The deceased followed, and he never came back alive, Smith returned down the yard, but the two prisoners remained. At this time there were several persons drinking in the house; the prisoner, Maria Orchard, came into the room where they were, and stated that her father was taken very ill, and that they must go away. There was also a man who required a light, about half-past nine o'clock, and as there was no one in the house, he went into the yard, and saw John Orchard stooping almost bent double, on something in the brewhouse. A woman of the name of Wright came to the house about twelve o'clock and was told by Maria Orchard that her father had been taken very ill and that she was afraid he would die. She asked her if they had sent for a medical man, she said she had not. This was between eleven and twelve o'clock, and it would be proved that the deceased must have been dead from half-past nine. Mr. Hillman, a medical man, was then called in; he found that there was a small puncture wound immediately over the heart, as if caused by a kitchen skewer or a small pointed instrument. There was no blood on the body, and the upper part of it was quite clean. It would be proved on the evening in question a smell of burning linen or woollen was in the neighbourhood and it would also be proved that the deceased had a flannel shirt. The learned Council then proceeded to call witnesses in support of the facts contained in his opening:–

Sarah Wright: I am the niece of the late John Orchard; he kept the Woolstaplers' Arms at Stourbridge; I was there from six o'clock to half-past eight – it was the 3rd August: I saw John Orchard at half-past eight; he was brewing. The brewhouse is at the back of the premises. His wife was also in the brewhouse. There were a great many people

drinking in the kitchen. I left the house at half-past eight, and went home; I was fetched at half-past eleven that night, by Maria and Sarah Orchard, her sister. They said their father was very ill, they thought he was dying. I went with them and I said it was a very extraordinary thing; I asked how it happened, and Maria said her father came reeling up the yard and tumbled over the tub. We went to the room opposite the brewhouse and saw Mrs. Orchard with her husband's head on her left breast, wiping the sweat off his face. He was dead. He was sat in a chair. I laid hold of his hand, and I said "Good God, he's dead." I put my hand on his cheek, and repeated he was dead. Mrs. Orchard said "Good God, I hope not." I asked her how it had happened? She told me he came reeling up the yard, and tumbled over two tubs. There is a yard or kind of passage between the room we were in and the brewhouse. Myself and Mrs. Orchard and Maria carried his body into the kitchen. Uncle and his wife lived very comfortable when he was not in liquor – when he was, he was very quarrelsome; to which he was addicted for the last two or three years.

Cross-examined by Mr. GODSON: He was drunk when I left; he had an accident by tumbling out of a gig two years ago, and since then we thought he was not exactly right; I have often heard him say he would put an end to his existence; if he found anything out. I suppose he meant to destroy himself; I do not know what he meant by "anything", I suppose it came from jealousy: I did not know that he was jealous of Smith, his Christian name is Joseph; I did not see Smith there that night; Martha Orchard told me, when she fetched me, that they had sent for a doctor, and so did Mrs. O. When sober, deceased was comfortable, but when tipsy he was unhappy, and made use of wild expressions; I think he used that sort of expression a week or fortnight before his death; when in liquor he had a violent temper; he had been married to Mrs. Orchard about twenty years; they had three girls and four boys living, and she had buried some betwixt, I think two; until he had the accident he was a comfortable married man, drunk or sober.

Joseph Smith is about middle age in life, and younger than Mrs. Orchard: I suppose Mrs. Orchard to be forty or more: I saw Mr. Hillman in the room; we were ordered to take the body upstairs and wash the lower parts; it was not washed till Mrs. Finch was called, who did it.

By the Court: The body was taken upstairs and washed, but not till it was ordered to be done. I have had many opportunities of knowing how deceased and his wife lived together, and never knew of any quarrel until about two or three years ago; I was reared with them; the wife appeared very kind and gentle to her husband; when he expressed his jealous suspicions, when in liquor, she always past it off and said "Oh he'll not think of it when he's sober." She was a good woman, and attached to her husband and family. They were kind to each other; and he loved his daughter, and she was kind to him; she looked after the family, and worked hard; I never heard him quarrel with her.

Mary Hook: I am the wife of Henry Hook. I was at his house the day Orchard died; it was a Thursday; it was the afternoon. They were brewing. I went down the yard for some grains. They were having a few words in the brewhouse, Mr. Orchard and Mrs. Orchard; the wort was running out of the pail; it rather spurted on Mrs. Orchard, and she said "get out, are you going to scald my feet." John Orchard said "you always let folks know my concerns; why don't you keep it to yourself." He meant if they quarrelled. I saw Mr. Smith, the carrier, in the house. It was about eight o'clock. John Orchard came and sat in the two-armed chair against me. I remember Ann Orchard went out into the back yard, while Orchard sat in the kitchen, and Smith followed her. Orchard lifted up his head looked round, and upon missing Smith, he walked out. There were 10 or 12 people in

the house at the time. Maria followed her father. Smith came back into the house within a few minutes. Maria then came back, and there was some kind of groaning; it was rather awful, but I can't tell what it was, and I said to her whatever is that noise? And she said "it is the children." She again went to into the back yard and immediately returned and said to Sarah, you must go to Mother, as I must wait upon the company. I left a little after ten, and there were many people there; John Orchard was in his shirt sleeves, a light waistcoat and an apron on up to his breast. He was fresh in liquor when I left the house. I and my husband went to our boat. Mr. Atkins and Joseph Orchard came to fetch us about half-eleven. I found Mrs. Orchard, and Maria, and Sarah Orchard sat against the window in the house. They were altogether. Orchard was laid on the bed. I went to see the body. I did not notice his shirt. I went into the yard with Mr. Parrott. We looked all round the yard; it had been washed, the brew house was washed, and the tubs were washed. Mrs. Orchard said "He might have done it against a nail. He came stumbling up the yard, and tumbled over a tub." We took a candle and looked over all the tubs, and did not find any nail – they were all even and smooth. We could not find his waistcoat or apron. Mrs. Orchard never came up at all to the room up stairs. Mr. Parrott was with us. I know a person of the name of Smith, a carrier. I have often heard very disrespectful enjealousment between Ann Orchard and John Orchard about Joseph Smith and have heard the deceased order him from the house at least two months before his death. I never saw the deceased strike Mrs. Orchard; but I have seen her strike him a time or two – it was about Smith they were quarrelling. She struck him on the face – he has had black eyes several times, and I have even sent my little boy for sticking plaster for his eyes. Martha was a very bad girl to her father. She has jumped up and taken a knife, and said she would run it through him if he did not hold his noise. Martha always took her mother's part when she was quarrelling with her father. One night she was in the parlour, and had got him down, and I said oh dear, what are you doing? She said, see how my father is throttling me, and I said he is not; and her father said see how she is biting me on the shoulder.

By Mr. GODSON and the Court: The shirt was slightly marked as if it had fallen on the side; round the waist where he had leaned on something. I remarked that it was odd the shirt was so clean, and the trousers so dirty.

Martha Atkins, wife of John Atkins: I was at Orchard's house in the afternoon of the 3rd of August last. I saw John Orchard go out at the back door into the yard. I afterwards saw Joseph Smith come in. I did not see Maria Orchard in the house at the time. Maria came and asked me to get John Atkins to go as her father was very ill, and they did not want to bring him through the company. John Atkins and I left as soon as the drink was out, and in a very short time the other persons went out also. I was the last person in the house.

By the Court: My husband and I were called back by Maria about a quarter of an hour afterwards. She said "John, John;" he ran to her, and she said she thought her father was dying. We then went back to the house. I saw Mr. Orchard sitting on a chair in the kitchen. A woman of the name of Wright was there. My husband said "Oh! Mrs. Orchard, here's a dead man." She said "Oh, dear! What do you say?" A surgeon came in. When he came in Ann Orchard said "She thought it was done with a nail." Before that the Doctor asked her if he carried a penknife; she said he did not. I saw Parrot look to see if they could find a nail, after she had spoken about the nail.

Cross-examined: Was her expression "it might be done by a nail?" It was. Did not the surgeon say pointing to the wound upon the breast, how came this and she said she did

not know unless it was by a nail from his falling over a tub? Yes – I did not see anyone go out after him or before him. I did not see Mrs. Orchard nor Smith go out into yard. Smith went out by the front door about a quarter of an hour after he came from the yard. Smith did not leave the kitchen after Orchard went out into the yard till he left the house by the front door.

Cross-examined: by Mr. GODSON: We left about half-past 10. Saw Mrs. Hook there, and she left perhaps about a quarter of an hour before us. Also during the evening I saw Joseph Smith, with his father, and John Partridge, who keeps the Jolly Soldier in Pig Street [now Coventry Street]. The three were drinking together, and left the house an hour before us.

Henry Hook: I am the husband of the witness Mrs. Mary Hook; I was with her at Orchard's on the 3rd of August 1837. John Orchard had a light waistcoat and brewer's apron on and was in his shirtsleeves. His shirt was neither clean nor very dirty. I left the house at a quarter past 10, and was fetched back at about twelve by Joseph Orchard and Mr. and Mrs. Atkins. I saw Orchard dead in the bed. I saw two spots of blood on the shirt the size of a horse bean, and a little betwixt his fingers of the right hand. The upper part of the body was clean, the lower part was not. I examined the shirt to see if there was a hole in it, and there was not, as I could find. The spots of blood were over the wound. I said to Maria in the back yard, your father is a murdered man; and she catched fast hold of my hand, squeezed it and said "He is, he is, he is, it's not me Master Hook, it's not me."

Joseph Parratt: I am constable of Stourbridge: I was called about half-past eleven of the night of the murder. The body was upstairs; his shirt was rather clean, not quite clean, it was daubed as if worn only on a Sunday; it was put on wrong side out. I found that on looking at the wound, I did not see any blood on the shirt. I saw the wound on the left breast and pressed it with my finger, and a little blood came, which I wiped on the shirt. The body appeared about the chest as if it had been washed.

By the Court: How do you know it was washed?

Witness: Because the chest was remarkably clean. I saw Mrs. Orchard sitting in the kitchen. I said to Mrs. Orchard this is a bad affair, Mr. Orchard is dead, and had been for some time; how came he so? She said she could not tell, he came staggering across the yard and fell upon a tub. I said I thought the wound was mortal, and she said nothing. There was no hole in the shirt.

The Judge remarked that it must be mere conjecture as to the cleanliness to the body all men were not alike for cleanliness. The witness said he had never seen Orchard's chest before, but it had the appearance of having been washed.

Thomas Smith: I live in the parish or Oldswinford. I was at Orchard's in the afternoon, between four and five o'clock. I talked with him; he had no waistcoat on. He had a brewing apron on, shirt sleeves turned up, and a flannel waistcoat under his shirt.

By the Court: How do you know it was a flannel waistcoat?

Witness: Oh, it came down below his shirt on his arm, and was bound with white binding.

Cross-examined by Mr. GODSON: There is a tan yard behind. I smelt nothing of the tan yard. From my work I can tell whether a flannel waistcoat is on fire or not, from the circumstances of fire often flying from the forge I work at. I did not know that Orchard wore flannel. I did not speak to Craig or Parratt. There were three or four of us on the bridge, and there were two women and a man in the house where the body was at the time I perceived the smell.

Joseph Mees: I am an iron puddler by trade; I was with last witness, and perceived a smell come from Orchard's house. It was a smell of linen or woollen burning, but strongest of woollen. The smell is familiar to me, I can judge of the difference.

By Mr. GODSON: I smelt the two smells together. When linen and woollen are burnt together, and there is a smell of burning linen and burning woollen, does that make a third smell! No answer but a tittering through the Court.

Wm. Perry: On 23rd May assisted in searching River Stour, saw a boy pick up a skewer about three quarters of a yard from Orchard's kitchen window. Boy gave it to me, and I gave it to Craig, the Constable.

Cross-examined by Mr. GODSON: I was not in Craig's custody. I had been in his custody the day before. I did not go to the river with him; he was in the Stour at the time I came. There had been men drawing off the water. The water had been drawn off before this time by order of the magistrates. I did not know how often. I was 28 days in custody. I knew of the search the day after I was liberated, because it was talked about in the village and town. Never spoke with Craig upon the subject. I have not seen the boy who picked up the skewer since. He was in the river and several boys were there too. Craig, the constable did not see the boy who found the skewer. I am a nailer, but never made skewers in my life.

William Craig: is a police officer, at Stourbridge. The river Stour was searched 21st May, by order of the magistrates. Perry gave me a skewer [produces the skewer]. Except it being wet, there was no difference in the skewer when found and now.

Cross-examined by Mr. GODSON: Was any mud on the skewer when it was given to you?

Witness: There was river dirt on it; you may call it mud if you please. I did not see the boy who found the skewer. The river had been searched partially before, but the water was not got out sufficiently till this time. It is sometimes a rapid river in flood. It is 21 feet broad. It was on the former partial searches laid dry for 8 feet on the side opposite Orchard's house.

John Hillman: In August last I was assistant to Mr. Cooper, surgeon, Stourbridge; was called for at about half past ten on the night of the 3rd of August last, to the house of the deceased. Deceased was on a chair in the centre of the kitchen. Ann Orchard sat upon the screen, three yards from the body. I examined the body and tried to feel his pulse, but could not feel any. I found he was dead, and in my opinion had been dead at least two hours.

By the court: Are you sure of that?

Witness: I think so. I perceived the wound in the breast, and I asked her if she knew what caused it. She said she did not, unless it was caused by a nail in falling over a tub in the yard. I said that I did not think the wound had been caused by a nail, or the edges would not have been so smooth. There was a single spot of blood only above the orifice of the wound, and the shirt was stained. The shirt was not buttoned. I examined to see if there was any hole in the shirt opposite the wound, and there was none. I ordered the body to be taken up stairs, and the lower part to be washed. I see the skewer on the desk before me, and in my opinion such an instrument would produce the wound. I attended the post mortem examination.

Cross-examined by Mr. LEE: I have attended persons who have died from injuries of the head. The wound was in the heart, and circulation would stop immediately, and the lower extremities would be cold first. The wound was traversed by Mr. Cooper.

Thomas Cooper, surgeon, Stourbridge: On Friday morning the 4th August, about 7 o'clock, I went to the Woolstaplers' Arms, and examined the body of the deceased. Introduced this probe into the wound, all the length of this probe, 4½ inches. Opened the body in the morning. There was a puncture on the left breast between the third and fourth ribs, it passed over the fourth rib, entered the chest between the fourth and fifth rib, then passed obliquely across the chest to the right side, it penetrated the pericardium, in which there was 12 oz. of blood; there was about two pounds of blood in the chest. The wound penetrated the right ventricle of the heart, and through the anterior and posterior wall of the heart. The extent of the wound was about 5½ inches. I have seen the skewer, and I believe the wound might be caused by an instrument similar to that. Deceased in my judgement could not have withdrawn such an instrument had he killed himself.

Cross-examined by Mr. GODSON: I believe that the man might have staggered a few yards after receiving the wound. I have read of a man after being shot in the heart running 100 yards, and then leaping over a hedge, but I do not believe it. In my opinion, after such a wound a man might live five minutes, but I do not believe he could live twenty minutes. I swear that the wound was not a round one but a long one, a longitudinal one. Mr. Freer, surgeon, was not present at that experiment. I have spoken about this wound with different surgeons and have had differences of opinion as to whether the wound could be given to a man by himself with such an instrument, but as to his withdrawing it we have no difference about that.

Mr. GODSON: Supposing a man to strike himself at such an oblique direction with a sharp instrument could he withdraw it?

Witness: I will not swear that he could do so, but I do not believe it. Owing to the internal effusion, and the oblique direction of the wound, there would be little effusion of blood. As soon as the heart was touched, the circulation would begin to cease, and that would make the body cool.

Isaac Downing, Surgeon, Stourbridge: Examined the body on the day of the Inquest. In my judgement such a wound might have been inflicted by such an instrument, and I think that such a wound would produce death in a very few minutes. I don't think the deceased could have inflicted the wound himself; I don't think it impossible, but it is exceedingly improbable that he could have withdrawn the instrument. As to external bleeding, that would depend upon the rupture of the valve. I think there would have been a little external bleeding, but there might have been none, and there might have been a considerable quantity.

By the Court: In this case I think there must have been bleeding. I think there would have been no bleeding had the wound formed a valve, that is, had it detached a portion of muscle, so that at every inspiration it would fall upon the wound, and act exactly as a valve.

Cross-examined by Mr. GODSON: I have had no difference of opinion on this subject. I do not believe the man could have struck himself. If I were to state that the man struck himself so that he wounded himself as deceased was I should be saying that which is contrary to my conscience.

Mrs. Finch, examined for the defence by Mr. GODSON: is the wife of Joseph Finch, has been a washerwoman for seven years to the family, and never saw flannels worn by Orchard, or washed them. When was in liquor he was in a low despondent way, and would walk about gnashing his teeth.

By the Court: I was called out of bed about twelve o-clock on the night of the deceased's death, by Mrs. Wright and Sarah Orchard. The Watchman said "past twelve"

as I came from my house. I took three minutes to walk to Orchard's and staid there all night. I observed no smell of burning. Mrs. Orchard sat in the kitchen, and I staid with her all the time.

The Watchman not only patrolled the streets at night keeping law and order, but also had to shout out the time at given intervals, and a further job was keeping a wary eye open for fires, which were a particular hazard at this time. At midnight he might call 'Twelve o'clock and all's well.'

His LORDSHIP then observed, that several witnesses were not examined; there was Smith and Sarah Orchard.

Mr. GODSON: Yes My Lord.

This closing the case for the prosecution:

Mr. GODSON then opened the defence for the prisoners in a very argumentative and ingenuous manner, and at great length. He observed that the indictment had charged each of the prisoners with being the murderer, and each of them with being an accessory. Now it was certain that there was but one wound, and that it could only have been inflicted by one person. It was certain by the evidence which had been placed before the Court that Maria was not the person who had committed the murder – indeed the man Hook had exonerated her from the charge; but where was the man Joseph Smith? Where was the sister Sarah? – Each of whom could have explained that there was not time – that there was not a possibility of Maria Orchard's being able to perpetrate or participate in the foul transaction. He again enquired why Smith, who could have explained what had occurred in the yard, was not brought forward? He had not fled his country; and why the sister Sarah, who had twice been examined before the Magistrates, was not also present. It was not for him to bring them. He complained that Maria, who could also have explained the transactions of that night – Maria, against whom not one tittle of evidence would bear, and who stood at that moment fully acquitted, had been placed in the dock, so as to deprive him of that evidence which would have exonerated both herself and her mother. He would not say that Smith had committed the deed; but by the evidence there was the choice of three who did – either that Smith did it, or that the widow did it, or that the deceased had inflicted the wound himself. He then dealt upon the improbability of the wife's murdering the man with whom she had lived kindly and comfortably a number of years, and by whom she had a large family, and who was assisting to maintain them in comfort and respectability.

He commented severely upon the evidence of Mrs. Hook and Parrett, who, if there had been any attempt at concealment of a murder, would not have been allowed to have been present and have searched the premises when they did and as they did; neither would the sister have been sent to the mother in the first instance, and a Doctor and other parties sent for immediately. He then proceeded to show from the evidence, that Orchard had threatened suicide, and the possibility of Orchard himself having committed the act. He concluded a very eloquent and feeling appeal to the Jury, and not without some effect both upon them and the Court. The result of the examination was apparent when the evidence had been sifted and laid before the Court by Mr. GODSON.

The Jury consulted together for a few minutes, and then returned their verdict, finding both prisoners Not Guilty. – His LORDSHIP observed that they had found a very proper verdict.

The case, which occupied about seven hours was concluded at six o'clock.

THE MURDER OF CHRISTINA COLLINS AT RUGELEY

BERROW'S WORCESTER JOURNAL, THURSDAY 19 MARCH 1840

Staffordshire Assizes

These Assizes commenced on Wednesday last, before Mr. Baron Gurney and Mr. Justice Patterson. The commission was opened on the previous evening, their Lordships having been escorted into town by the High Sheriff, Henry John Pye, Esq., of Clifton Hall, and a numerous retinue. The Learned Judges attended divine service at St. Mary's Church on Wednesday morning, the sermon being delivered by the Rev. Robert Taylor, Rector of Clifton Campbell; and their Lordships immediately afterwards took their seats in their respective courts. The following trial excited considerable interest:–

THE MURDER OF CHRISTINA COLLINS
CONVICTION OF THE MURDERERS

James Owen, aged 39, George Thomas, alias Dobell, aged 27, and William Ellis, alias Lambert, were on Monday placed at the bar, charged with the wilful murder of Christina Collins, on the 17th day of June, 1839, at the parish of Rugeley. The prisoners were rather rough looking men, and their dress and appearance completely indicated the class in which they belonged. They took their places at the bar with a degree of readiness, and manifested great composure during the trial.

Mr. Sergeant Ludlow and Mr. Lee appeared for the prosecution, and Mr. Godson and Mr. Yardley for the prisoners.

Mr. Sergeant Ludlow, after a few observations on the importance of the case, gave a minute detail of the whole transaction, as developed by the testimony of the witnesses, after which he said there were only three ways of accounting for the deceased's death – she might have fallen into the water accidentally; she might have thrown herself in; or she was thrown in by wilful act of the prisoners, or some of them. After expressing his reliant on the discrimination of the jury and on their wish to do justice, the Learned Counsel concluded by calling.

William Brooks, witness said, he was porter to Pickford and Co., on Sunday, the 16th June, he saw a woman passing in one of the boats. Owen had the command of that boat, and Thomas and Lambert were two of the crew, and a boy named Musson was with them. Heard the woman say to Thomas, "Leave me alone, I will have nothing to say to you."

Ann Mills, lock-keeper at the Hoo Mill lock, said that about twelve o'clock on Sunday night, the 16th June, she heard a cry. Got up and saw a woman on the top of a boat in the lock. It was one of Pickford's boats, and there were three men with it; the

woman got off the boat. She cried for her shoes; and after she got her shoes she sat outside the cabin, with her legs hanging down. She said to the men, "Don't attempt me; I'll not go into the cabin; I'll not go down there." Witness asked one of the men "Who they had got there," and he said a passenger. She asked if anyone was with her, and he said her husband.

James Mills, the husband of the last witness heard the screams – they were cries as of a person in distress. Saw a woman on the top of the cabin. Heard his wife inquire respecting the woman. (His account of the questions and answers were the same as hers.)

William Musson was one of the crew of the boat with the prisoners. Got out at Colwich lock to go to the horse; the woman was then in the cabin in the boat, with her shoes and bonnet off. When they got to Brindley Bank she was not there. Owen was steering. At that time they had got round the turn; they went round the turn as usual. When he went into the boat at the stop place he asked where the woman was. Owen said he believed she was drowned, and asked for some silver to pay Dobell. A little time after that, went over the cabin and saw Owen in the hold, and a box opened; the two boxes had been tied with a light-coloured cord. Remembered Bach's man calling out, and Owen telling him to shut the cabin door. He was confined in gaol with the prisoners, but did not hear Dobell or Lambert say anything about the woman or the boat when in prison. – Cross-examined. When witness went on board at Brindley Bank, Ellis was asleep; heard him snore. Last saw the woman on the cross bed in the cabin at Colwich lock; was with Thomas at Aston lock. Thomas then said "He wished the woman had been at hell, or somewhere else; for he hated the sight of her." When they passed Hoo Mill lock he was asleep, and did not hear any screams.

William Kirk said he was Pickford's agent at Fazeley. He remembered the arrival of Mr. Robotham and of the boat at Fazeley. He told Lambert to bring the papers into the office, he wanted to speak to him. He said "D--n and ---- the woman; if she has drowned herself I cannot help it." According to witness's recollection Robotham was not then present, and witness had not said anything about the woman. Owen was in the cabin, and witness told him to come into the office with the papers: Owen said he had lost a passenger, and was sorry for it. Witness then went to search for the boxes. Owen said he last saw the woman at Colwich lock, and thought she was off her head. She had left the boat at Colwich lock, and would go no further. Dobell, on coming into the office, said he hoped the woman, using a very coarse expression was burning in hell.

By Mr. Godson. – Dobell was very drunk when he used this language; and such persons, when drunk, often use very coarse language.

William Harrison, headborough [a petty constable, or parish constable] of Fazeley, was at the canal when the boat arrived. Lambert said, "D--- the woman, what do we know about the woman? If she had a mind to drown herself, she might." This was before anything had been said to them. Owen said he believed she had drowned herself. (The witness then produced the deceased's bonnet, which seemed to be made of faded blue silk, and was much crushed.) Owen told witness, at Rugeley, "Her wanted very little drowning." Witness had been to see the place where the body was found. Witness replied, "I should think none at all from the place where she was drowned." The water at the place was shallow, about eighteen or nineteen inches deep; this was about a week afterwards.

By the Court. – Was sure he mentioned this conversation at the former trial.

Francis Jackson said that Owen was left in his care at Fazeley. Owen was handcuffed

to witness. A man came to Owen, and Owen said to him, "Do go and tell the two men in the hold to be sure and swear we left the woman at Colwich lock." The man came again next day and said he had done so. Owen said, "then do it again, and be sure."

Thomas Grant, a boatman, was on Brindley bank on the morning of the 17th of June last, about five o'clock, and found the body of a woman about eighty yards below turn; the water was about eighteen or nineteen inches deep; the woman had no bonnet or shoes on; her face was downwards; John Johnson was with me.

John Johnson made a similar statement; he said the body was about four feet from the side; there was a high bank above it; the body was warm, the water was warm. It is a regular turn from the Brindley bank to the stop place; from thence to where the body was found it is straight.

Hannah Phillips remembered the inquest at Rugeley; saw the body of the woman; she had on a gown and handkerchief, a white petticoat and a pair of drawers. The body of the gown on the left arm was a little torn by the sleeve being ripped from it; the body of it was torn also; the neckerchief too was torn on the left side.

Elizabeth Matthews assisted in taking off the clothes of deceased; took off the drawers; they were in the same state now, except where she cut them to get them off.

Elizabeth Price lived in Liverpool. Remembered the deceased leaving on the 15th of June. She was very neat in her person, and a dressmaker by business.

Robert Collins said Christina Collins was his wife. He left her at Liverpool at the latter end of May, 1839, but afterwards sent her a sovereign to come to London. Saw the body at Rugeley, it was the body of his wife.

Joseph Orgill was convicted of bigamy, and had received a pardon. While he was in gaol at Stafford Owen had a conversation with him, on a Sunday night during the Assizes. The witness said – After we were locked up in our cell, I said, "Mine is a bad job." He said, "So is mine. I can't think why they have taken the boy away from the other two men. Perhaps he is going to be a witness against us; but it cannot be about the woman; it must be about something else, for he does not know anything about her. The other two men committed a rape upon her, and mauled her to death. I am free. I'm afraid there will be a hanging job." I said, "I cannot tell." He then said to me they had a woman passenger in the boat who was going to London. They had some whisky in the boat, and they all got drunk except the woman. When they were drunk they began to be rough with her. She got off the boat, and they met another boat. They asked them if they had met a woman, they told him "Yes." He asked "How far off?" He said he would (using a coarse word) have her. He went on till he came to the lockhouse, where she was talking to the woman. She was afraid to go with them, but did go. Dobell and Lambert went on with mauling her all the way, and they committed rape or rapes. The woman screamed out, and said, "Oh, captain what are you doing? Oh! my Collins, Collins. I wish he was here." He remained in the boat till they got to Colwich lock, where he was called up. He was drunk with whisky, and loth to get up. The other two men came into the boat, and the boy went out. The woman also got out; she got over the side, and her legs were half over. They (Dobell and Lambert) got her in the cabin again, where they committed a rape again. Witness asked if she was dead. Owen said, "She was completely mauled to death. I tell you she was dead." He said "what made them do it?" They knew what they had done. (In reply to a question from the Learned Judge, the witness said Owen did not state what he meant by "doing it.") They were afraid the woman would tell. They had a quarrel

amongst them about it. Dobell came in to steer the boat, and took the woman out of the cabin and laid her on the top. Whether she was pushed off, or rolled off in going round the turn, he could not tell. Dobell saw the last of her. He said they had made a bad job of it, for they had left her shoes and bonnet in the cabin. Nothing then occurred until they came to Fradley Junction, where he wished to leave the things. Dobell, he said, went to the box, and took a piece of calico print. He remonstrated, when Dobell said they should be alright if he'd hold his noise, and as to the boxes she'd come no more after them. Owen then said to witness, "Did you take notice of the chapter read by the Chaplain? It was on purpose for us." Witness said "Why so?" Owen replied, "Because there was so much about hanging in it; but I hope they will not hang us, but we will get off with transportation, and then I don't care. We have made a bad job of it altogether. If Dobell and Thomas had let the woman alone at Colwich lock she'd have been alive and well enough."

Mr. Godson cross-examined the witness at considerable length. The principal point established in favour of the prisoners was that Owen said the woman was dead before she was put in the water.

Mr. Barnett, surgeon, of Rugeley, stated that he examined the body; he found two small bruises on the right arm below the elbow. The cavities on the right side of the heart were gorged with blood; the viscera were all healthy; there was frothy mucus about the mouth and throat, and water in the stomach. Applying his judgement and experience, and he had been in the profession twenty years, he should say death was caused by suffocation through drowning.

In cross-examination, Mr. Barnett admitted that the symptoms were not decisive of death by drowning, but they were generally as he had stated.

Mr. Godson, in an able speech, addressed the Jury for the prisoners.

Mr. Baron Gurney, in summing up, went through the evidence, and pointed out its bearings with great perspicuity. In conclusion, he said the first object of the law was not the conviction of the guilty, but the protection of the innocent. They would take the whole into their consideration, and consider if one, or two, or three, were concerned, and did commit a murder. If they had a fair and rational doubt of the guilt of the prisoners, or any one of them, they would give him the benefit of it. However disgusting the case might be, they ought rather to take care that that disgust did not lead them to take less evidence of the fact, as it ought rather to induce them to require more.

The Jury retired to consider the verdict. In about half an hour they returned, and in reply to separate questions from Mr. Bellamy, the clerk of the arraigns, said that James Owen was guilty; that George Thomas was guilty; that William Ellis was guilty.

The prisoners, were then asked why the sentence of death should not be passed upon them according to the law, made no answer, nor did they evince any particular emotion while the verdict was given.

The customary proclamation for silence was made, and the Learned Judge proceeded to pronounce the sentence of the law as follows:–

"James Owen, George Thomas, and William Ellis, after a long and patient hearing, a Jury of your countrymen have felt themselves constrained to pronounce you guilty of a foul murder – of murder committed on an unoffending woman placed in your charge, and whom you were bound to protect. There is also too much reason to believe that she was the object of your lust, and that you committed murder to prevent the punishment due to that offence. Look not for pardon in this world. Look only to Him who has

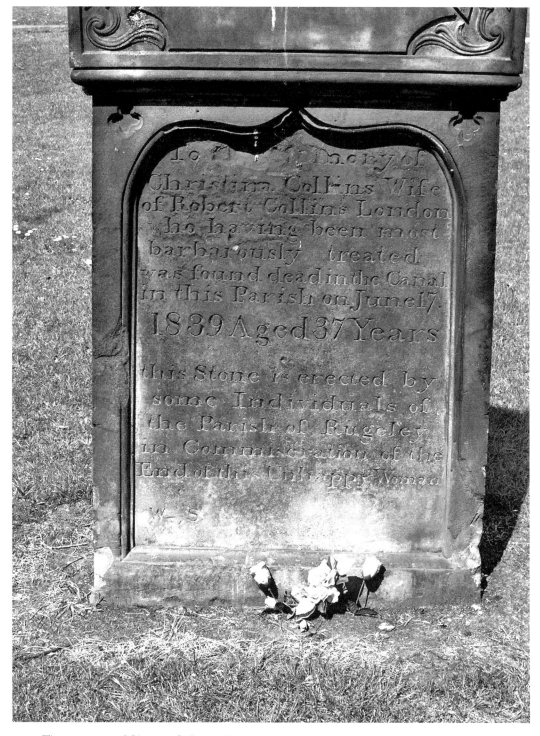

The gravestone of Christina Collins in Rugeley churchyard, paid for by public subscription from the people of Rugeley.

promised to extend pardon to all penitent sinners. Prepare for an ignominious death. The case is one most painful and disgusting. It only remains for me to pronounce the sentence of the law, which is, that you be taken to the place from whence you came, and thence to a place of execution, and there be hanged by neck till you are dead, and may the Lord have mercy on you."

The prisoners heard the sentence with the same stolid composure as they had evinced during the trial. They left the bar without saying a word. Owen's countenance slightly changed – in the others there was no perceptible difference, except that Ellis slightly smiled.

Worcester, 16 April 1840

The execution of Owen and Thomas took place in front of the county gaol, Stafford, on Saturday, a confirmation of the respite in favour of Ellis having been received by the under Sheriff in the course of the morning; it is now generally believed that the latter culprit was not present at the time that the unfortunate woman was murdered. The Rev. R. Buckeridge, the Chaplain, administered the sacrament to the three culprits on Saturday at twelve o'clock, and it was then for the first time communicated to Ellis that his execution had been respited. He was very much affected on being made acquainted with this circumstance, and requested an interview with his fellow prisoners; this was permitted by the Governor of the gaol and the scene is described as very affecting. Owen and Thomas who had before evinced some degree of animosity towards each other, appeared perfectly reconciled, and frequently shook hands; they asserted that they had no further communication to make with regard to the crime for which they were about to suffer. After the last offices of religion had been administered to them, they were led to the pressroom, and their arms having been pinioned they ascended the steps of the platform without assistance. The required preparations were then gone through, and the bolt having been drawn, the wretched men were launched into eternity. The concourse of persons assembled upon the occasion was unprecedentedly great, but they dispersed immediately after the execution. – It is confidently stated that the life of Ellis will now be spared, as the other prisoners have confirmed his assertion that he was asleep when the deceased met with her death. – The bodies after being suspended for the usual period, were taken down and were buried within the precincts of the prison.

From 1841, all crimes considered as 'Capital Crimes', with the exception of murder, were treated more humanely, and given life sentences of transportation to the Australian colonies. This was later reduced to even more lenient sentences of twenty, fifteen, and ten years. The author's great-great-grandfather, Joseph Bingham, was sentenced to fifteen years' transportation for burglary in 1845. He would probably have been hanged had he committed the same crime ten years earlier. Instead, he died from bronchitis in 1869, aged fifty-eight, at Hamilton, Van Diemen's Land (Tasmania). Murder remained the exception and was still a capital offence, punished by public execution, which continued up until 1868.

THE COVENTRY STREET MURDER AT STOURBRIDGE

BERROW'S WORCESTER JOURNAL, THURSDAY 21 JULY 1842

Sampson Shipston, 32, brazier, was placed at the bar, charged with the wilful murder of John Gooden, at Oldswinford, in April last.

Mr. Whitmore opened the prosecution by stating the details; he then called.

Ezekiel Pardoe, who deposed, On the 6th April I was lodging in the house where the prisoner was, at Coventry Street, Stourbridge: I don't know the name of the mistress, except that she was called Mary; I have been there a fortnight; there were two children in the house belonging to this woman; the younger was aged two years and two months, I don't know its name; the elder appeared to be a boy about ten or eleven years old. The room in which I lodged was upstairs: I had a bed there; there were three standing beds and two on the floor in that room; the two boys slept together on a straw or chaff bed on the floor. On Wednesday, the 6th of April, I came home about four o'clock in the afternoon, and saw the little boy sitting on some bricks by the fire-place downstairs. I had seen him on the day before, sitting in the prisoner's lap, and the child had a mark or bruise between the chin and ear, and the prisoner held a bottle in his hand; he replied to my question that a blind man had knocked the child down the steps at the door, and had inflicted some injury on it; he then gave it food out of a can, but the child was sick. In consequence of having seen this, on Wednesday I took particular notice; and observed that the swelling on the face was abated, and that the child seemed better and cheerful. I went to bed about nine o'clock, and the child was taken to bed by the prisoner at the same time; he put it on the straw bed next to the wall. The elder boy was sent up to bed about ten o'clock, and laid down with his younger brother. At twelve o'clock I heard the younger child cry out; it was loud enough to be heard down stairs; the prisoner usually slept downstairs; after the child had been crying for some time, the prisoner, being undressed, came up without a light, and smacked the child, accompanied with a threat that "he would knock the life of it out;" The child continued crying, and the prisoner left the room, but soon afterwards returned without a light, and having smacked it again, and said "you young ----- I'll knock the liver out of you." Prisoner then went down, when the child was quiet for half an hour, and then began crying again, on which the prisoner came up with a light, put the candle on the floor, knelt by the bed, and said "Now I'll pay you for all;" He then took the child in his arms shook and struck it, and put it down again. The child then seemed to have lost its power to cry, and struggled to catch its breath. Prisoner then went downstairs, and the child continued its struggling noise for about a quarter of an hour. Sarah Lockett, the prisoner's sister then got up, and called for a light, when the child's mother brought a

candle, and taking it up, exclaimed "Oh! good Lord, my child is in fits;" it was then taken downstairs. One hour and a half afterwards the child was brought up, and I found that it was dead.

Michael Sherlock, the elder brother, who slept with the deceased, deposed that he had been out begging the whole of the day in question, and came home about nine o'clock; when he went to bed his little brother was asleep. He went to sleep also. And was awoke by the prisoner saying to his little brother " You young ----- you shan't live much longer." (The remainder of this little lad's testimony was corroborative by Pardoe's, as to the brutal treatment received by the child, with the addition that at the third appearance of the prisoner he punished the child till its mouth was filled with blood and a gurgling sound was made in the throat, on which the prisoner went to the top of the stairs and said that "something must be the matter with the child;" the mother then came up.) – the prisoner asked the witness if he had not seen him take up some water for the child; to which he replied in the negative.

While Stourbridge at this time was considered to be an affluent town, there were certain areas of the town, and in particular the Coventry Street area, that were less affluent; the 1837 map of Stourbridge shows there were seven public houses along its length. We are unable to pinpoint where in Coventry Street this tenement was. We do know that Coventry Street continued into an area known as the Irish Quarter, known for the slums which then existed.

Sarah Lockett was the next sworn, and, at the request of the prisoner, gave testimony as to the nature of the fall which the child had received on the Tuesday, it being as she stated very severe.

Mr. H. Betts, surgeon, of Stourbridge, examined the body of the child on the Thursday after its death; it was much bruised under the chin, extending to both ears, and on the right side of the forehead were a number of bruises; the whole of these could certainly not have been caused by a fall; the marks on the throat appeared as though they had been caused by a grasping; they were of a more recent occurrence than the bruises on the forehead and another on the chin. On opening the head several small extravasations of blood were observed without any external corresponded mark; the whole of the upper part of the brain was enveloped in blood. This effusion was in his opinion the immediate cause of death; and the effusion was probably caused by the violence or blows; but he did not think it probable that the fall was the cause of it.

This was the case for the prosecution; and the prisoner, who was undefended, then denied that he had ill-treated the child in the manner that had been represented, asserting that if he had not from time to time paid attention to its wants the child would have been starved.

The Learned Judge then recapitulated the facts disclosed in the trial evidently leaning towards the prisoner, by directing the Jury to consider well whether any malice aforethought, or contemplated murder, had been established; or rather if the death had been accelerated or produced, though unintentionally, by harsh and brutal treatment; his Lordship also remarked on the fact that no dangerous weapon had been used by the prisoner, which would probably have been the case had he contemplated murder.

The Jury then consulted, and shortly reached their verdict, "That the prisoner is not guilty of murder, but of man-slaughter." – The sentence was seven years' transportation.

THE MURDER OF ANN GRIFFITHS
AT WEDNESBURY

STAFFORDSHIRE ADVERTISER, 3 AUGUST 1844

WILLIAM BEARDS, stated in the calendar to be 35 years of age, was charged with the wilful murder of Ann Griffiths, at the parish of Wednesbury, on 16th March 1844.

The prisoner, (who's countenance, though not prepossessing, was not strongly marked by anything which indicated a ferocious sanguinary disposition) delivered his plea of "not guilty" in a firm and unfaltering voice. He appeared in the gaol dress, and did not seem to have suffered any great degree of mental anguish during his imprisonment.

A lengthy report of the trial of William Beards can be found in the *Staffordshire Advertiser* and various other newspapers of that time. Below is a short version of the circumstances leading to his trial, together with his confession and execution.

William Beards was indicted for the murder of Ann Griffiths, who was the housekeeper to Mr. Crowther, a rich coal master of Wednesbury. He was a well-known character in the locality of Wednesbury, frequenting the numerous public houses that then existed. He was a casual worker of no fixed address, who at times slept at his brother's house or alternatively in barns or stables wherever he chanced to be. His meals were infrequent, preferring a regular supply of beer to that of food, which often left him in a state of intoxication.

On the day of the murder he was out of work and at a loose end. He was drunk the night before and had slept in Mr. Crowther's stable. In the morning he decided to call upon Mr. Crowther to see if he could offer him a job, because he had previously worked for him and lived at his house. On this occasion he was not at home, but Ann Griffiths his housekeeper was, and she was on her own. He had a few words with her, and she eventually told him to leave and also threatened to throw some hot water over him. At this he lost his temper and picked up a carpenter's claw hammer and struck her several times on the head. He then helped himself to clothing from Mr. Crowther's bedroom and food from the pantry, and also three silver spoons. (He had knowledge of the layout of Mr. Crowther's household, having previously worked there.) He took two half crowns from the purse of Ann Griffiths, and then cut her throat with a knife taken from the kitchen. After leaving the house he went to several public houses, leaving behind a trail of footprints in the wet paths – it had been snowing. He spent the night at his brother's house, where the police awoke him next morning. His clothes were found to be bloodstained, and several persons had seen him near Mr. Crowther's house, and his shoes exactly matched the imprints in the paths of Mr. Crowther's grounds. Mr. Crowther gave him a good character reference, saying that he had foiled a robbery at his house while in his employment.

He was found guilty and condemned to death.

Staffordshire, Saturday 17 August 1844
THE WEDNESBURY MURDER
THE CONFESSION OF BEARDS

My name is William Beards. I was born January 3rd, 1811, in Dudley. I am guilty of the murder of Ann Griffiths. It was done on Saturday the 16th March 1844. The Saturday before this, I received my wages for working as an excavator, making a new street; I was employed by Mr. Frost, the surveyor; I think I was in his service about five weeks. On the Monday, about seven o'clock in the morning, of that week, when the murder was committed, I applied to Mr. Frost's foreman for a job, but he did not give me any, because it was wet. I therefore went to assist a man to load some stable manure for Mr. Frost's farm; and about nine o'clock in the forenoon of the same day, I helped Mr. Hartopp to kill a pig. He gave me some bread and cheese and beer for my trouble. At night I slept at my brother's house; I also slept there on Tuesday and Wednesday nights; but on Thursday night I slept in the engine-house belonging to Quaker Lines. On Friday morning, at half-past nine till near eleven o'clock in the forenoon, I was at Wednesbury, in the market-place, and there spoke to Spittal, one of the witnesses at my trial; I also saw Guest, another witness, but did not say anything to him. From Wednesbury I went to West Bromwich, and called on Isaac Birch, a relation of mine. He was not at home, but his wife was and she gave me some bread and cheese and ale. I left a little after two o'clock in the afternoon. After this I walked on to the Gas-works, and looked at what was going on there. I went next to Gold's-hill. I stopped at many works that afternoon, afterwards I went to see my brother; it was near dark when I got to his house; he wished me to sleep there, but I wouldn't. I staid with him about three quarters of an hour; I had something to eat at his house. Between 8 and 9 o'clock that night I met a young man in Wednesbury, I never saw before, as I know of; he asked me where he could get a nights lodging? I told him I couldn't tell him, without it was a lodging house. He said he wouldn't go there. He then asked me to go with him into the Dragon's. I left him at a late hour. He seemed like a hawker. He paid for some bread and cheese and ale. I should think we drank three or four pints of ale. The Dragon is about fifty or sixty yards off Mr. Crowther's stable. About twelve or one o'clock, between night and morning on Saturday, I went to Mr. Crowther's hay-loft and slept there. I was very tipsy, or I shouldn't have gone. I did not leave the loft till about ten that morning; and the first place I went to was Mr. Crowther's house. I went through his yard door, which leads to his back kitchen. The yard door was not locked, it was only latched. I went and stood agin the brewhouse door, and then saw her standing agin the kitchen door. I then said to her, "Is Mr. Crowther in?" Her asked, "What do you want him for?" I told her, I heard as he wanted some soughing [sowing] done in his fields, and I wished him to give me the job. Her said to me, "You know he is not at home – that's not what you've come for." I asked her "How her know'd that?" Her said "You had better go." I said, "You're very saucy." Her came out of the kitchen, and leaned agin the brewhouse, when her told me to be off. Her was going about her work, walking backwards and forwards to the brewhouse while her talked with me. Her afterwards came out of the kitchen to the brewhouse, and her had a saucepan in her hands; I think her had just taken it off the kitchen fire; it had boiling water in it. Her said, as her was carrying it, "If you don't be off, I'll thrown this hot water over you." Her saying this, was the occasion of me flying into a passion with her; and while she was stooping and putting the saucepan over a ledge or shelf near the oven in the brewhouse, and raising herself up again, I took a carpenter's hammer [claw

hammer] lying on the step of the brewhouse door, and struck her with one side of it on the head, just above her ear; I only gave one blow; her fell from me, with her head agin the oven, which is about a yard from the brewhouse door. Her screamed out twice, and instantly fell down. Her did not scuffle with me; her couldn't. When it hit her, I stood on the yard floor, on the bricks, and close to the brewhouse door; her was near this door. I started to go off and went as far as the door, which I then locked and left the key in; but instead of going out of the yard, I turned back, as if I wished to put an end to her. Her was stunned like. I next went up into Mr. Crowther's bedroom, and took his waistcoat and trowsers out of a chest of drawers; I opened three boxes there; I pulled the boxes from the wall. I then went into the servant's bedroom, and took a handkerchief out. When I came down stairs into the kitchen, I took a small black handled dinner knife, belonging to Mr. Crowther, and cut her throat with it. I think her would have lived if I had not used the knife. After she was dead, I took out of her pocket a purse containing two half-crown pieces. I then went into the pantry and ate a piece of a fruit pie. After this I went into the kitchen again and took three silver table spoons out of the kitchen cupboard. While I was in the kitchen the butcher came to the front kitchen door; it was locked, but not by me; it was always kept so. I saw the butcher coming down the gravel walk when I was taking the spoons out of the cupboard; he didn't see me, because he had his umbrella, as it was snowing and raining fast. After he came I made off, and unlocked the hall door to get out, and left it open – from the glass door of the hall facing West Bromwich, straight down through the orchard, and down the field, till I got into Riding-lane then I walked fast through the Mounts. I went near, but not on the Wednesbury bridge, which I left to the right; I then went on the canal side. I did not see anyone but Burns, and that was when I got off the canal. I left the aqueduct about a mile to the left hand. I went along the canal to Gold's hill, where I stopped about one hour. When I got off the canal side (where I saw Burns) then I went away along the Oldfields. About half a mile from the whimsy boiler hole I buried the three silver spoons, putting them under the Nipkin wooden bridge, leading off to Crook-eye furnace, leading out of "the Mounts." When I reached the whimsy boiler hole I threw the bundle, containing the waistcoat and trowsers into it.

The Oxford English Dictionary gives no definition of a whimsey or whimsy, although it defines a whim as a kind of windlass for raising water, coal or ore from a mine. Since this whimsey employs an engine and a fire (probably a steam engine), we may assume it was something to do with the pits in this area. At one time there was a public house in Dudley called The Whimsey.

After this I went along the Dudley road, and called on Griffith, a huckster, [a hawker, traveller, bargain maker or haggler] and bought half an ounce of tobacco, which cost me three halfpence; then just above Griffith's, at the Pack-horse, I bought half a pint of ale, which cost me another three half-pence. After this I went to James Parish's, who keeps the "Boards" public-house, in Wednesbury; I got there about twelve at noon, and left at two in the afternoon; I know that was the hour, because I heard Quaker Line's bell ringing at the time for the men to go to work. A few minutes before two a man named Trusfield came into the "Boards," where I was and spoke of the murder. I think Mr. Crowther returned home about a quarter before two and almost immediately after he went out and gave information of it. I am quite sure that no one suspected me at Parish's. After leaving the "Boards," I walked to Pittaway's, and spent the rest of the afternoon with him and

wife and daughter. While at Pittaway's, I sent out and ordered half an ounce of tobacco, which I gave three halfpence for, and half a gallon of ale, which cost me a shilling. I staid at Pittaway's till six o'clock in the evening. About that time he and me went to a public house, that used to be called "the Bush," agin Lea brook Bridge; we drank two pints of ale, which I paid sixpence for. From Lea brook Bridge he and me and another man, a stranger to me, went into the Pack-horse, and I paid for two pints of ale. Pittaway went away, and left me and the stranger there. The stranger and me went out of this public house together about nine o'clock at night; he walked with me about fifty yards on the Holyhead road; he then left me and went back again to the Pack-horse; after parting from him I went to my brother's. I was so tipsy that I hardly know'd what I was about. My brother asked me if I had heard that Mr. Crowther's servant was murdered. He cried very much, and said that people judged as I had done it. I made light of it to him. I think I went to bed as soon as I got in. I was taken up by a policeman next morning about eleven o'clock. I solemnly declare that when I went to Crowther's house it was only to ask him for a job of work, and that I expected to find him at home. I had no thought, afore this, of injuring his servant or of robbing him; but it came into my head all at once to do what I did; for I was vexed with the servant for speaking as she did to me. I feel that I deserve to die for having committed so dreadful a crime as I have, and I sincerely pray that God will have mercy upon my soul, and pardon my sins for Jesus Christ's sake.

WILLIAM BEARDS

Signed in our presence,

Thos. Brutton, Governor. Thomas Sedger, M.A. Chaplain. August 15th 1844.

That Beards has made any confession at all, is owing, we believe, to the praiseworthy exertions of Mr. Brutton, the governor, and the Rev. T. Sedger, the Chaplain of the county prison. Beards is a man naturally of great firmness of purpose and self possession; his expression of countenance denotes the existence of these qualities; and it was not to be expected that such a man would be very easily moved. His spirit, however, has been constantly broken. The Chaplain on Sunday last, both at the morning and afternoon services, delivered discourses appropriate to the occasion; that in the afternoon was considered the sermon more particularly applicable to the case of the wretched culprit. The text was from Romans, 6th chap, 23d verse, – "The wages of sin is death, but the gift of God is eternal life, through Jesus Christ Our Lord." We understand that the sermon was most impressive; and that even in that congregation, "albeit unused to the melting mood." There was scarcely a dry eye. Beards did not weep; but he was apparently powerfully wrought upon; he leaned with his face upon his hand and exhibited signs of acute mental feeling. On the following day, Monday, his father, brother, brother's wife, and nephew came to see him, and accompanied by the Chaplain visited him in his cell. The interview, we understand, was very affecting. Beards seriously admonished them all to conduct themselves better for the future. He advised his brother to bring up his (Beards's) nephew in the right way, and go with him to Church on the Sunday. He hoped, he said to meet them all in heaven; but exhorted them to lead a different life.

Beards has since attended very closely to the valuable instructions of the Rev. Chaplain. He confesses that he has, for the last three or four years, led a very sinful life, both working and getting drunk on Sundays; that he has kept bad company, and has very seldom gone to Church. He expresses great anxiety about his father and brother; his own words are "See, what I've come to!"

When the Chaplain left Beards last night, he expressed himself as being at peace with the world, and prepared to die. Mr. Brutton, the Governor, who has paid much attention to the wretched man, says that during the many years he has been Governor of the gaol, he never witnessed more genuine signs of repentance in a convict.

The execution is expected to take place this morning (Saturday) at eight o'clock.

THE EXECUTION OF WILLIAM BEARDS
STAFFORD – SATURDAY MORNING, NINE O'CLOCK.

The murderer, Beards, is no more! The cases of few men, who have fallen by the hands of the executioner, have excited less commiseration than that of the wretched malefactor who has this morning paid the forfeit of his life on the scaffold. It was quite expected that the assemblage of spectators from South Staffordshire (especially from the neighbourhood of Wednesbury, the scene of the murder, and where Beards was well known) would be considerable, and this expectation was fully realised. At an early hour, in the morning, workmen were employed constructing the apparatus of death, and the break of day was ushered by the sad sounds occasioned by the preparations for the execution. During the night Beards slept soundly for several hours, and about five o'clock he rose to prepare himself for the awful doom which awaited him. A little after six o'clock the Rev. Chaplain arrived, and having entered the cell of the wretched man, Beards entered upon his devotional exercises with becoming fervency and decorum, appearing to be desirous of spending the last moments allotted to him in supplicating the Divine mercy. During the whole time the Chaplain was with him he maintained his composure and self possession and although he manifested during the last scene occasional slight indications of dread, yet he went through these awful moments with astonishing firmness.

Shortly before eight o'clock, the executioner entered the condemned cell and pinioned the arms of the miserable culprit, and R. W. Hand. Esq., Under Sheriff, having made the customary demand, the mournful procession was formed, and slowly moved towards the fatal spot; the prison bell tolling the knell of death, and the Chaplain impressively reading the burial service. The culprit walked steadily, and appeared to be earnestly engaged in prayer for mercy. On arriving at the foot of the drop, Beards looked upwards, and ascended with a firm and unfaltering step; and on reaching the top he turned his head enquiring upon the assembled crowd in front of the scaffold as though eager to recognise some persons present. Up to this time all was still as death, save the mournful note of the prison bell, and the distant buzz of the spectators. Whilst the rope was being adjusted, the wretched culprit seemed to stagger a little. Soon afterwards the drop fell; for about two minutes his body was violently convulsed, and then the unfortunate malefactor ceased to live.

Just before the drop fell he was heard by one of the officers of the prison to say with earnestness, "I hope the Lord Jesus will have mercy upon my soul." At the moment he fell, a suppressed murmur escaped from the crowd. In a few moments afterwards, the vast multitude began to disperse. After hanging the usual time, his body was cut down, and buried within the precincts of the gaol.

The assembly it is conjectured was larger than on any former occasion, except when the boatmen were executed for the murder of Christina Collins. It is supposed that 5,000 people were present.

THE MURDER OF
LUCY RICHARDS AT LYE

WORCESTER HERALD SUPPLEMENT, SATURDAY 24 JULY 1852

Worcester Assizes, July 21st 1852 Before Mr. Justice Cresswell
MURDER OF A CHILD BY ITS MOTHER AT OLDSWINFORD
ROBINS, MARY, alias RICHARDS, MARY ANN, aged 25, single woman, was charged
with the wilful murder of her infant, Lucy Richards, at the parish of Oldswinford.

The following reference to the parish of Oldswinford relates to a murder which took place in the
parish of Lye in which the victim was thrown into a pit at the Hayes, making three murders in all.
All the bodies were taken to the Swan Inn in Lye Waste, where the inquests were held.

Mr. Whitmore and Mr. Best appeared for the prosecution. Mr. Huddleston for the
defence.

The prisoner, who had a vulgar set of features, and a dull look, appeared much
distressed and feeble. She wept occasionally during the trial, and now and then
exclaimed in a low tone, "My child! My child!" she was allowed to sit during the whole
of the proceedings.

Alfred Knowles examined by Mr. Best. – I am a miner. I know the Hayes fire clay pit,
in the parish of Oldswinford. I was at work there on the 23rd of June, drawing water out
of it. I found in the pit the body of a child. There was about two inches of water over
the child when I found it. I delivered the body to Police-constable Selley. I had been at
work there on the Saturday previous to that Wednesday. The mouth of the pit was left
open. There were clothes on the child.

Cross-examined. – The pit was about thirty yards from the footpath. We began to
draw the water at seven o'clock that morning and there was a depth of four feet of water
in it at that time. There was no water in the pit on the Saturday. The track by the pit
leads to Netherend and Cradley. It is the shortest way across to those places.

The footpath mentioned was the ancient path that once ran from the Hayes, from opposite
Wood Street to Hayes Lane, known as 'The Lime Kilns'. It continued on by a further
footpath, a little lower down Hayes Lane, which went to Netherend and Cradley, and would
be, probably, the shortest distance on foot to both Netherend and Cradley. Neither exist today,
having been built over by factory units.

The stuff that has been drawn out of the pit makes a bank round it. The child lay on
its back.

By the Court. – The pit was forty yards deep, and five feet diameter at the mouth.

Police-constable Selley examined by Mr. Best. – I received the body of a child from the last witness. I took it to the Swan at the Lye.

Cross-examined. – The child was dressed. I know the poor girl's mother; she lives next door to me. I hear the girl has been subject to fits, but I don't know it. I have heard she is considered soft, but I don't know it of my own knowledge.

Henry Burton, superintendent of police, examined by Mr. Whitmore. – I apprehended the prisoner on the 23th of June. I asked her if she had been confined lately. She said she had not had a child for the last two years. A surgeon of the name of Wilson was then brought to her. He examined her breasts and declared she had recently had a child. I then charged her with the murder of the child found in the pit. She said – "I'll tell you the truth, Mr. Burton. I have had a child born at Mary Ann Banister's, at Bilston, but it died after being put in a warm bath, and was buried with the man who died of the fever at Bilston." I know Beach and Manley. They are employed at the Wolverhampton Union Workhouse. They were brought to Stourbridge police station on the following Saturday, the 26th.

Cross-examined. – It was on the Wednesday I took her into custody, but left her in the charge of officers at her own house till the next day. She had a fit of hysterics when I returned to the house with the doctor on the Wednesday. She continued in and out of them all the time I was there, which was about an hour. She was so ill I thought it advisable to leave her at home. I took her to the station-house the following morning, and she was put to bed. She was well enough to be removed from the station-house by the following Tuesday. I have known the girl for years, and I do not consider her of bright and clear intellect.

Re-examined by Mr. Whitmore. – When she made the first answer to me she was not in a hysterical condition. The hysterical state had come on when I returned with Mr. Wilson.

By the Court. – She was with her mother washing when I first went.

Edward Moore, examined by Mr. Best. – I am a surgeon at Halesowen. On the 24th June last, I examined a dead child at the Swan Inn, Lye Waste. I found that the substance of the brain was smashed. The injuries were sufficient to cause the death of the child; they were such as would be produced by a fall into a pit. The stomach contained a considerable quantity of milk.

Cross-examined. – There was no discolouration of the scalp. Usually we should find discolouration of the scalp when wounds are inflicted during life. We do not usually find it when breaking of a bone or contusion takes place after death. It is very unusual to find contusions, given during life, without discolouration. Sometimes there is congestion of the lungs observed in the body of a child, which has died of convulsions; but there is often no post-mortem appearance at all of a morbid character. If a child died of convulsions I should not be surprised to find a little frothy mucus in the lungs. If life were to be suddenly arrested by convulsions, I should expect to find the left side of the heart empty, because the last act of the heart is contraction. I should also expect the membrane of the brain to be congested. In this case I found a small quantity of mucus in the lungs, the left side of the heart empty, the lungs slightly congested, and the brain also, but it was difficult to say to what extent, in consequence of the injuries done to it. The brain was much congested. I have had much experience in cases of midwifery. I have seen instances where the mother at a period after the birth has been deprived

of her reason for a short time. We may have puerperal fever, which generally comes on in three or four days, or rather before that, when secretion of milk comes. It may occur a fortnight after, but seldom does. I have seen other cases where women have in a fortnight or three weeks after delivery had been seized with insanity – for instance, those of puerperal mania, which is a species of insanity. It may occur at any period after confinement, but the most frequent period is before the secretion of the milk is established. It may come on a fortnight or three weeks after, or even later. The fact of a person being subject to fits might most probably give a predisposition to it.

By the Court. – The post-mortem appearances do not enable me either to affirm or deny that the child had convulsions. The injuries are consistent with the supposition that the child had been thrown down either before death or immediately after death.

Mr. Wilson, surgeon, Stourbridge, examined by Mr. Best. – On the night of Wednesday, June 23, about ten o'clock, I examined the prisoner's breasts and found them full of milk. I was of opinion she had recently suckled. She was in a very hysterical state, but was not labouring under puerperal fever or mania at the time.

By the Court. – I heard her talking to Burton. She was then very hysterical, but what she said to him was continuous, notwithstanding the hysterics.

Ann Beach, examined by Mr. Best. – I am assistant nurse at the Wolverhampton Union Workhouse. I attend to the lying-in ward. I remember the prisoner being admitted, but I can't say the day of the month. She was confined there and stayed a fortnight afterwards. The child was a female; I was present when it was baptised; it was named Lucy Richards. The prisoner went in the Union by the name of Mary Ann Richards. It was a healthy child. The prisoner left the house on the 19th about half-past twelve in the day with her child. (The witness here described the clothes in which the child was dressed.) I saw the child dead at Stourbridge, on the following Saturday, and also the prisoner at the station. As soon as she saw me she fainted. I afterwards asked her how she could think of making away her child. She said the devil had tempted her to make it away.

Cross-examined. – Mrs. Turner and another woman were in the room. It was about an hour after the woman fainted that I began to talk to her. It was as soon as she got better. She fainted in the yard and was carried to bed. She was crying very bad when I went into the room, and I asked her this question whilst she was crying. I know the child had had fits at the workhouse, perhaps two or three in the day. It was subject to them. The night before the child left the workhouse it was put into a warm bath for the convulsion fits by the doctor's order.

By Mr. Best. – It was pretty well when it left.

Ann Manley, storekeeper at the Wolverhampton Workhouse, examined by Mr. Best proved that the clothes found on the body were those she had given out of the stores to the prisoner for her baby. She then said – I saw the prisoner on the 26th June at the station-house at Stourbridge. She was brought into the yard and fainted away. She was taken then into the cell. I afterwards went into the cell, and asked her how she could be so unfeeling a mother to murder her own child. She said in reply, she sat down and suckled the child; the child had a fit, and she threw it into the pit.

Mary Turner examined. – I am the wife of John Turner, of Stourbridge, and live at the police station. The prisoner was in my charge on Saturday, 26th. I remember Beach and Manley coming to the police station on that day. I was in the cell when Manley came in. The prisoner said "Oh, Manley, I did throw my child into the pit." Manley said, "How

could you be such a cruel mother?" The prisoner said, "Oh! The devil tempted me, and I threw it into the pit." She cried a good deal, and said the child had a fit; she suckled the child; then it recovered, and she threw it in the pit.

James Everett, shoemaker, Lye, said he saw the prisoner on the evening of the 19th coming from the direction of the Hayes' pits, towards her own home, and about two hundred yards from the pits. She had nothing with her.

This concluded the case for the prosecution.

Mr. Huddleston said, that cases of this kind were the most painful they had to decide. They sat as judges on matters affecting the life of a fellow-creature upon most fallible evidence, and that fellow-creature a young woman not possessed of a clear intellect, and subject to fits. They were asked to place interpretations upon expressions she had made use of, which the rest of the case did not seem to warrant, and which even the expressions themselves did not fairly bear out. What gentleman in that box could venture to say he could repeat accurately half-a-dozen words made use of by the witness? An illustration of the difficulty of giving expressions correctly, was shown whilst Manley was giving her evidence. The words, "It had a fit," had escaped the attention of the most vigilant person in the Court – His Lordship himself. If, then, it was possible for his Lordship, who was watching the case, to lose a portion of it, was it not possible for the witness to speak accurately with respect to the statements of this poor raving creature. Manley herself said that she asked the girl how it was she came to murder her own child, but when cross-examined admitted that she said, "How could you thrown your own child into the pit?" It was quite clear that if the child was taken with a fit by the side of the pit and died, and the mother in agony of the moment threw it down into the pit, it would not be murder. The appearances that the doctor found were such as allowed, the supposition that the child died before it was thrown in. Then it was a singular fact in the case that there was no discolouration on the body. A violent blow after death produced no discolouration. This showed the probability of the suggestion that the child was thrown down after death. Would the Jury dare to affirm upon their oaths, in a matter affecting the life of a fellow creature, what the doctor who examined the body dared not say. The child was subjected to convulsions as the evidence plainly proved, and the probability was that it was taken with one of those mysterious visitations to which all are subject and by which its life was destroyed, and that the mother in her misery had removed from her sight the painful object by throwing it down the pit. He concluded by observing the serious nature of the charge, and the necessity that the Jury should be satisfied beyond all doubt, before giving a verdict of guilty, that the child was thrown into the pit alive by the prisoner with the wicked intention of putting an end to its existence.

Alfred Knowles was recalled by the Court and asked whether the appearance about the mouth of the pit was such as would indicate to a person living in the neighbourhood that it had been recently worked? He replied that anyone would know that it was being worked.

His Lordship commenced his address to the Jury upon the evidence by remarking upon the solemnity of the duty they had to discharge in this case, and calling upon them to exercise their judgement freely and fearlessly upon the facts, regardless of the consequences which might result from their verdict. He then proceeded to comment upon the evidence, which he read at length. There was no doubt he remarked, that the prisoner had made a false statement in the first instance to Burton, when she denied the fact that she had been recently confined of a child, and again when she said she had been

confined at Bilston. With respect to the other expressions said to be made use of by the prisoner in the hearing of the female witnesses, the Jury must be cautious in the extent to which they received them, because it was extremely difficult, even under the most favourable circumstances, to repeat from memory the exact words used by a person, after any considerable lapse of time. The Jury had, as had been remarked, an instance of the difficulty of describing correctly expressions of another. By leaving out a few words, or not describing the words in the correct order, the meaning of an individual might easily be perverted or obscured. He expressed his opinion that there was no reason to doubt that the girl had thrown the child into the pit, but the Jury must decide from the facts whether the child was alive or dead at the time. There were three points to which he should particular direct the attention of the Jury. The first was, that the child was thrown into the pit with its clothes on, and it might be supposed that a person who wished to commit murder would be more careful to destroy the means of identifying the body in case it should be discovered, by removing the clothes. The second was that the pit was being worked and that any person in the neighbourhood, used to the appearances at the pit mouths, would be able to know that such was the case. The prisoner lived near the pits, and it must be supposed would be well aware that the body would soon be discovered. The third point for their consideration was whether, supposing the woman threw the child into the pit alive, she was in a sound state of mind? The law inferred that every person was in possession of sufficient reason to be accountable for his actions unless the contrary was proved. What proof to the contrary was given here? There had been some talk about puerperal fever and mania, but the learned Council did not press that point. None of the witnesses who could speak to the prisoner being attacked by anything of the kind had been asked the question. The mother of the girl could have been called if the girl had shown any symptoms of unsoundness of mind on her return home. It would be straining the matter too far to assume that the prisoner was not in possession of sufficient reasoning faculties at the time this was done. The main question would be whether the child was alive when thrown into the pit, and was wilfully thrown down for the purpose of destroying its life.

The Jury, after some minutes spent in consultation, requested liberty to retire, and they were accordingly removed under the usual protection from communication with others. In half an hour they returned. Their verdict was that the prisoner was guilty of wilfully throwing the child alive into the pit, but they recommended her to mercy.

His Lordship enquired upon what grounds the recommendation was founded.

A Juryman replied – "We think her sufficiently sound in mind to be responsible for her actions, but we think she was not sufficiently so to resist the temptation."

His Lordship having put on the black cap proceeded to pass sentence, the prisoner meanwhile exhibiting much alarm and agitation. He said – The Jury have, after a careful consideration of the evidence, convicted you of the crime laid to your charge; nor can I come to any other conclusion than that you have been, as was said to you by some of the witnesses, that cruel mother capable of destroying your own offspring. The Jury consider you to be a person of sufficient intellect to be responsible for your own actions, and have found you guilty, but not enjoying the same amount of understanding bestowed upon the majority of mankind, have thought fit to recommend you to mercy, and that recommendation shall, of course, be duly forwarded to her Majesty's advisers; but I should be sadly misleading you if I instructed you to hope that the terrible sentence I shall have to pronounce will not be fully carried into effect. (The prisoner here threw herself upon

the shoulder of a female who was attending her and hid her face.) On the contrary, I am bound to tell you it is extremely probable. At present I see no reason to doubt it – that the dread sentence of the law will be executed. (Sensation.) You are indeed in a fearful position. It is a dreadful thing to see a young woman in the very prime of life and apparently in full health, now standing before me, who yet within a few short weeks must suffer a violent death. I know not whether you are now calm enough to listen to what I have to say – it shall be but little. I have no authority – no commission to tell you what to fear or what to hope for in the future – to hope for beyond the grave. (The learned Justice appeared too much affected to proceed without frequent pauses.) Here, I have told you, you have little hope; but if you have never listened to religious instruction, I pray you to do it now. There is always a person appointed to administer such instruction to persons in your situation, and to afford hope and consolation to such as are truly penitent. To his care I resign you during the remainder of your days, trusting you will fully profit by the teachings he will, according to his sacred office, be authorised to give. I will not make any observations upon the dreadful crime you have committed. It is unnecessary that I should try to excite detestation of your crime in the mind of anyone here. No one can fail to be impressed with the horrible nature of the offence – that of wilfully destroying your own offspring. I trust your sad fate will be a lesson to all who depart from the course of virtue. We here see the terrible consequences, which result in one false step, and the terrible temptation, which result. The sentence of the Court is, that you be taken hence to the place whence you came, thence to the place of execution, and that there you be hanged by the neck until you are dead; after you are dead, that your body be buried within the precincts of the prison in which you are confined, and may the Lord have mercy on your soul.

The impressive manner in which this sentence was delivered by his Lordship had a visible effect upon every one present. There were no female spectators to give way to violent grief, but tearful eyes and serious looks amongst the rougher sex who formed the audience, indicated the presence of excited feelings throughout the Court. The prisoner being insensible towards the conclusion of his Lordship's address and at its termination was carried below in the arms of a stout officer of the gaol.

WORCESTER HERALD, SATURDAY 31 JULY 1852

THE CONVICT MARY ROBINS. – Since our last, a petition to the Queen praying for mercy for this unhappy creature has been extensively signed by Magistrates of this county and city, Clergy, and citizens generally. The petition was also signed by the High Sheriff, who kindly undertook the duty of transmitting it to the Home Secretary, and it is to be hoped that the benevolent object of the petitioners will be attained. There is no marked change in the demeanour of the wretched woman; she remains apparently under a proper apprehension of her awful position, and she does not deny her guilt, but says the deed was done in a state of distraction, not knowing what she did.

The following letter has been addressed to us by a gentleman intimately versant in the administration of the criminal law, and one of the last persons, we should say, to write as he does accept under a deep conviction that there are mitigating circumstances in this miserable woman's case, which, if they do not entitle her to mercy, yet ought to justify its extension to her, even in the eyes of those who deem the example of public executions as of a salutary tendency:–

TO THE EDITOR OF THE WORCESTER HERALD.

Sir, – I am induced to address you in reference to the case of the female under sentence of death in our county goal, and upon whom the law is, at present, left to take its course.

The facts in reference to the dreadful crime she committed are soon told. In fourteen or fifteen days after her confinement in a Union workhouse she was allowed to depart in a very weak state of health, in body and mind, as proved on her trial, with her infant, which was subject to convulsions. Having in this weak state travelled on foot a distance of ten or twelve miles, she sits down, fatigued and exhausted; her infant's convulsions returned; she had no place to go to, her father having declared he would not receive her; and thus driven to despair, and no doubt distressed in mind determined to pursue a course which would prevent her infant sharing her sorrows and difficulties. Either a Union workhouse or the open air was the alternative, and the latter with no means of support!! This was her position! In the sorrowful, difficult, and distracted state of mind she committed the dreadful crime for which she is sentenced to die.

I ask whether under such circumstances a public execution of this poor wretched woman will create any other feeling than that of sympathy in the public mind? Are not the circumstances stated of a mitigating character? Are they not stronger, or at least as strong, as those, which have operated in modern times to save the lives of those who have been convicted of similar crimes? (No doubt you could supply instances.) Why then should this poor wretch be made an exception from that clemency which has of late prevailed in similar cases where such circumstances of mitigation appeared? Of late Judges have interposed their influence to save the forfeited lives of poor wretches convicted before them, and who have been driven to desperation in the same way as this wretched woman was; and in this case the JURY RECOMMENDED HER TO MERCY.

After what has of late been done in cases like the present – the lives of the culprits spared – it would seem to be something like caprice to hang this wretched woman. Surely, therefore, an immediate application should be made to Mr. Justice Cresswell (who is not wanting in feeling of humanity), before whom she was tried, in furtherance of a petition to the Queen, already forwarded, and signed by several county and city Magistrates and others who have expressed their opinion, and who see no good in taking the life of this wretched woman.

Do not suppose, Mr. Editor that I desire this malefactor to go unpunished, or that I feel anything short of abhorrence in reference to her crime; no such thing. I feel strongly that her execution will only create sympathy, as her present position does very generally, and will have no beneficial effect by way of warning; that her case contains circumstances of great mitigation; that effect ought to be given to the recommendation of the Jury; therefore that her life ought to be spared, especially as it would only be consistent with what has been done in many similar cases.

I hope the feeling of the citizens of Worcester and its neighbourhood will be roused and expressed to the learned Judge in this case, and I feel assured that that course is the only effectual one to be pursued.

I am, Sir, Your obedient Servant,

C. July 28

A number of similar letters can be found in the newspapers of this time, relating to the same subject.

THE Sorrowful Lamentation!

Of Mary Robins, 25, under the Sentence of Death in Worcester Gaol, for the murder of her infant at Kingswinford, June 21st. 1852,

Ye tender hearted Christians all,
 Come listen unto me.
While I relate a tale of woe —
 Which ends my misery.
Mary Robins is my name.
 And dreadful it is known :
For the murder of my infant child,
 Would melt a heart of stone,

Murder is my awful crime.
 And is denounced by heaven,
And on my head my infants blood,
 I hope to be forgiven.
So I was apprehended,
 To Worcester sent with speed'
And now I'm doom'd to suffer,
 all for this dreadful deed.

At the last Worcester assizes,
 I was placed at the bar,
That I was guilty of the deed'
 the Jury did declare !

The Judge the sentence passed on me.
 and then to me did say—
" For the murder of your infant child,
 " You must die upon the tree ! "

In a dungeon dark. in irons bound.
 I bitterly do weep,
The midnight bell, the thoughts of death
 deprive me of my sleep.
The ghastly form of my infant babe.
 appears fresh before my sight,
Strikes terror to my guilty soul,
 amidst the shades of night.

My old companions all I pray.
 take warning by my fate.
Beware of murdering's fatal sway,
 before it is to late.
For in good thought you all must keep,
 and shun such wicked ways,
The thoughts of death makes me to weep
 in these my latter days

My life is forfeit to the laws,
 For the deed that I have done,
Good people all—pray for me.
 When I am dead and gone.
May the Lord have mercy on my soul,
 Have mercy Lord, I pray,
When I appear before thy throne,
 On the Judgement Day !

Wright. Printer, Birmingham.

The original source of this poem is unknown. Discovered at Worcester Record Office, the poem is definitely about the same Mary Robins mentioned in this book, except it is inaccurate, in as much as she did not kill her daughter, Lucy, at Kingswinford, but at the Hayes in Lye, which was previously in the parish of Oldswinford.

Worcester, Saturday 7 August 1852

The Convict Mary Robins. – It is with heartfelt satisfaction that we now state that the High Sheriff received a despatch from the Home Office on Thursday morning, intimating that her Majesty had been graciously pleased to grant commutation of this wretched creature to Transportation for Life. Intelligence of this great change in her position was communicated to the convict. The community of this city and of this county owe a heavy debt of gratitude, for their escape from the disgrace, which would have been entailed by the public execution of such a woman, to those benevolent persons whose efforts have at length prevailed. We may enumerate among these the High Sheriff, T. G. Curtler, Esq., the visiting Magistrates as a body, our worthy representative, Mr. Laslett, M.P. &c., and it is as an example teaching the value of perseverance and adhesion to principle under difficulties, and in circumstances of great discouragement, that we now state some of those efforts in some detail. In doing so we cannot avoid bestowing special commendation on Mr. Curtler for his humane and untiring exertions in this matter, we know it would be more agreeable to that gentleman's feeling were his share in the proceedings passed over in silence.

In the last Herald it was stated that a partition to the Queen for mercy, signed by the Magistrates, Clergy and others, had been transmitted to her Majesty by the High Sheriff; it was pointed out that the Judge who tried the convict should be appealed to, setting forth the circumstances existing in her case, and we now add that after the proceedings were adapted, they have happily proved successful.

On Friday Mr. Curtler went to Stourbridge to investigate the case, and there communicated with Mr. Robins the committing Magistrate, Supt. Burton, of the police, the surgeon who had examined the convict and the Magistrates who usually act for the district. Mr. Robins had on Monday previous, written to the Home Secretary, representing how useless the execution would be in point of example, from the general feeling of sympathy that existed in her favour.

William Robins, no relation to Mary, was a Stourbridge banker in partnership with Hill and Bate, owning the Old Bank on the corner of Coventry Street and High Street, known as Hill, Bate & Robins; he was also High Sheriff of Worcestershire in 1843.

His opinion may be inferred from the following passage in his letter:– "When the unfortunate girl was brought before me for examination, she appeared to be very weak in intellect, and had it been my province to try her instead of committing her for trial, I should have felt indisposed to hold her responsible for her conduct." Supt. Burton stated that he had known her for years, she was of weak intellect, a "very soft one," not able to resist any persuasion, or to form any judgement of her own. He did not believe she premeditated the murder, or else she would not have carried the child twelve miles to a place within sight of her father's door. His Lordship recommended that the memorial presented to him from the citizens of Worcester, should be transmitted to the Home Secretary, which was done on Tuesday; and we only to add, that eventually these efforts have resulted in the extension of mercy to the unhappy woman.

Mary Robins sailed from Woolwich on 27 November 1852, bound for Van Diemen's Land (Tasmania) on board the *Duchess of Northumberland*, together with a further 218 female convicts. After 144 days, they arrived at Hobart on 21 April 1853.

Above is the Convict Record of Mary Robins. It is printed here with the kind permission of the Archives Office of Tasmania, who are the copyright owners (Ref Con 41/1/37). The record states that Mary was 'tried at Worcester Ass. 17th July 1852, – Life S. Arrived 21/4/53. Wesleyan Re. Transported for Wilful Murder of – Single 2 children, Stated this offence. Destroying my own Child 14 days old. Sentenced to Die but was reprieved Single 2 children. Surgeons report good.' She is described as a 'Needle Woman, 4/11¼ tall, aged 26, hair light, and blue eyes. Native place – Worcestershire. Remarks – Left wrist burnt – Subject to hysteria. Ticket of Leave 13/1/57. Conditional Pardon 27th Sept 1859.' Her record states she had two children. Children were not normally transported with parents.

She married Edward Wells, at Launceston, on 27 September 1854, a convict sentenced to seven years for embezzling £8 6s 0d at Nottingham; they had three children, all boys. Edward died at Kingston in 1861.

Mary married William Turfrey, a widower, also a convict, sentenced to ten years, at Oxford for burglary, by whom she had two children, one a girl she called Lucy.

Mary Turfrey (Robins) died at Ranelagh near Hobart on 21 November 1903, aged seventy-six years.

Her daughter, Lucy, married Charles Brown in 1881, and Ernest Wagg in 1899. She died in 1943.

Burns of the above nature would suggest that Mary was a nailer, back in Lye. A conditional pardon allowed her to move freely around the colonies of Australia, but not to return home to England.

THE MURDER OF MARY PARDOE AT THE SEVEN STARS, OLDSWINFORD

WORCESTER HERALD, SATURDAY 14 AUGUST 1852

MURDEROUS SHOOTING AT OLDSWINFORD
A WOMAN KILLED AND OTHER PERSONS SERIOUSLY WOUNDED

The village of Oldswinford was on Monday night the scene of a tragedy, which has created a great sensation throughout the neighbourhood. There is a small public house at Lower Swinford, called the Seven Stars, near the railway bridge over the road to Prescott. It was kept by a painter named David Davies, whose family consisted of his wife and only son, fifteen years of age. On Monday night a number of navvies from the adjacent railway works were drinking in the house, and a quarrel having arisen amongst them, they went into a neighbouring field, and two of the company fought. At the conclusion of the contest they returned to the house, and still continued to make a great deal of noise amongst themselves. The fight and the subsequent quarrelling drew a crowd of people about the front of the house, and whilst things were in a state of disorder Davies came home in an angry mood about nine o'clock, and endeavoured to disperse the mob in front, which consisted chiefly of unruly boys, though there were a few grown-up persons amongst them. He struck several blows with a stick at the crowd, and it seems that someone threw a stone at him in return. He went almost immediately up the stairs, and, in spite of remonstrance, fired a number of shots amongst the people from a double-barrelled gun, which he loaded and re-loaded for that purpose.

The first shot brought a woman to the ground, and caused her immediate death, and the second, which seems instantaneously to have followed, severely injuring a young man residing in the neighbourhood. The three others, which were afterwards fired upon, also produced serious effects, though the consequences are not likely to be so fatal. Having perpetrated this outrage his rage appears to have been satisfied and he laid aside his weapons and descended to a lower room, where he was soon afterwards taken into custody by Mr. Burton, the superintendent of police at Stourbridge.

On Tuesday morning Davies was taken before the Magistrates, William Robins, Esq., and Captain Hickman, at the Stourbridge police office.

Captain Hickman was the son of Martha Hickman, who was the owner of the Stamber Mill, which was a forge or hammer mill for making scythes. The Hickmans were originally 'clothyers' of Stourbridge who became clay merchants and brick manufacturers at Stambermill, and owned large areas of land in Stourbridge, Lye and Wollescote. The family home was the Castle in Church Road, Oldswinford, less than 100 yards from the Seven Stars. Captain Richard Hickman was living at the Castle at the time of the event described above; he had

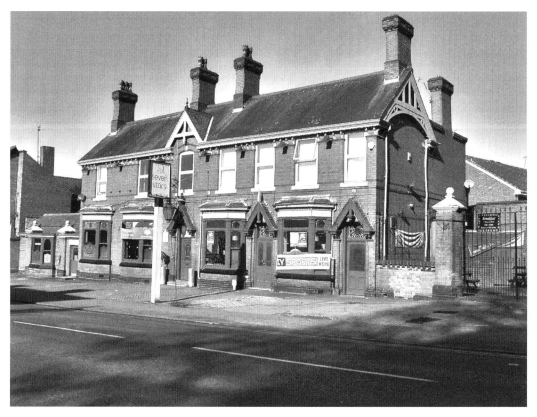

The Seven Stars, as it is today, is much bigger than the Seven Stars described in the evidence as 'a small public house' in Lower Swinford in 1852.

been a captain in the Royal Marines and commanded the Stourbridge troop of the 'Queen's Own' which put down the riots in Lye in 1842 and quelled the riots in Dudley by parading with two field pieces and positioned them to face the rioters.

His son, David Davies a lad between fifteen and sixteen years of age, was also brought up in custody. Davies, the elder, is about 38 years of age. He did not seem fully to understand the dangerous situation in which his recklessness had placed him. Mr. Harward was present to conduct the prosecution, and Mr. Tudor and Mr. C. W. Collis appeared for the prisoner; the latter gentlemen however, chose to defer any defence they had, and declined for the present to cross-examine witnesses.

Thomas Pardoe, deposed that he was at Davies's house, on the evening in question. Davies shortly after came in. He had a stick with him, with which he struck some persons in the crowd. He went upstairs and returned shortly with a single-barrelled gun. Witness heard Davies then say, "I've given 'em a sweep, and I'll give 'em another – a double one." Witness had previously heard the report of a gun. George Smith, who was present, took the gun, which had a cap on, from him, and Davies left the kitchen. Smith removed the cap from the gun. Witness told Smith the gun was loaded. Witness did not see anybody else go up stairs. He was sent for to the public house by the parish

constable Chance, in consequence of a breach of the peace. Witness heard four reports of a gun altogether.

John Sparrow, of Chawnhill, deposed, he saw the prisoner come to the middle up-stair window with a double-barrel gun. He opened the window, and immediately upon saying "Here's into you, you be b--------," he fired. Witness was standing not far from the house; if he had not ducked his head and dropped down he should have been wounded. A woman named Mary Pardoe was shot dead. She was about ten yards from the prisoner at the time. The prisoner discharged the second barrel, and a young man, named William Wooldridge fell from injuries he received. Witness had now changed his position, and was standing by Moreton's house, which is opposite, witness could see plainly into the bedroom, and saw him charge the gun. The prisoner, after opening the window, leaned over and presenting the gun up the road in the direction where the crowd of persons was standing, and discharged the two barrels again, one almost immediately after the other. Witness saw Mrs. Brentnall wounded, and she would have fallen had she not been caught by the bystanders. Witness then went off for his own safety, and went to the tap-room of Morton's public-house, opposite, where he afterwards heard another report of a gun.

Supt. Burton disposed to apprehending the prisoner on Monday. He charged him with shooting and killing Mary Pardoe, when he replied, "See how they've shot me," and denied that he had had a gun in his hand or seen one that day. The officer found in his pocket eight percussion caps. He also produced two guns – one a double-barrel and the other a single-barrel. They appeared to have been discharged very recently and smelt of gunpowder. They were both loaded and capped, which the contents the officer drew in court. The barrels were loaded with slugs and large shot.

Mr. Thomas M. Harding, surgeon, then deposed to being called in to attend the sufferers on the evening stated. Mary Pardoe was quite dead. He found a gunshot wound on the left cheek and left side of the neck and shoulder; the wounds in his opinion were sufficient to cause death. He also examined a young man named William Wooldridge, a butcher; he had a gunshot wound on his right cheek and right side of his neck, extending to his right shoulder and part of his chest. He lies in imminent danger. A woman named Fletcher was also examined by witness; she was injured by a gunshot wound on the inside of the right thigh, leg, and ankle. James Haywood was similarly wounded in the back of the right leg and thigh. Mrs. Brentnall was also seen by witness, but being a patient of Mr. Betts's, she was now under that gentleman's care. She is the wife of Mr. Charles Brentnall, a highly respectable man, and is said to be seriously injured.

The case was then adjourned till Thursday, after occupying upwards of three hours.

Worcester, 21 August 1852
RESUMED EXAMINATION BEFORE THE MAGISTRATES.
On Thursday the prisoners were both brought up at eleven o'clock, at the Public-office. The Magistrates present were William Robins, W. Trow, and R, Scott, Esqrs. and Captain Hickman. Mr. Harward again appeared for the prosecution; and Messrs. Tudor and C. W. Collis for the prisoners. The elder prisoner had his head bound up with a handkerchief. In answer to a question from the bench, he said that the doctor had dressed the wound on his head and tied it up. His demeanour in Court was quiet and serious, and he appeared very attentive to the statements of the witnesses. The son seemed to be about sixteen years of age. With the exception of a little heaviness in the

eye, the expression of his countenance was tolerable good, and gave no token of a brutal or malicious disposition.

The first witness examined to-day was Mr. Wilson, the excise man, whose testimony in chief was similar to that given by him before the coroner on Wednesday. He said, however, that he saw the powder and shot run into the gun. He was closely cross-examined by Mr. Tudor, and said – There could be no mistake about the son following his father up stairs with the candle in the first instance. I went up immediately after the son. I am prepared to swear that the son gave him something to ram down the gun. (After some pressing) I am prepared to say it was paper. It had been crushed in a man's pocket. I have had experience in guns and shooting. It looked like paper that was put in and not like wadding. Before any shot was fired I said, "For God's sake don't shoot, you'll get your neck stretched." I am positive that was before a shot was fired. I could not see into the room when I heard the first report; I was three or four steps from the top. I did not hear him say anything in the room. The next witness was the parish constable, Chance; he was examined strongly upon the point whether he saw the son go up stairs with the father. He persisted in saying he did not see the son at that time.

In cross-examination, he said there had been a fight in a field at the back of the house, and a man named Mallen had marks of violence on his face. Mallen pointed out a man with whom he had been fighting and said he had stolen a cleaver. He (witness) did not go into the house for an hour, but at last charged Thomas Pardoe to assist in taking the man. He was afraid of being killed. (Mr. Robins said a constable should have no ideas of that kind.)

About this same time, at Warwick Sessions, John Harris was indicted for refusing to assist a constable in quelling a disturbance, when charged by him so to do, was found guilty and sentenced to be imprisoned for seven days in gaol. The Court observed that by the common law, any private person, as well as a constable, was bound to use his best endeavours to prevent an affray when he saw the peace broken in his presence; and a person who refused to assist when called upon was punishable by fine and imprisonment. It was further observed by the Court, that the object of this prosecution was not so much to punish the prisoner as to inform the public that they were bound to assist a constable when called upon by him, and if they refused they did so at their peril, and were liable to be punished.

There was loud talking in the house. There were too many for him to go in by himself. Had the man been in custody when Davies came in? Pardoe, whom he had charged to assist, was there.

The man charged with felony was brought down here, but there was no real charge of felony. Captain Hickman observed that this man ought to have been brought out of the public house at once when taken by Chance. He also said that if the parish constables had done their duty, in all probability this melancholy affair would not have existed.

Mr. Thomas Massey Harding was next further examined. – He said: I have made a post-mortem examination of Mary Pardoe. I found extravasation of blood in the pericardium, from the superior vena cava, not more than one quarter of an inch from the right auricle of the heart. It was a round or nearly oval hole, such as would be produced by a shot. I also found several wounds of the aorta, and several shots in the

left lung. I made a dissection of the neck on the left side, and found a perforation of the internal jugular vein, and a wound of the carotid artery. I believe her death, was instantaneous. I handed the slug and shots to Superintendent Burton. (These were produced, there were seven or eight shots, and one rather larger piece of lead, which was said to be a slug.)

Thomas Pardoe was now brought up for cross-examination. – He said he was a nephew to Mary Pardoe. There was a noise and disturbance, which brought him to the spot. Chance came and immediately charged him to assist to take the man from Davies's. Chance came out for more assistance, and did not come back for nearly three-quarters of an hour. He (witness) was left in the house, and there was a great row amongst them. He added: When I first went, Davies's son was there. In consequence of the violence of the navvies in the kitchen the son went over a hedge to fetch his father. The boy came back, and said that his father would come and give them "the sweep." In a few minutes Davies came to the door, which was fastened with a drop latch. He beat the people with his stick, and that roused more people. They were quiet till he laid on them with the stick. Chance was then present. I laid hold of Davies, got him into the house, and fastened the door. When he came in he had his hand to the back of his head, and said, "They have given me a peppering, I'll go and give them one." Davies went up stairs in a minute or so after he came in; he said, "I'll go and give 'em a sweep." The first two shots were fired in about a second; there was no time to put on a cap between the two. After this he brought down a single-barrelled gun, and gave it to a navvy, saying "Protect yourself." The navvy was in no danger. I told the navvy that the gun was loaded, so he took the cap off. Davies said, "I'll give the b------s another sweep; I'll give them an extra charge." I remonstrated with him, but it was no use. He went up again, and I heard both barrels fired. After he had fired the two barrels, he came down a second time, and stood a bit in the same place, he then said he would go and give them another peppering. Next he went up stairs again, and I heard another shot fired. Mr. Burton came in about five minutes. Davies would not let the door be opened at first, but when he heard Mr. Burton's voice he let the door be opened.

John Sparrow was next cross-examined at some length. He said that Davies stood within two yards of the window when he re-loaded.

Supt. Burton was further examined. – He produced ten shots and one slug taken from the body of Mary Pardoe. He also produced the guns and a bag with shot and slugs similar to those found in the body.

In cross-examination he stated that when he drew the charges from the gun he found that common gun wadding had been used and not paper. He also found a quantity of the same wadding in the prisoner's bed-room. Found Davies in the house, with this head tied up. He complained of injuries to his head. The bandage on his head was put there by Mr. Harding. He (witness) had charge of the police-station. He found from the report of Police-constable Panting that on Monday night, application was made by the boy Davies for the assistance of the police, and he wished him to come to protect his father.

Police-constable Panting said that at a quarter or twenty minutes past nine, young Davies came to the station, saying that there was a row round his father's house, and that Mr. Chance, the constable, wanted assistance.

Capt. Hickman, stated that about ten minutes past ten he was told what had occurred, and went to Davies's house. Found Burton there, and Davies, and a number of navvies.

He ordered that Davies and all the navvies should be taken into custody, which was done. Mrs. Davies reluctantly gave him a single-barrelled gun, and his servant brought him a double-barrelled gun downstairs, together with a shot bag, &c. Davies, when he (witness) first went in, said "Look how they have served me?"

William Walker, servant to last witness, proved that in Davies's bed-room he found a double-barrelled gun, and a powder flask and shot bag.

The Magistrates then committed the older prisoner for Wilful Murder, and refused to take bail. They considered that the evidence showed the boy to be an accessory, and they therefore committed him as a principal in the second degree. They were, however, willing to accept for the boy in two sureties for £100 each.

Mr. Tudor intimated that bail would be found as required.

Mr. Robins said it would be advisable to remove the elder prisoner to Worcester as soon as possible, and Mr. Burton replied that he would be sent off that evening.

When the arrangements for securing attendance of the witnesses were being made out, Mr. Wilson remarked, that he should be sent to Ireland, perhaps, before the next Assizes, to which the elder Davies replied, that it would not matter if he went to the gallows, for the lies he had told.

The prisoners were then removed, and the Court rose at half-past five, after sitting six hours and a half. Davies was lodged in the County Gaol about mid-day to-day (Friday.)

Saturday 12 March 1853
THE OLDSWINFORD TRAGEDY.
DAVIES, David, the elder, aged 47, painter, and DAVIES, David, the younger, aged 15, painter, were charged with the wilful murder of Mary Pardoe, on the 9th August, last, at Oldswinford. Mr. Serjeant Allan prosecuted, and Mr. Huddleston defended.

David Davies and his son David were charged with the wilful murder of Mary Pardoe and appeared at the bar to face the charge and Davies (senior) was asked how he pleaded. He at first refused to answer, and then said, 'I have killed nobody.' His son, on the same charge, replied, 'Not Guilty.' There then followed a long debate as to if David Davies senior was fit to plead or was he insane?

Various people were called to give evidence to the state of his mind; meanwhile, the prisoner's behaviour became quite erratic and a number of officers stood by to restrain him if necessary. The judge called for a brief adjournment while medical officers examined the prisoner. He was then returned to the bar and again asked if he was guilty or not guilty. He again gave no answer. The jury was then sworn to try his state of mind. There then followed a long procedure of various medical practitioners who gave evidence as to the state of Davies's sanity. Finally after consultation the jury returned a verdict that the prisoner was insane, and unfit to plead.

His Lordship, addressing the Clerk of the Court, said – Let him be detained in custody till Her Majesty's further pleasure be known.

On the application of Mr. Kettle, as council for the younger prisoner, the lad was ordered to be discharged when bail for his appearance to the amount of £100 was found.

The boy was then remanded to appear before the next Assizes.

Worcester, 16 July 1853

The Oldswinford Murder

David Davies, 16, was charged with the wilful murder of Mary Pardoe, on the 9th of August last. Mr. Best for the prosecution opened the case by saying that it was necessary he should state the reason of the elder Davies not being at the bar was that he was confined during Her Majesty's pleasure, on the grounds of insanity.

Supt. Burton, of Stourbridge, deposed that the Seven Stars public-house, Oldswinford, was occupied by David Davies the elder, on the 9th August, a model of the house was placed on the counsel's table, which was sworn to be correct by Mr. Burton. He further deposed that from the stairs a person could not see into the front room. He found some gun-wading on the drawers in the front room, on the night of the murder. Drew the charge of a gun, in which there were pellets of the same make and substance. There were two guns, a single and a double barrel, both loaded with powder and shot.

Thomas Pardoe, labourer, living at Oldswinford, went to the Seven Stars about half-past eight on the night of August 9th. There had been some noise in the house among some "navvies." Witness was called in as a constable. Prisoner had gone to fetch his father. The "navvies" were threatening to thrash anybody who interfered with them. When the elder Davies came in he said he would "blow the ----- all of a ruck," and went upstairs, and witness heard him fire two barrels.

By the Judge – There were people outside the house. Davies came downstairs with a single barrelled gun, and said he had swept some off and he would give them another. He went up stairs again and witness heard two barrels fired again. The prisoner was there, but witness did not see him go up stairs. The elder Davies when he came in said someone had struck him on the head with a stone. Witness saw Davies's head bleeding after the shooting was over. Had let Davies go about a minute before the first fire. Could not say where Davies stood when he fired, there was about time for him to reach his gun and walk to the window. Prisoner could have gone up the stairs without going through the passage by a door into the cellar. Saw John Wilson in the house when the single-barrelled gun was brought into the kitchen and asked a "navvie" to take the cap off the nipple. There was great confusion when Davies had fired the gun. Davies wanted a "navvie" to go with him, and fire; but Wilson said to him, "do you want to be hung too!"

James Chance, constable at Oldswinford, deposed he went to the Seven Stars public-house on the 9th of August last. There were many persons there drinking. Davies came in about a quarter of an hour after witness, who left the house five minutes after. There were a number of men, women, and children outside the house – not making any disturbance. Witness heard a gun fired five times. Did not see any one in the house stripped for fighting when he went in. Did not see the prisoners after eight o'clock that night. The first shot was fired directly after witness came out of the house, and he saw the elder Davies in the passage a minute before. He did not see Wilson in the house.

John Wilson, excise officer, was at the Seven Stars, Oldswinford, on the 9th August. Saw the elder Davies go up stairs, load a double-barrelled gun, and his son went with him, holding a candle. Witness said "For God's sake Davies don't shoot – you'll get your neck stretched." Davies was standing at the top of the stairs when he loaded the gun, and his son (the prisoner) handed the ammunition to his father. The elder Davies went into the front room and fired. The prisoner went with his father into the room. Just afterwards the elder Davies ran down stairs and said he had been struck on the head

with a stone. The prisoner followed his father down stairs. Witness said to the prisoner "You naughty boy, how can you do so!" and he answered, "It serves the ------ right, go into them father." They reloaded the gun, went up the stairs, and fired again. Witness asked the father not to shoot them, but he answered as before.

Cross-examined by Mr. Kettle. – Went out of the house by the back door, being much excited, and heard one report then. When witness first saw Davies that night he came to the door and knocked some one down with a stick. The witness, after some difficulty, showed in the model of the premises the back door and the place where he saw the elder Davies after the shooting. Witness did not go up stairs because Davies threatened to shoot him, and left the house as soon as he could. Believed a policeman came to him respecting the matter. Had not given information before to the police.

Re-examined – Did not know any one was killed on the night of the 9th of August.

William Pardoe, deposed he was passing the Seven Stars about half-past nine on the 9th of August with his wife. David Davies opened the top window and fired a double-barrelled gun, which killed witness's wife. Heard shots – five in all.

Mr. Harding, surgeon, Stourbridge, deposed he made a post-mortem examination of the body of Mary Pardoe and found a gunshot had struck the large vein just where it entered the heart, which caused instant death.

John Sparrow deposed that he was near the Seven Stars and saw David Davies fire a double-barrelled gun, which killed woman by the first shot, and afterwards wounded a man. Davies leaned out of the window.

Cross-examined. – Saw Davies in the room loading the gun, and come forward to the window to fire again; saw no one else in the room.

Re-examined. – There was a light in the room, which seemed to come from the door.

By a Juror. – He loaded a double-barrelled gun, saw him put in the powder and shot.

Thomas Lawley, sawyer, was near the Seven Stars and saw Davies come to the window, open it, and fire two shots, saying "Here's into you, you -----." There was a light in the room when he came to the window, but it went out of the room again when he had fired.

Cross-examined. – Saw the light as soon as Davies came to the window. Saw Davies reloading the gun, but did not see him put any charge in it.

By Mr. Keating. – Thomas Hall saw the firing, and a light come into the room. Saw Davies reload the gun.

John Sparrow recalled by Mr. Kettle. – After the first firing witness went into Moreton's garden, on the opposite side of the road, on a level with the room Davies was in.

The evidence for the prosecution being closed, Mr. Keating addressed the jury for the defence, endeavouring to show that the elder Davies only was criminally responsible for the murder.

Mr. Justice Coleridge summed up at considerable length, very carefully and elaborately reviewing the evidence.

The Jury consulted for some time and returned a verdict of "Not Guilty."

The court then adjourned.

Four years later, David Davies, senior, was again brought before the Court for retrial.

WORCESTER HERALD, 19 JULY 1856

THE MURDER AT OLDSWINFORD.

Summer Assizes

DAVIES, David, aged 50, publican, was placed at the bar, charged with the wilful murder of Mary Pardoe, at Oldswinford, on the 9th of August 1852.

The circumstances of this case will be recollected by our readers, and are alluded to in the Judge's charge. The facts were these – In the month of August 1852, the prisoner, David Davies, was landlord of the Seven Stars Inn, Oldswinford; and his son, David Davies, lived with him. On the 9th of that month there was a disturbance caused at his house by some railway labourers, and old Davies, failing in quelling the row, and being struck by one of the men, became much excited, and rushing into his house, ran upstairs, saying, "Here goes to blow their bloody heads off." He then loaded a double-barrelled gun with powder and shot, the son assisting and encouraging his father. An excise man, named Wilson, tried to cool him, and said "For God's sake, Davies, don't shoot;" but the prisoner threatened to "blow his brains out" if he interfered. He then went to a front room looking into the street (his son accompanying him and carrying a candle), and fired both barrels of the gun out of the window at the crowd, saying at the same time, "Here's into ye, ye b------s." The prisoner Davies and his son were bought up for trial at the Worcestershire Spring Assizes of 1853, before Mr. Justice Williams. Davies then behaved in a most extravagant manner, tearing his hair and talking incoherently. A jury was therefore, sworn to try the question of his sanity, and several medical gentlemen, and the governor of the county prison, Mr. Stable were examined. Dr. Malden and three other medical men were inclined to think he was capable of pleading, and thought the symptoms of insanity were assumed. The governor of the gaol and other witnesses had noticed a gradual increasing restlessness and excitement since his incarceration, and Dr. Jeffery considered him insane. The jury on that occasion found that he was of unsound mind, and he was ordered to be kept in a lunatic asylum during Her Majesty's pleasure. He was so confined until the spring of the present year, when he was reported by the medical officers of the asylum to be sane, and was accordingly transferred to the Worcester County gaol, to take his trial on the capital charge at these assizes. The prisoner, when arraigned, seemed perfectly conscious of his awful position, and was much affected. He appeared quite sound and healthy, and in every way acted rationally, in conversing with his solicitor and counsel. He was dressed in a suit of black, and bore a very respectable appearance.

Mr. Huddleston, in addressing his Lordship, said that he and Mr. Powell appeared on behalf of this unfortunate man, who would have been tried four years ago for the crime of murder, but was adjudged to be unfit for the trial on account of his alleged insanity. He (Mr. Huddleston) had consulted with his learned friend, and they were of opinion that although the death of Mary Pardoe must be attributed to the act of the prisoner, yet, under all the circumstances, it must eventually resolve itself into a case of manslaughter. The prisoner was now quite recovered, and was desirous of withdrawing his plea, and pleading guilty of manslaughter. No evidence would therefore be offered on the charge of murder.

His Lordship then directed the jury to find the prisoner not guilty of murder, and he having pleaded guilty of the manslaughter was then sentenced to two years imprisonment, the learned Judge adding that he named that period in order to give a full opportunity of asserting whether the prisoner had really recovered his senses or not. If it should be found that he had entirely recovered he would probably be discharged at an earlier period.

THE MURDER OF ANN MASON AT DUDLEY

BERROW'S WORCESTER JOURNAL, 21 JULY 1855

MEADOWS, Joseph, aged 23, whitesmith, was indicted for the wilful murder of Mary Ann Mason, (who was said to be 17 years of age) at Dudley on the 12th May.

The prisoner was a short, thick-set man, about 5 feet 4 inches in height, with a pale complexion, no whiskers, and a wild restless eye. He was dressed in a dark-brown mixture coat, buttoning closely, a black silk neckerchief, and dark trousers. Although apparently conscious of the awful situation in which he stood, the emotion, which he displayed, was by no means commensurate with it. When called as to how he pleaded, he said "Not guilty."

Mr. Huddleston prosecuted, and very briefly stated the facts of the case. The prisoner had been anxious to pay his addresses to a young woman, a domestic servant, named Mason; but circumstances having come to her knowledge not very creditable to his character, she declined his acquaintance, and took a situation at some distance away in order to avoid him. He however found her out, that she was in service at the "Sailor's Return Inn", Kate's Hill, near Dudley, and paid her several visits there, but without effecting any change in her determination. Early on the morning of the 12th May, the prisoner, actuated either by jealousy or revenge, obtained a gun from the house of his master, loaded it, and proceeded to the Sailor's Return, but it did not appear that any conversation took place between him and the deceased. There was some other men in the kitchen at the time, while the deceased and her mistress were cleaning the room; the prisoner took the opportunity of the temporary absence of the mistress and the inattention of the men in the room to fire the fatal shot, which almost instantly took away the young woman's life.

Mr. Cresswell, who was with Mr. Huddleston, then called –

William Ingram. – I am a miner at Kate's-hill, near Dudley. On the 12th May, between seven and eight in the morning, I was at the Sailor's Return, with William Robinson. Prisoner was there, sitting in a corner between a window and the fire-place, the mistress and the servant were mopping the house at the time. The report of a carbine arrested my attention. I went to prisoner and said "Oh, you rogue, you have murdered that wench; you have shot her." The girl had fallen on the floor, and prisoner was in the corner; he said "I have got another revolver in my pocket," I remained with him, and sent for a policeman.

Cross-examined by Mr. Kettle, for the defence. – It was after eight o'clock when we first went into the house. We went into no other part of the house but the kitchen. The prisoner had a cup of ale by the side of the fireplace. The mistress had just left the

kitchen when the carbine was fired. I was perhaps about half an hour in the house before the carbine was fired. I had not seen the carbine before. Prisoner sat on a screen, but I and Robinson sat on chairs.

Mary Hunt, wife of the landlord of the Sailor's Return. – Prisoner was at our house on the 11th May, about ten at night. Mary Ann Mason was in my service. She passed as his sister, and had been nearly seven weeks in my service. When he came in on Friday evening she went on with her work, and did not speak to him. On Saturday morning, shortly after seven, he was in the kitchen, and had a pint of ale. He remained in the kitchen. I had been helping to clean the kitchen with Mason. I went out of the kitchen for a bucket of water, and when I came to the door I saw the prisoner levelling a carbine, and the flash came in my face. Prisoner was standing at the time. I called the master. The girl fell towards me, and breathed about 13 minutes, and then died. The shot had struck her under the left ear. My husband came in and collared the prisoner. The only words I heard the prisoner say were, "Now I am satisfied." There was nothing insane in the prisoner's conduct or observations.

William Robinson was at the Sailor's Return between eight and nine o'clock. I sat against the window in the tap-room. The mistress, the servant, and the prisoner were there. I was about a yard from him. I heard a report, and turning round saw the girl fall. The carbine was on the floor by me. Prisoner picked it up, and I took it from him.

Cross-examined. – Deceased was in a stooping position, mopping the room. When the shot was fired, he was about six or seven feet away. I turned round instantly I heard the report, and saw the carbine.

Joseph Jewkes, Police superintendent at Dudley, was called in by Robinson on the morning in question. Took prisoner into custody, and saw that the girl had received some shot wounds near her ear. Mr. Meredith, surgeon, was in attendance. I produced the carbine. Charged the prisoner with having shot his sister. He said "I did. I've had my revenge; I've heard 'em say revenge is sweet. I left home for that purpose; I've done it, and now I'm satisfied." I searched him and found a shot and powder flask, the shot weighing 3¼ oz., and the powder nearly ¼ oz., and there were some copper caps. On the road to the station he said, "It's not my sister; it's a young woman I followed for about ten months. I was determined if I couldn't have her no one else should." I said "It's a pity you were not prevented, there being two men in the kitchen." He said, "They hadn't a chance; I pulled the carbine from behind my back and fired it off in an instance; I threw it down to pick the girl up, but I was prevented."

Cross-examined. – I have repeated these observations partly from memory, and have partly revived my recollection from an inspection of the depositions a few days ago. I have seen no depositions but my own. I will positively swear he said, "I left home for that purpose."

William Hunt, landlord of the Sailor's Return, deposed that the prisoner first entered the house about ten minutes before seven. When witness heard the report, he ran into the kitchen and collared the prisoner, who said, "I've done what I intended to do."

Cross-examined. – Saw nothing peculiar in the prisoner's conduct on the previous night. When something was wanted in the kitchen, the girl asked her mistress to go in instead of her, as she did not want to see her brother, who had caused her parents many a score of hours of uneasiness. I said he was the biggest sawny (a simpleton) I had ever seen; he would not drink out of the glass I took him, but wanted a larger one. I saw nothing mad about him. He drank his ale, and asked me to drink with him.

Joseph Rann. – I am a whitesmith at Round Oak. Prisoner was articled to me for four years, of which two years are expired. On the Friday night he did not come home till two on Saturday morning, when he seemed intoxicated. I left him on the sofa. Next morning I went downstairs at seven, and he was gone. Afterwards I went to the gaol, and saw him. I said, "You've done for yourself now," and he said, "I intended to do it before I started." The carbine is mine, and so are the powder-flask and shot case.

Mr. Johnson, surgeon, deposed that the wounds inflicted had occasioned death.

This was the case for the prosecution.

Mr. Kettle then addressed the jury at some length, and with much earnestness for the defence. He was certain they would feel a manly thankfulness to him if he showed them a path by which they might escape from giving a verdict, which would consign the prisoner to a painful and ignominious death. For this end, he begged them to accompany him through his analysis of the evidence. The testimony divided itself into two kinds – first, of words spoken, and then of deeds done. There were no words spoken till after the flash of the gun, but he would consider the words first. Having commented on Mrs. Hunt's being called now for the first time as a most serious disadvantage to the prisoner, he observed that words were always depended upon memory, and, however conscientious those who related conversations might be, they often fell into mistakes, as the jury might very well gather from the deportment and manner of the witness Jewkes. On the night before, the prisoner was in such a state of idiotic inebriety that he could not find the way to his own bed. He had a drink again at seven o'clock in the morning and was as if his life depended on his drunken utterances that morning? There was no evidence that there was any extraordinary attachment on the part of the prisoner to the deceased girl. But if that was so, there certainly were evidences that that attachment was reciprocated. She was a well-conducted girl, and as such could only have deceived her master by representing herself as the prisoner's sister for the sake of having favoured interviews with him. The prisoner took the carbine not loaded, but with the ammunition and caps for loading it, not for the purpose of assassination, but with the intention of loading the gun before the girl, and threatening in his drunkenness, to shoot himself, for the purpose of obtaining, as he said to one of the witnesses, an answer from her. Up to the very commission of the act everything tended to show that he did not intend to take away the life of his sweetheart. On this theory he left the matter to the jury; he would add nothing to the distress with which they must necessarily discharge their duty, but he was sure that they would be thankful to him if he had shown them they might escape from the responsibility of returning a verdict against the prisoner which would involve the loss of his life. He left the matter in their hands with perfect confidence.

The learned Judge then digested the evidence. He set aside the objection to Mrs. Hunt's evidence. His Lordship then went through seriatim the whole of the evidence of the various witnesses, remarking that there was no proof of any acts or words on the part of the prisoner that indicated insanity. As to Jewkes's reading a copy of his depositions, the rule of law was that every witness had a perfect right to refresh his memory by referring to that account of a certain transaction, which he had made when it was fresh in his recollection. With regard to the alleged intoxication, that, if proved, would be no answer to the charge, though in some cases it might be a ground for mitigation of punishment. In this case, however, there was not a shadow of evidence that the prisoner was intoxicated at the time of the murder. There appeared to be no doubt of the prisoner having fired the gun, and it was for the jury to say whether that act had been done wilfully, and by deliberate intention.

His Lordship's address entirely removed every prop of defence – weak as it necessarily was – from the case, and in about one minute after its close the jury returned a verdict of GUILTY.

The Judge then put on the black cap and said – "Joseph Meadows, you have been charged with the dreadful murder of Mary Ann Mason, to whom you appear to have been for some months attached. You have been defended by the ability and eloquence of learned counsel. You have at last been convicted by an attentive and impartial jury; and I will only say it is one of the clearest cases which, according to all experience I have ever had, or by my reading become acquainted with, that ever appeared for decision in a criminal court. You appear to have taken offence at some part of the conduct of that poor girl. It may be that the expressions that were dropped to the relative to the payment of a weekly sum by you towards your illegitimate child may throw some light on what has occurred in this sad transaction. It may be that, on her becoming acquainted with that part of your conduct of which she had been previously ignorant, she may have expressed a determination, which led you to do this deed. There can be little doubt that you were set on this dreadful course the night before the event happened. You rose in the morning, and proceeding from your master's house, armed with a deadly weapon, you took the opportunity when the mistress was absent and the two guests in the kitchen inattentive, and you fired the fatal shot which in a few moments deprived her of existence. It only remains for me to pass on you the awful sentence of the law, and that is, that you be taken to the place from whence you came, and from thence to the place of execution, where you will be hanged by the neck until you are dead; and that your body shall be afterwards interred within the prison where you shall have last been confined previously to your execution."

The prisoner, on hearing his awful fate, displayed no emotion beyond what might have been expected of a person who had been convicted for the first time of a theft or other petty crime; and making no observation, he rapidly disappeared down the stairs to his cell.

The Court rose before six o'clock.

WORCESTER HERALD, 11 AUGUST 1855

Execution of Joseph Meadows for the Murder of Ann Mason
During the week the excitement remained, with the space in front of the prison being daily thronged like a fair with idle and curious people.

Eight o'clock on Saturday morning was fixed for the execution. Soon after daylight, people began to assemble in the space in front of the gaol and in the Infirmary Walk. Some of these had evidently come from the country, but the most were plainly residents in the city. By seven o'clock about a thousand had congregated, and from that time a continued influx of spectators arrived till eight, but the crowd was not so great as on the former occasions, and to the last there was plenty of room on the gaol side of the road for persons to pass freely along. The middle and opposite side of the road, however, were crowded, and every spot commanding a view of the dismal drop was occupied. From the roof of the prison, when the fatal moment drew near, the scene was strangely peculiar. In every direction the ground was covered with people with their faces directed towards the scaffold in anxious anticipation. The concourse was chiefly made up of males of the working class, and militiamen, the red coats of the latter glaring very distinctly

amongst the darker attire of their neighbours. Several individuals were pointed out to us as having come from distant parts of the county, and remained perseveringly in attendance in Salt Lane day after day, in order to be present at the execution. Within the gaol, the prisoners, male and female would be drawn up in lines in exercising yards that commanded a view of the drop, all having their eyes riveted upon that gloomy looking instrument of death.

The place of execution was the roof of the gaol between the front entrance tower and the tower at the eastern corner. In the erection of the prison, a proper position for the drop was not provided, and the erection of a platform of considerable extent was necessary. Access was gained to it by stairs to the top of the entrance tower, and an inclined plane of planking from the top of that tower down to the lower roof, on which the platform was built. During the Friday night the drop was erected upon this platform, and now stood out against the summer sky a most melancholy and dreary looking object.

The convict since his sentence had been confined in one of the day rooms in the centre of the prison, securely ironed by the legs to a strong column of brickwork that supports the roof. His chain permitted him a few yards of movement about the area. A warder remained with him night and day, and towards the latter end of the week two were present nightly in the cell. His last night of life was passed upon his bed, but sleeplessly. At five o'clock the next morning he took a breakfast of tea and bread and butter, with a good appetite. About half past six he was visited by the chaplain, with whom he conversed upon his approaching end, and prayer was offered up. The minister then retired for a short time, and at a few minutes to eight he again went into the room to deliver the last words of exhortation and hope. The prisoner never expressed any feeling of assurance that his sins had been forgiven, but he seemed to hope confidently for the reception of mercy through the merits of Christ. He frequently uttered the words, "Jesus, Son of David, have mercy upon me!"

A few minutes before eight o'clock the convict was led from his cell into the yard. He was pale, calm and collected, and dressed in a brown vicuna coat, a grey cloth cap, a pair of black cloth trousers, and waistcoat, black woollen gloves, and blucher boots. The lower buttons of his coat were buttoned. With one hand he supported the fetters with which his ancles were bound, and with the other he held a dark silk handkerchief before his mouth and the lower part of his nose. A procession was then formed, a number of javelin men in front; Mr. Walker, of Upton, the Under Sheriff, and Mr. Tymbs, of this city, acting Under Sheriff, bearing wands, following next. Mr. Stables, the governor of the gaol carrying a wand, followed, and the Chaplain in his gown, reading sentences from the burial service. Immediately behind the Chaplain came the prisoner, with a prison officer on each side, and two more officers closed the train. The prisoner walked with a firm steady step. On arriving at the entrance tower, the persons composing the procession proceeded singly up the narrow stairs of the tower till they arrived at a landing, which is called "the pinioning room."

Here Calcraft, the executioner, was waiting to receive the culprit. The prisoner was motioned to sit down upon a folding stool, and on his immediately complying; the officers of the gaol unlocked and removed the irons from his legs. Then Calcraft went behind the prisoner and pinioned his arms behind him with a strap. Next he removed the prisoner's neck tie, and thrust it inside the wretched man's coat. The prisoner here, in a low tone requested Calcraft to button the coat to the top, which the executioner

accordingly did. These preparations made, he was conducted in the same manner as before to the top of the entrance tower. Whilst ascending the steps he requested Calcraft to be as quick as he could be over the work, and walked on as steadily and composed as before. Calcraft replied that it should not take a minute. As soon as the spectators outside caught sight of the criminal, a loud murmur of conversation arose, which almost instantly subsided, and the crowd remained nearly silent, every eye fixed upon one object. The Chaplain accompanied his charge to the foot of the drop, and then retired from the platform. The prisoner scarcely glanced at the crowd, but mounted the steps of the scaffold firmly by the side of Calcraft, who went up between the prisoner and the outside spectators. Then he placed the doomed man under the beam, and quickly performed the usual duties. The prisoner stood with his back to the populace. Calcraft receiving from the prisoner another request that he would make it as short a business as possible, shook hands with him, descended from the drop drew the bolt and ended the life of the unfortunate culprit. Amongst the crowd there were some suppressed screams and moans and great sympathy was shown by the female prisoners within the walls. It was as near as possible to eight o'clock when the drop fell, and in a few seconds all signs of life had departed from the body. Scarcely a struggle could be seen, and it is supposed that his death was instantaneous. Calcraft reported that when at the last moment he shook hands with the convict, he could detect no weakness or tremor in him, and is of the opinion that the convict felt less agitation and excited than many of those whose duty brought them to the scaffold to see the law carried out.

The body remained suspended an hour, at the end of which period it was taken down and placed in a coffin without removing the clothing, and during the day was buried within the precincts of the gaol, immediately by the side of Pulley, the last person hung at this gallows.

The crowd, which had behaved with the greatest propriety during the whole period of the gathering, quietly dispersed as soon as the body was removed from the beam.

We are informed that the unhappy man was a native of Milton Keynes, his parents died whilst he was a child, and after their death an uncle took upon himself the rearing of him and other members of the family. When Meadows was old enough to go to work, he was placed with a blacksmith near Newport Pagnell, but shortly after left, and being somewhat of a roving disposition, and came to Worcestershire, where he found employment at a Mr. Hill's shoeing smith, at Netherton, near Dudley, with whom he stayed some time. Next he obtained a situation with Messrs. Keep and Watkins, spade makers, Stourbridge. During his residence in Stourbridge he formed an acquaintance with a young woman named Kimberley, the result of which was an illegitimate child. Some time after the birth of this child, Meadows was summoned before the Magistrates as the father, and he was ordered to pay 1s. 9d. per week towards the maintenance of the child. Subsequently he neglected to comply with this order, and a warrant having been obtained against him by Kimberley, he was taken into custody and committed to the County gaol for a month. When he obtained his 21st year he articled himself for four years to Mr. Rann, a white smith at Round Oak, and made considerable progress in the business. He lived in his master's house, and was well treated, but his habits were dissipated and irregular, and he frequently stayed out late at night. It was during his stay with Mr. Rann that he became acquainted with Mary Ann Mason, a young woman then in the service of Mr. Comoli, at Dudley, but a native of Woodside, near Dudley, and the acquaintance soon ripened into courtship, though it is probable that

the woman's affection was checked in its development by discovery that the disposition and habits of her lover were not as would lead to happiness in the married state. Mary Ann Mason, towards the latter end of April last, moved from her situation to another, at the "Sailor's Return," Kate's Hill, near Dudley, probably with the intention of avoiding his visits. Meadows, however, followed her to this house and visited her several times; on such occasions he passed himself off as her brother, the woman herself assisting in the deception. At length, perhaps from receiving indubitable intelligence of his former liaison with the female at Stourbridge, she evinced a determination to break off the courtship. This conduct on her part appears to have produced a powerful effect upon his mind, and having brooded upon the matter until disappointed love and jealousy rendered him furious and utterly contemptuous of life, he sought her presence and committed that foul deed for which he has now suffered so shocking expiation. The Sailor's Return is a very respectable house in the best quarter of the district called Kate's Hill.

The grave of Mary Ann Mason can be found in the graveyeard of St John the Evangelist church, at Kate's Hill. It is said that it is the only known grave in England of a murder victim that names the murderer. The inscription reads:

ERECTED
BY
VOLUNTARY SUBSCRIPTION
To the Memory of
MARY ANN MASON.
who was murdered by Joseph Meadows
on the 12th of May 1855
Aged 17 Years.

THE MURDER OF DAVID TAYLOR AT QUARRY BANK

WORCESTER HERALD, 15 MARCH 1856

At Quarry Bank, in the neighbourhood of Brierley-hill, on Sunday evening last, David Taylor, nailer, twenty-one years of age, met with his death under circumstances which threaten to lead to the most serious consequences, three men, father and sons, are now in custody on a charge of committing the murder, they are Josiah Chivers, aged fifty-nine, Joseph Chivers, aged thirty, and Josiah Chivers, aged twenty, the two sons of the first-mentioned. It seems that somebody had been "larking" with a cart in which old Chivers and his youngest son had come to visit Joseph, and left at his door. The Chiverses ran out to chastise the mischief-makers, and several persons collected around. A witness, named Morris, saw Joseph Chivers run at David Taylor and knock him down, and fall upon him, and remained upon him for four or five minutes, exclaiming, "D--n him, I'll murder him." Morris saw Joseph Chivers strike the deceased while upon him, but he could not see whether there was anything in his hand. The deceased cried "Murder." When Joseph Chivers immediately after getting up from him said, "I'll stop the b------- hooting murder." The brutes all went away, leaving Taylor dead or dying in the street, and there he lay until a policeman discovered him lying dead in a pool of his own blood. The inquest on the body of David Taylor was concluded on Tuesday last, at the Royal Oak, Quarry Bank, and the jury returned a verdict of "Wilful murder."

At Stafford Assizes, Joseph Chivers, aged 30, miner was tried for the wilful murder of David Taylor, on the 10th March, 1856 at Kingswinford. [Quarry Bank was part of the Kingswinford Parish at this time.] On Sunday night, the 9th March last the prisoner was at home with his father and mother and brother who lived on the road leading from Cradley-Heath to Brierley-Hill. At a little after twelve o'clock a party passed the door of the house, and some of them did something, which provoked the prisoner to come out. There was a cart near the road, and some of the party had taken it and pushed it up against the door. The prisoner came out, followed the party, and charged one of them with running the cart against the door. A scuffle ensued, in the course of which the prisoner was seen to knock the deceased David Taylor down in the road and fall upon him. He was seen to strike the deceased two or three blows while he was down, and the deceased cried out, "Oh, he is murdering me!" The prisoner was then got off, and his mother, who was also there, said, "Oh, Joseph, I fear you have killed him;" upon which he said, "if I have not killed him I will." The prisoner was taken into custody the same morning, and charged with being in the affray and causing the death, upon which he said it was a bad job the poor man was dead, but he did not strike a blow. A knife was afterwards found in a field near the spot, and from the post-mortem examination it was

clear that the death was caused by some sharp instrument. There were wounds on the ear and temples, a contusion on the left jaw, and a mortal wound in the chest. Some sharp instrument had passed through the ribs on the left side, penetrated the lungs and pericardium, and separated the pulmonary artery, so as to cause immediate death. But at what precise time the man died was not apparent, as for the man's companions, as well as his assailant, ran away, and left him to his fate. He was found at three o'clock in the morning, lying dead by the road-side. The jury found the prisoner guilty of manslaughter. Mr. Justice Wightman, in passing sentence, said he considered the offence one of a very aggravated description, and little short of murder, and the prisoner must be transported for fifteen years.

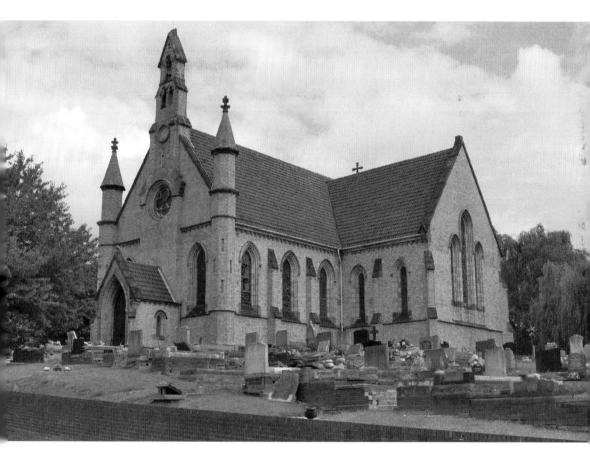

Christ Church is the parish church of Quarry Bank; it was built in the 1840s in what was once a quiet suburb of Brierly Hill. Quarry Bank is within easy walking distance of the busy Merry Hill Shopping Centre. The area's most notable historic event occurred one night during the Blitz, when German bombers dropped two landmines in the town centre. Luckily, the mines failed to go off.

THE MURDER OF ELIZABETH MILLWARD OF LYE

WORCESTER HERALD, 19 JULY 1856

Phipson, John, aged 22, nailer, was charged with the wilful murder of Elizabeth Millward at Oldswinford, on the 27th of June.

Mr. Best prosecuted, and stated the facts of the case. He then called,

Eliza Millward. – I am the daughter of the deceased. I was with her at a nail shop at the Lye on the 27th of June. We were at work. A girl named Mary Ann Phipson was there too; she is the niece of the prisoner, who was also there at work. In the middle of the shop is a place called the hearth; my mother stood on one side and the prisoner on the other. Prisoner was drinking some water, and my mother throwed a handful of slack in his face. She was angry with him. He threw slack in her face, and she returned it. He then took a piece of iron out of the fire and threw it at her. My mother tumbled against the block. The rod of iron had gone all through her clothes and burnt it. She screamed out, and I went to her. Elizabeth Poole then came, and they took her away. I went to fetch my uncle, and when I came back my mother was dead. Ann Woodward was also with my mother.

Cross-examined by Mr. Powell. – I was making a nail at the time. My mother was not standing in her own stall, but by Phipson's block. The slack thrown by my mother was iron fillings, and they were sharp.

Elizabeth Poole. – My nail shop is all but three yards from Phipson's. About three o'clock in the afternoon in question I heard a scream, and went to Elizabeth Millward, who was lying on the ground. I saw she was burnt in the side. I fetched her some water, and she was taken home.

Cross-examined. – It is a very small shop. The slack dust gives very great pain when it is thrown into the eye. The prisoner seemed exceedingly sorry, and almost ready to drop.

Ann Wood. – My nail shop is next to the deceased's. I heard a noise there, and went and saw her bending down, and her daughter had hold of her. In about two or three minutes I got her out of the shop, when she fetched one gasp and died.

Cross-examined. – I spoke to the prisoner, and he said "Its done her no harm, I hope." He never took his eyes off her, and seemed ready to drop. It appeared as if he was swiping something out of his eyes. I have known him from a child, and have never known him do harm to anyone.

Mr. Harding, surgeon, of Stourbridge, deposed that he examined the deceased's body, and found the main blood vessel of the body, (the aorta), wounded. The iron had penetrated between the ribs; but had it struck her cross-ways it would have burnt the skin badly but could not have entered the body.

The learned Judge said there was not a shadow of foundation for the charge of murder; and he therefore directed a verdict of manslaughter.

Mr. Powell stated that he was instructed to say, for the defence that the prisoner was nearly blinded with the dust thrown at him, and in attempting to grasp a lot of slack to return the fire, he inadvertently took hold of the iron and threw it with the slack.

A verdict of manslaughter was returned.

Mr. Turner, Mr. Eveson, and Mr. John Pearson, all residents of the neighbourhood of the Lye, gave the prisoner an excellent character from his early youth.

His Lordship read the prisoner an admonitory lesson as to his conduct in future, and to bridle his passions.

Sentence – a fortnight's solitary confinement.

This is the interior of a small nail shop. Note the hearth, around which other workers would gather. 'Babbies' of young mothers would be reared in the nail shop, and rocked to sleep in their cradles on the bellows. Note also the red-hot rod held by the nailer.

THE MURDER OF SOPHIE OCKOLD OF OLDBURY

BERROW'S WORCESTER JOURNAL, 20 DECEMBER 1862

WORCESTERSHIRE WINTER ASSIZES.

The Commission for the holding of the Winter Assizes for the city and county of Worcester, was opened on Wednesday last by Mr. Justice Mellor, the Judge who takes the Oxford Circuit. His Lordship reached the Shrub-hill Railway Station by the afternoon train, from Shrewsbury and at the station was received by the High Sheriff of the county, Sir. E. H. Lechmere, Bart. The learned Judge then entered the High Sheriff's carriage, and, escorted by the javelin men, proceeded to the Shirehall, where he lunched and robed. He then opened the commission for the county, and afterwards drove to the Guildhall.

The Winter Assizes were additional to the Assizes held in March and July, and were only commissioned when extra work demanded them.

WIFE MURDER AT OLDBURY

William Ockold, 69, tailor, a white-headed old man, was placed upon his trial, charged with the wilful murder of his wife, Sophie Ockold, on the 8th November, 1862, at Oldbury.

Mr. Richards, with Mr. Griffiths, were for the prosecution, and Mr. Benson for the defence.

Mr. Richards, in opening the case, said the prisoner at the bar stood charged with the wilful murder of his wife Sophie, and that he (the learned counsel) was quite sure that the jury would therefore give the case their best consideration. It appeared that the prisoner resided at Oldbury, where he carried on the trade of a tailor. He was, as the jury observed, an elderly man, and his wife, the deceased, was also an elderly person. The learned counsel then went on to state the facts of the case, and said that on Friday, the 7th November, a young woman, named Maria Grazebrook, called at their house and there saw the prisoner at his table working and the old woman on the floor. The latter appeared in great pain, and she had for some time past been suffering from disease of the kidneys, or some other ailment. The young woman offered to make her some tea, but she declined the offer, and the prisoner said "No, she wants to go to bed and groan, to keep me awake all night, as she did last night; but she shall not keep me awake again tonight." The same evening, the son and daughter-in-law of the old people went to the house, and carried the old woman to bed, as she was unable to get upstairs by herself. After which they left. About three the next morning, a policeman, who was passing the house, heard the prisoner apparently in the act of beating his wife. The prisoner was

heard to curse and swear, and sometimes afterwards a man, who was going to his horses, heard the prisoner using violent language, and the old woman say, "Oh, Bill, Bill you'll kill me for my poor head is ready to split."

The first witness was then called.

Maria Grazebrook, who said I am a servant to Mrs. Woodall, who keeps the George and Dragon public-house in Halesowen-street, Oldbury. I know the prisoner and I know his wife Sophie. I call them grandfather and grandmother. I have known them four or five years. On Friday, the 7th of November, I went to their house, and saw the deceased. She was sitting on the floor with her head on the bench. She was groaning very much and appeared to be in very great pain. I asked her if she could take a cup of tea or some broth, and she said no. The prisoner said "No, her does not want drink, her wants to go to bed that she may lie groaning and keep me awake again as she did last night, but her shant again to night." On the following (Saturday) morning, about twenty minutes to nine o'clock, I again went to their house. Prisoner was sitting on the table sewing. I said "good morning grandfather, how is grandmother this morning." He said, "I don't know." I asked him where she was, and he said, "I don't know." When he said that, I noticed his hand was bruised and stained with blood. I then said what's that. He studied a little while, and then said "it's from giving her a punch in her mouth." I said, "giving her a punch in the mouth, whatever did you do that for, she was ill enough without you doing that." He said, "For going off and getting drunk with that Jack Hadley. I said, "Why you know she was not able to walk across the house, let alone go and get drunk." He said, "Well her was quite drunk, and I didn't know about it till this morning." I then said, "Where is she?" and he said, "I don't know." I said, "Is she in bed?" he replied, "I don't know." I went towards the stairs, he said, "You ban't going upstairs," and I said, "I don't want to." I then called "grandmother" four times, but received no answer. I then ran upstairs, but when I was half way up, he said, "Come back." I said, "I shan't, and went on. When I got to the top of the stairs, I saw Mrs. Ockold lying on the floor. Her face was covered with blood. She lay on her back, with her face uppermost. Her head was towards the window and her legs towards the stairs. Her right arm was bruised very much, and the skin was off it. The blood upon her face was getting dry. I touched her leg, and then ran downstairs, for her leg was cold. When I got down, I saw the prisoner, who was sitting on the table, and I said, "You old brute, you have killed that old woman." He said "Her ain't dead, is er?" and I said, "She is, though." He said "Her is not dead, her's only asleep" I said, "Yes, her is quite dead." He replied, "Her's only asleep." And I said, "She'll never wake up again." I then ran out and fetched Mrs. Weston and Mrs. Woodall, who went up part of the stairs till they could see the body, and Mrs. Weston ran away, she becoming frightened. Mrs. Woodall and I stood at the door. The prisoner then went upstairs, and Mrs. Woodall and I heard something dragging along the floor. He remained about four minutes, and he then came down and stood in the chimney corner. Mrs. Weston then came back with her husband, and whilst Mr. Weston went upstairs, prisoner went into the pantry and washed the blood off his hands. I then fetched Simmons, the policeman, and Mr. Cooper, the surgeon, and just before Mr. Cooper's coming I went upstairs again. Simmons went up too, and we saw the body lying on the bed. I picked up some grey hairs, like the old lady's. There was about a handful. Simmons, after going upstairs, took the prisoner into custody. On the table where the prisoner was sitting, I saw part of a mopstick. It had the appearance

of having been split off recently. It was the part of the stick where the mop had been attached. At times, the old people did not agree.

Re-examined: I picked up the hair in the presence of Mrs. Weston and Mrs. Woodall. Prisoner's hand had blood on it before I heard the dragging on the floor above.

Thomas Ockold, was then called: He said, I am the prisoner's son. I remember going to my father's house on Friday evening, the 7th of November. It was hard on seven o'clock when I went there. I saw the deceased, my mother, who sat on the bench and had her head on the table; she appeared to be very ill. Prisoner was getting her a cup of tea. My wife went upstairs and made the bed for deceased, and I held deceased head back as she could not hold it up herself, while my wife poured some tea down her throat. Deceased said something about having had a stroke. She was quite sober, and I carried her upstairs. When we got her upstairs we undressed her and put her to bed, she could not walk, and I carried her upstairs very easily. As soon as we got her into bed, Mr. Cooper's assistant came, and I then went downstairs. Prisoner was standing by the fire, and he said if her lived to the 3rd of May she would have been married to him fifty years. The following morning I was fetched to the house, and got there about nine o'clock. The body of deceased was then lying on the bed. The policeman came shortly afterwards and took possession of the premises.

Cross-examined: Deceased was my own mother. On the Friday evening the prisoner seemed kind in his manner to deceased, and he said he hoped she would get better.

Lavina Woodall said: I am landlady of the George and Dragon public-house and on Saturday morning, the 8th of November, Maria Grazebrook fetched me into the prisoner's house. Prisoner was standing by the fire, and I asked him if we might go up and see the old lady, and he said "Yes, you may go up if you like." We then went up, and I saw Maria Grazebrook pick up some hair. It was woman's hair. She gave me the hair, and I gave it to Mrs. Weston. The old man's hair is lighter than the old lady's was, and the hair that was picked up resembled the old lady's. There was blood on the steps. I observed that there was a sever blow on deceased's temple. There was blood upon one of her arms and the skin was off, I saw part of a mop's stale on the table, which appeared to have been freshly broken.

Hannah Forrester, landlady of the Royal Oak public-house, Oldbury, said: I know the prisoner and knew his wife, and I recollect that on Friday night, the 7th at about ten o'clock, he came to my house and had some beer. He said, "You don't know do you that our old woman is very ill." I said, "No," and he said, "Yes, she is very bad indeed. The doctor has been to see her twice, and is coming to see her to-morrow morning again; that does not look as if she is very well," I said, "No, I think it is very dangerous," and he said, "I think it will soon be all over with her." He finished his half pint of beer and went away. On the following morning, at about twenty minutes to eight he came to our house again, and he called for half a pint of beer, and I asked him how the old lady was. He said, "Oh, I have laid her straight upon the floor." I replied, "she is not dead, is she?" He said, "No, but I've give it her." I said, "What for?" and he said, "Why, bad as she was yesterday afternoon, she got up and dressed herself, and went off along with that Jack Hadley and she got so drunk she could not find her way home, and when she was at home she did not know where she was." I said, "Oh, you should not have done that." Prisoner and deceased frequently came to the house together and drank there.

P.C. Daniel Hutchins said: I am stationed at Oldbury, and was on duty on the night of the 7th and morning of the 8th November, in Halesowen-street. Where prisoner lived

was on my beat. As I passed by prisoner's house I heard him downstairs cursing and swearing and making a great noise, and he seemed to be cursing at someone upstairs. I heard groans upstairs. I went away, and in about ten minutes returned, when I heard someone, whom I believe to be the prisoner, go to the foot of stairs. I listened and heard prisoner mock at the groan. He said, "You ---- old cat; you are very bad I daresay; but I never knew you when you were good," adding "D--- your old eyes, if you don't come down stairs I will ----," but the rest of the sentence I did not hear. It was not the first time, by several, that I had heard cursing and swearing in the house.

Cross-examined: I did not hear any cursing and swearing or groaning till ten minutes past three. I am certain the groans came from upstairs. I did not think it my duty to interfere, as I had so often heard the same sounds before. I am quite sure I heard the prisoner mocking the groans. I had known the deceased and prisoner for two years, and I had heard her use violent language to the prisoner.

Jerimiah Bradley, a labourer, said: I live in Furnace-road, Oldbury, and about four o'clock on the morning of Saturday, the 8th November, I was at my stables. I heard a noise, which came from prisoner's house, and I went to the door of the house. I heard prisoner using very bad language to the old lady. He called her an old ---- The old lady appeared to be downstairs, and I heard her say "Oh, Bill, don't kill me, for my head is ready to split." She said that as many as three or four times.

Cross-examined: I have heard them abusing each other at other times. The words the old woman used were not "Oh, Bill, thou'll kill me." She said "Oh, Bill, don't kill me."

P. S. Samuel Simmons said: I am stationed at Oldbury, and from information I received, on the 8th November I went to the prisoner's house about nine in the morning. I saw prisoner, who was standing in the chimney corner. The house was full of people, and I said to Ockold, "This is a bad job," and he said, "it is." I went upstairs and saw deceased lying on the bed. She appeared to be dead, and the face was covered with blood. I came down stairs, and took the prisoner into custody. Someone in the crowd said, "You naughty old man, what could you have been thinking of to serve the old woman like that?" He said "I did not do it wilfully." I then removed him to the station and charged him with wilfully murdering his wife. He said "I only struck her once." I then made an examination of his person, and saw that there was some skin off the forefinger of the right hand, and before I had spoken he said "I did that against her teeth." I observed the mouth of the old woman, and saw that she had not any teeth. I then examined his shirt and trowsers and found blood on both. I went back to the house and examined the stairs and found blood upon them. There were large patches of blood on four or five of the steps. In the pantry I found part of a mop stale. There was blood on the bosom of the shirt, and on the shoulder. In the station the prisoner said his wife had been drinking along with Jack Hadley, that she had come home drunk, that she would not get up to get him any breakfast, and that he had been at work all night. He said she had been drinking at James's. I know Mrs. James, who is here now.

Cross-examined: I think he repeated more than once that he did not do it wilfully. He did not say where he struck her. I made every search for the remaining portion of the mop stale, but could not find it. I looked in the fire place, but could see no trace of wood ashes.

Mr. Thomas Richard Cooper said: I am a surgeon practising at Oldbury, and in November last I was attending Mrs. Ockold for disease of the kidneys. I remember being fetched to Ockold's house about nine on the morning of the 8th November. When

I got to the house I saw the deceased who was quite dead, but the body was warm. I made an external examination of the body and observed blood, especially over the face. There were several bruises about it, and abrasures of the skin of the right arm. The blood was chiefly on the face, and was partly from the nose and on the right cheek. There were several bruises about the body, some of recent date and some of older date. There was a wound on the right cheek, which went down to the bone. There was extravasation of blood over the whole of the right cheek, and there was an abrasion of the skin on the left cheek. The eyes were dull and congested. There was an abrasion of about three inches on the left arm, and there were several abrasions on the leg. They were of recent date – quite as recent as that morning I should think. The deceased had no teeth, and had not had them for some time. I should say she was 74 to 75, from her appearance. On Monday the 10th I made a post mortem examination of the body. The corresponding muscle on the left side was in a healthy state. I traced the temporal muscle down to the cheek bone. I found the arch of the cheek bone broken. The other cheek bone was healthy. In my opinion the injury to the arch of the cheek bone could not have been caused by a fall. Part of a mop stale would inflict the injuries. I think the deceased was struck more than once. I think the injuries could not have been produced by one blow only. The character of the injury to the temporal muscle was widely different from the injury to the right cheek bone. The disorganization to the temporal muscle might have been done by one blow. The injury to the right cheek certainly could not have been caused by a blow from the fist. The stomach was empty, and I did not detect any trace of beer or spirits. There was an abscess in the kidneys. The cause of death was pressure upon the brain, from an oozing of blood from a ruptured vessel, ruptured by a blow from some heavy blunt substance.

Cross-examined: I should say that when I saw the body deceased had been dead three of four hours. A less degree of violence might be required to break the cheekbone of a person of deceased's age than that of the young person. I am quite sure deceased had no teeth. I think the blow on the cheek would cause death. It would cause the rupture of a vessel in the brain. I think such a blow on the cheek on anyone would be likely to cause death. The wounds on the temple and cheek were very near together. The injury to the temple may have been caused by falling downstairs, but certainly not the injuries to the cheek. The injuries to the cheek might have been caused by a heavy fall against a sharp post. It is possible that a person flung from a higher to a lower level might meet with such an injury.

This was the case for the prosecution.

Mr. Benson then replied for the defence, and in the course of an eloquent address, claimed the sympathy of the jury in the arduous and responsible task that had fallen to his lot. He asked their indulgence to all the suggestions, which he should make to them on behalf of the unfortunate old man whose life was in their hands, but in the interests of justice he called upon them not to be led away from the right path by the thrilling tale of horror, which his learned friend had brought before them. The law was jealous of life, and the law, if wilful murder be the verdict, was inexorable in demanding a life for a life. He contended, however, that in the eye of the law there had been, in this case, no murder. It might be that homicide – a very culpable act of homicide – had been committed, but certainly the prisoner had not been guilty of wilful murder. Let them look over the facts of the case, not as it had been brought before them on the part of the Crown, where every thing had been done to blacken the evidence against the prisoner,

and to conceal that which would speak in his favour – but in a fair and impartial way – not that he blamed the counsel for the Crown, for they had but followed out their instructions. There was always a motive for a murder, but what was it here? Why there was none, positively none, for the death of the poor old woman would absolutely tend to deprive the prisoner of his means of livelihood, for as they had heard from one of the witnesses, the old woman did half his work. He did not ask them, as sensible and reasoning men, to disbelieve that the poor old woman met her death at the hand of this wretched old man, but what he sought to prove was, that he had done no murder. The learned counsel then proceeded to go through the whole of the evidence minutely, criticising every portion of it, and putting it to the jury whether, supposing the prisoner knew he had killed the deceased, was it not extraordinary that he made no attempt at concealment, or that he did not prevent the witness, Maria Grazebrook, from going up into the bedroom, when he must have known that that battered corpse of the poor old woman was lying there. It was utterly impossible that the prisoner could have murdered the woman, then carried her up the stairs, and thrown down his burden on the floor, as he would a bale of goods, for, as they had heard, on the previous night, it required two persons to carry her to her bed. In conclusion, Mr. Benson said the old man now prayed him to make the same assertion as to his innocence of murder that he did when he was first charged with the offence. It was for them to say, seeing the uncertainty of the whole case, whether they could conscientiously come to the conclusion that the case was not one of wilful murder. He suggested there might have been a sudden struggle in the dark in the bedroom, when in a moment of blind rage prisoner struck his wife, and had gone down stairs in ignorance of the awful result. In that case their verdict would be manslaughter only.

The Learned Judge, in summing up, said the jury had already been told by the learned counsel engaged in the case, that a charge of wilful murder was one which required their most careful and attentive consideration. Now, the killing by one person of another was a prima facie murder, unless the circumstances accompanying the transaction, or from evidence given on the part of the accused, was such as to reduce the crime to manslaughter, and he knew of one instance only, where no struggle or contact had taken place between the parties, the law allowed the killing of a man to be reduced to manslaughter. That was when a man finding his wife in the act of adultery once killed her paramour. That was the only case when the crime was reduced to manslaughter where there was no provocation or struggle beyond the using of mere words. In deciding upon their verdict they must consider the provocation given not by words only but by the struggle, which might have taken place between the parties. But if the violence used was entirely on one side, it was murder. He quite agreed with the learned counsel for the defence who had conducted his case so ably, and who had exerted every faculty which man could use, that they must be very careful how they determined as to whether there was any act on the part of the woman. If there had been neither struggle nor contact, and the death blow was given by the prisoner, then their verdict would be one of wilful murder, and he would have to suffer accordingly. They must take care not to jump to a conclusion so fatal to the prisoner to say that he was guilty of wilful murder, unless they were satisfied that there was no conduct on the part of the wife, no struggle or contact so as to induce him to commit an act so deadly as that which he stood charged. The present was about the most important transaction that men could be engaged in, and the jury must deal with the matter fairly and according to the oath they had taken. On the one

hand they must not be led away by any feeling of compassion, which might be excited for the prisoner, not on the other hand by any feeling of indignation. His lordship subsequently went through the whole of the evidence, and in the course of doing so observed that the witnesses had given their testimony very fairly. In his concluding remarks, the Learned Judge said he did not know that he had ever heard a case which was surrounded by more extraordinary circumstances, and he then referred to the fact that when the dead body of the woman was first seen by Grazebrook, the prisoner was quietly sewing. If they believed that the violence used on the night that the woman met her death was not brought about by her in any way they would convict the prisoner of wilful murder; but if, on the other hand, they were of opinion that the deceased's death was brought about by violence on the part of the prisoner with provocation, such provocation amounting to a struggle or a blow, or if death was the result of accident, such as a blow received in a fall, it would reduce the crime to manslaughter.

At half past three, the jury retired from the court to consider the verdict.

After an absence of more than an hour, the jury returned to the Court, when, amid the deep silence that prevailed.

The Clerk said, gentlemen are you agreed upon your verdict. How say you: Do you find the prisoner, William Ockold, guilty or not guilty.

The Chairman: Guilty.

The Clerk: And so you say all.

The Foreman: Yes, but we wish to recommend him to the mercy of the Court, on the account of his age, and in consequence of nothing having transpired during the trial detrimental to his previous character.

Silence in Court having been proclaimed,

His Lordship assumed the black cap, and said: William Ockold, you have been found guilty of the dreadful crime of murdering your own wife, to whom you have been married, by your own account, near upon fifty years. It is a most painful thing indeed to see a man at your advanced period of life convicted of such a crime – a crime against the wife whom you had sworn to love and cherish. The jury have recommended you to mercy, and I shall take care that the recommendation is transmitted to the proper quarter; but I have no power to hold out any hope to you. That power is absolutely vested in the person of the Sovereign. It is only from her clemency that any possible mitigation of your sentence can proceed. Whatever will be the course taken it is not for me to say, and I should be deceiving you if I held out any hopes of a remission of your sentence. I beseech you, therefore to be penitent and by prayer, to apply yourself to the throne of mercy, where you may obtain that mercy which you denied to your poor, ailing, and unfortunate wife; and that the short remainder of your days may be spent in preparing yourself for that doom which awaits you, when you must appear before that Judge before whom you must at last stand. The sentence, which I shall have to pass on you, is the sentence of the law. It is that you be taken hence to the place from whence you came, and that from thence you be taken to the place of execution, and that then you be hanged by the neck till your body is dead, and that your body be buried within the precincts of the prison where you were last confined, according to the provisions of the statute, and may God, in His infinite mercy, have mercy upon your soul.

The prisoner, a good-looking old man, behaved with extraordinary firmness throughout the whole of the trial, which lasted from half-past nine in the morning, till late in the afternoon. He paid great attention to the evidence, and to the address of

the learned counsel who conducted his defence, and the only perceptible change in his countenance took place at the moment when the jury, who held his fate in their hands, came into court. On receiving his sentence, he walked from the dock with a firm step.

Worcester, 3 January 1863
THE PUNISHMENT.
Pending the arrival of the reply to the memorials from Sir George Gray, the authorities, as a matter of course, proceeded with the erection of the gallows. The work was entrusted to Messrs. Wood and Son, and was most efficiently performed. During its progress it was watched by the curious, and every day saw little groups of spectators in front of the gaol. The gallows was erected on the roof area between the east and central tower of the gaol, and as it stood immediately opposite the Infirmary-walk, it was in the best position it could occupy to give room for the crowd of spectators at the execution. The apparatus was of the usual description, consisting of a platform and gangway and drop. Standing out against the grey sky at midnight on Thursday, the profile of the machine was revealed in all its hideousness, and there were a few, if any of the persons who saw it under these circumstances that must have felt uncomfortable at the sight. At the time mentioned, however, there were very few persons present and these rapidly thinned, so that by one o'clock the space in front of the gaol was left to the doubled patrols which the Superintendent of the city Police had thoughtfully put on duty. From that time he was restless and disturbed, getting up two or three times, and appearing to become a little more aware of the dreadful position he occupied. The night was a fearful one for the wind and rain, and no doubt the weather had its affect in limiting the number of spectators from a distance, which on this occasion was considerably smaller than usual. By their appearance it may be inferred that the great bulk of those who came from a distance were residents at Dudley, Oldbury and the neighbourhood in which the murder was committed. It was not till six o'clock this (Friday) morning that the spectators began to assemble, and then only a few stragglers made their appearance, but, as the morning wore on, the arrivals became more numerous, and towards eight o'clock persons of all ages came pouring up in continuous streams. At its greatest the mob – for so we must call it, in the entire absence of any respectable person – consisted of between 4,000 and 5,000 persons, and was remarkable for the number of women in it, being a far greater proportion than we ever before saw at an execution. To make the matter worse, many women and men too, had brought infants and children of tender years in their arms to witness the horrid spectacle.

Between six and seven this (Friday) morning, the condemned man rose from his bed for the last time, and at the usual hour partook of a good meal of tea and bread and butter. Afterwards he was visited by the Chaplain, who remained with him for nearly an hour, exalting him to remember how soon he was to render up his account of all his earthly deeds. All the preparations for the execution being complete, at half-past eight the prisoner was brought forth by the Governor and the officials, from his cell to his death. He wore the same clothes in which he was dressed at his trial, and outwardly there was the same quiet self-possessed air about him which he had all along borne, and very few who have outraged the laws of the country as he had done, and who have had to suffer the stern but righteous sentence, which awards a life for a life, have conducted themselves more firmly on the way of death. On the procession moving, the Chaplain commenced reading the burial service, which was continued until the eastern central

tower was reached, by which means access was had to the gallows. The pinioning room was a chamber just over the gate warden's lodge, and here a halt was made and the prisoner pinioned by Calcraft, the executioner. The culprit underwent the ceremony firmly, but in spite of his efforts, a tear rolled down his aged cheek. He speedily regained his firmness, however, the procession proceeding on its way, and the burial service was continued.

About eight o'clock the attention of the spectators was arrested by the appearance of the Governor of the Gaol and the executioner on the scaffold, which they examined and saw that the preparations were complete. The death bell in the gaol too, began to give out its mournful sounds. At half-past eight a few javelin men, under Mr. Bennett, took their position on the platform, and in a few minutes after the procession appeared. Ockold, followed closely by the executioner walked with a firm step across the platform to the steps leading to the drop, and when he turned his face towards the spectators a shudder seemed to run through all who looked upon him, the feeling found relief in a few smothered groans. The sight of this aged man, with his hard featured and pale face, white hair and whiskers, and spare form, steadily ascending to the drop, and then taking his place underneath the gallows, appeared to have an impressive effect upon the crowd. The executioner at once proceeded to adjust the rope, and with some difficulty, owing to its tightness, drew the cap over Ockold's face. He then shook hands with him, and the criminal's last words to him were, "I suppose I'm going now." As the executioner was descending the steps the sound of a groan from the convict's lips reached the crowd, and there was a cry of "hush" – the stillness of the grave followed. The sounds which fell indistinctly upon the crowd issued from the wretched man's mouth, and to those who were near took the shape of "Oh, Lord, have mercy on my soul! Oh, Lord, have mercy on me! Oh, dear! Oh, dear!" The bolt was drawn and the body fell with a sharp rebound; a hoarse murmur ran through the crowd, and after a very slight movement of the legs and hands the body settled into its position, death being almost instantaneous.

The mob rapidly thinned after this, but the greater number remained till the body was cut down, after hanging the usual time it was then lowered into the coffin at the foot of the drop, and was afterwards buried beside the graves of two other murderers – Pulley, who was hanged in 1849, and Meadows, who was executed in 1855 – in ground within the precincts of the gaol, and situated under the gaol wall which runs along by Easyrow. The culprit died, as was remarked, very easily, but it was found when the body was removed that the halter had cut right through the skin of the neck. Calcraft, who arrived in this city yesterday afternoon, and was accommodated with lodgings within the gaol, left again at about ten this morning for the railway station, en route for Liverpool, where he performs his dreadful office tomorrow, on the person of the condemned culprit sentenced to death at the last Assizes for the murder of a woman. On the 9th inst., another criminal will be hung at Bristol.

The execution of the William Ockold, in 1863, was the last public execution at Worcester, and all public executions ended in 1868. Execution was still the ultimate penalty for murder, which then took place, out of sight of the public, within the precincts of the Gaol.

THE MURDER OF HENRY SWINNERTON OF COSELEY

WORCESTER HERALD, 15 NOVEMBER 1862

MURDER AT COSELEY. – DUDLEY Another murder has to be chronicled to the list of such occurrences that have of late taken place in South Staffordshire. The name of the murdered man is Henry Swinnerton, who was by occupation a shingler and lived in the Darkhouse-lane. Near to Deepfields. His age is about 33. On Tuesday week at Sedgely wake, deceased went to the Three Horse-shoes, Ladymoor, and got intoxicated. On returning home he was waylaid and most brutally used by several ruffians who attacked him on the Blue Button Bridge. They threw him into a hedge, then dragged him out, ransacked his pockets, battered his head with life preservers and sticks, clasped his throat in order to strangle him, and finally left him insensible. They also abstracted from his pockets about 12s. Before leaving they threatened to throw him into the canal and were apparently deterred from putting the finishing stroke to their cowardly work by a person who came up at the moment, crying out that they were known, whereupon they scampered away. The person who came thus opportunely was Henry Kelsey known as "Farral," a young man who had been carousing with Swinnerton at the inn. When Swinnerton recovered he was eventually able to find his way home. He appears to have strictly enjoined Kelsey not to tell where he had been. He could not however conceal the bad usage he had received, and on Saturday afternoon, after undergoing much suffering, he divulged that he had been at a house of ill-fame. Sergeant Costello heard of the circumstance, and at once went in search of the gang, and captured two of the ruffians the same evening. On bringing them before the deceased the latter recognised them as those who had been concerned in so dreadfully assaulting him. Their names are Jesse Wilkes and William Henshaw, of Bilston, both were low characters, and one a brothel-house keeper. He also apprehended two women as being concerned in the savage attack. Swinnerton could not completely articulate, but he plainly showed by signs that he recognised the persons who had injured him. He died from the effects of the attack, and an inquest has been opened.

COSELEY

THE ALLEGED MURDER. – The adjourned inquest upon the body of the young man Henry Swinnerton, who was alleged to have died from a brutal ill usage received from two men on his way home, was resumed on Friday at Mr. Thompson's, Rising Sun Inn, Deepfields, before the Deputy Coroner, Mr. Phillips. As before Mr. Travis of West Bromwich, was present for the friends of the deceased. The evidence of Richard Griffiths, George Colley, Wm. Lea, Isaac Kelsey, and Sergeant Costello, disclosed a

sad state of immorality in the transactions through which the deceased lost his life. Mr. J. F. Griffiths, the surgeon who made the post mortem examination, said he found the lower jaw seriously fractured, the throat much bruised and swollen, and the lungs and brain much congested, the latter being occasioned by inflammation of the bronchial tubes, from which he considered the deceased had died. It appeared to him that the severe injuries about the jaw were caused by some blunted thing, and not fists, and those on the back by attempts to strangle him. He was quite sure that death was not the result of natural agency, but primarily caused by violence.

The jury returned a verdict of "Manslaughter" against Jesse Watts and William Henshaw. Sergeant Costello's prompt and effective action in the matter was approvingly spoken of by the coroner and the jury.

Worcester, 13 December 1862
STAFFORDSHIRE WINTER ASSIZES. – The business of these Assizes were terminated on Saturday last. The calendar was not a light one as it contained three cases of murder; one resulted in a verdict of manslaughter. In the case of the manslaughter of Henry Swinnerton at Coseley, Jesse Watts was clearly the most culpable, and he accordingly was sentenced to ten years' penal servitude; the two women, who appear to have done everything in their power to assist him in his violent treatment of the deceased, were sentenced to six years' penal servitude; while the old man, Wm. Henshaw was sent to prison for fifteen months.

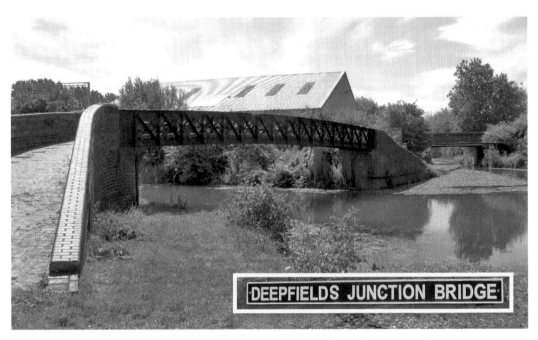

The official name of the bridge above is the Deepfields Junction Bridge. It is one of the original canal bridges situated at the branch of the Coseley Canal to Deepfields. The Blue Button Bridge, where the assault took place, could not be found, and is unheard of in the area. It is possible it was just a nickname at the time (1862), or it could have been the unofficial name of the bridge above.

THE MURDER OF HANNAH THOMPSON OF SEDGLEY

Berrow's Worcester Journal, 3 January 1863

SHOCKING ATTACK OF A FATHER UPON HIS DAUGHTER.

The man, Isaac Thompson, who on the scorching his child to death at Sedgley, awaits his trial at the next Stafford Assizes, has been again apprehended for an attack upon another of his children. In this case, although the child has very narrowly escaped death, the particulars are no less revolting than those of the former one. On Sunday night, about half-past eleven, he returned home, after having been carousing in a public-house till a late hour with his wife. He appears not to have come home with her, for on his arrival he asked his daughter Hannah, a girl about nine years old, "where her mother was." Hannah is the eldest but one of the family, and all the other children were in bed upstairs. She replied that she did not know. He directed her to go and search for her, and the child having done so, returned without finding her mother. He at once seized a poker which is about eighteen inches long, and worn into a sharp point, at the end, and, horrible to relate, thrust it at the head of the child, wounding it to the extent of about three inches and a half. The blow penetrated above the left ear, and passing through the scalp, it is doubtful whether it did not touch the brain. The poor child bled profusely, her clothes being completely saturated with blood. Another daughter, Rachael, the eldest child, hearing the noise, and the groans of her sister, rushed downstairs and sought by her screams out of doors the assistance of a neighbour named Spruceson. A number of people were attracted by the cries and on arriving did all they could for the poor girl, and at once fetched the police, who took the father into custody. The child is in a dangerous condition.

Worcester, 21 March 1863

STAFFORDSHIRE LENT ASSIZES. Child Murder case at Sedgley. – Isaac Thompson was charged with killing and slaying his daughter, Hannah, aged eight years. On Saturday night, December 31st, the prisoner returned home from a public-house, and finding his wife, who was of drunken dissolute habits, absent he in a moment of anger raised a poker and hurled it at the head of the child. The weapon entered the skull, blood flowed profusely, and subsequently death ensued. The jury returned a verdict of guilty, accompanied by a recommendation to mercy on account of the provocation, which the prisoner had received from his wife. The recommendation was taken into consideration, and the prisoner was sentenced to a fortnight's imprisonment, this period to date from the commencement of the Assizes. Upon a second charge of killing another child no evidence was offered, but it would appear that this was a case merely of negligence. It would seem that the prisoner had on a certain night in October taken his child downstairs, and placing it on a settle before the fire, had left it in that position by itself all night. On the following morning the body of the child was found burnt to a cinder.

THE MURDER OF ELIZA SILLITOE

WORCESTER HERALD, 10 DECEMBER 1864

MURDER AT COSELEY

At Stafford, Richard Hale, Collier, aged 30 and Cecilia Baker, aged 30, both residing in Coseley, parish of Sedgley, were convicted of wilfully murdering Eliza Sillitoe, daughter of the former prisoner, about six years of age, on the 20th July last. Mr. Motteram and Mr. Hill conducted the case for the prosecution, and Mr. Browne defended.

The murderers had been cohabitating as husband and wife; their victim was the child of the man by his deceased wife but born before their marriage. On the 20th July last the child was last seen alive; 13 days afterwards a witness of the name of Clarke was walking through the Gravel Hole Fields at Coseley, and he had with him a little dog, which went in amongst the wheat, and Clarke very soon discovered that it had found something, for it refused to leave a certain part of the field, and barking and yelping. Clarke went to see what was the matter, and there found the dead body of Eliza Sillitoe, in a state of decomposition. He afterwards discovered that there was a track in the wheat leading from the footpath at the side of the field to where the dead body lay. Her boots, which were nearly new, had been taken off, and were lying close to her shoulders; her stockings had also been taken off, and stuffed inside the boots. Her little hat was also lying upside down, about a foot from the shoulders, with her hair-net inside. The worms had so preyed upon the body that it was almost impossible from the appearance to distinguish the sex of the child. The witness communicated with Mr. Smith, surgeon, and afterwards with the police. Mr. Smith came at once to the spot, and on attempting to lift the body, the head fell off. From the decomposed state of the body it was not possible for any of the witnesses to say whether the throat of the child was cut or not. All the muscles, integuments, and flesh around the neck had been so entirely eaten off by the worms that it was impossible to say whether it was so or not, the child was perfectly healthy on the day it was missed, and the surgeons ascertained that not a bone in the child's body was broken, and that there was nothing whatever to indicate that any violence had taken place other than the cutting of the throat. When the child was last seen, on Wednesday, the 20th of July, there was a handkerchief around its neck, and on the day when the body was found this very handkerchief was found a few hours afterwards, not far from the body, covered, or to use the expression of the witness, "jellied" with blood. It was found in a place to which it must have been thrown by the hand that last used it. When the handkerchief came to be examined a cut of about an inch and a quarter, made by a sharp instrument, was

found in the corner of it, somewhere about the spot where if the child's throat was cut, the operation would be performed.

The evidence, although circumstantial, was remarkable strong; one witness almost saw the act of murder; several witnesses saw both prisoners close to the spot where the murdered child was found on the day when she was missed; the male murderer was known to have behaved brutally to the child, and to have threatened her life that he might be freed from the burden of maintaining her.

John Jones stated he was an hairdresser, and lived at Coseley. He had known the female for six or seven years: I remembered being in sight of the same field on Wednesday, the 20th day of July. I was in another field close by. It was about two o'clock when I was there on the 20th of July. I saw the prisoners coming up the inside of a hedge bordering the field. The girl was with them. They stopped by the brink of the gravel hole. Hale appeared to make some suggestion to Baker, but she evidently did not agree to it. Hale then went into the gravel hole with the child, and the woman stood by; but they came out, and they then moved from that spot – all three of them – down the hedge-side to the bottom of the field, turning up to the left, and walked into the wheat in the next field. When they got to a certain spot there was hesitation, and Hale having beat down the corn and they sat down. This was 20 yards from the footpath. The child was with Baker, and Baker was sitting down; so was Hale. They were sitting about a yard and half apart. I saw Baker push the child to Hale, and Hale took the child on his lap. The child then got away from Hale, and ran a few paces down the field, and he after it. He brought it back and threw it down. He then knelt down and took a handkerchief from his pocket, and I thought he was bandaging its head. The child shrieked, but the voice became choked instantly almost, and it then cried like a child crying itself to sleep. On getting to the top of the field I put on my glasses and looked towards the place where I had seen them, but they were not there. When I heard where the body was found, I said, "Why that's the very place where I saw a man and woman and child some weeks ago! I afterwards went and looked at the spot and identified it as the very place."

Mrs. Johnson, with whom the murders lodged, said that the prisoner's treatment of the little girl was very bad. She mentioned a particular instance in which he attempted, in a great passion, to kick her, and she interfered. The prisoner said that if she had not he would have killed her. Witness replied, "You shan't kill her in my house. Your love is surely all gone for your child." "It is," said the prisoner, "and was, above a month ago." Thomas Johnson, husband of the last witness, said: The prisoner lodged with me about 13 months. He ill-used his child very much, especially when he came home drunk. He used to say "that if he could get shut of the young ------ he would do so. He said if he had got to be hung, he might as well be hung for the young ------ as anyone else. The last time I saw him ill-use her was about a month before he left our house. She let the poker fall, and he, up with his fist, struck her against the oven. My wife interfered, and prevented him doing further damage. – Henry Green, deposed: I am a puddler, living at Coseley. I remember the day that the child was lost. I know the prisoner Hale. I saw him on that day about four or half-past four, on the road about 400 yards from Mrs. Johnson's. He came to me and asked me if I had seen his child; I said, no. He said he had beaten the child for going to Mrs. Johnson's. I said he should not beat an orphan from going where she was treated like a daughter. He said he didn't care; he would kick every bone out of her hide if she was gone there. I told him if he did he would get in charge of the police. He said he did not care a ---- for the police.

Hannah Baker deposed. – I am servant at the White House, Coseley. On Wednesday, the 20th July, I was coming out of the White House, and saw Eliza Sillitoe, the deceased child. It was a quarter-past two. The White House is about two minutes' walk from the house were Hale lives. The child had a crust in her hand, and was crying. I asked her where she was going? She said, "I am going, and I am not coming back again." She gave no reason why she was not coming back.

His Lordship, in charging the jury remarked that there was no witnesses that actually saw what was done; but if juries waited until the instrument was actually plunged in, or death handed in the cup, there rarely or never would be a conviction of the crime of murder. Having further commented on the evidences, his Lordship remarked that he sincerely wished it were in his power to say more in favour of the prisoner Hale than he had done. As regarded the woman, excepting taking the child and throwing it into Hale's lap, she seemed rather to have been passive in the transaction; but if she were present at the commission of the crime, and knew of it, and consented to it, she was a principal only in the second degree, and she was equally guilty with the actual perpetrator. She would not have been excused by participation with her husband in such an act, still less could she be excused by participation with a man who was not her husband.

The jury were absent about an hour considering their verdict; they returned into Court the verdict of "Guilty" against both prisoners. The man received the verdict with evident, though suppressed excitement. The woman, calm at first, broke down, and gave way to mental agony. Sentence was passed in the usual form, without hope of mercy. The female, having been asked if she had anything to say why execution should be stayed, pleaded pregnancy. A jury of matrons was then called, and both prisoners were removed from the dock. After an interval of ten minutes the female prisoner was brought back, and the jury returned a verdict of "Quick with child." His Lordship then ordered the execution of the woman to be stayed until delivery, or until Her Majesty's further pleasure should be known.

Worcester, 24 December 1864

THE CONDEMNED CULPRITS AT STAFFORD

The execution of Hale, one of the two murderers now in Stafford gaol under sentence of death is fixed for Tuesday next, the 27th inst. Hale, who is under sentence of death for the child murder at Coseley, still persists in declaring his innocence, though it is believed he does this with the dogged determination of an uneducated strong-willed man, and in the hope even yet of obtaining a reprieve. On Monday, Hale was visited by his brother and two other relatives.

THE MURDER OF ALFRED MEREDITH AT WOODSIDE, DUDLEY

Enoch Whiston, a twenty-one-year-old man, employed as a groom by a large firm of Iron Masters at Woodside, had been paying his address, for about six months, to a young lady aged twenty-three by the name of Mary Terry of Commonside, Pensnett. They had saved about £30 and he had promised her another £25. They were planning to get married on Christmas Eve 1878.

Alfred Meredith, aged twenty-four, was a clerk to the company of Hill & Smith Ironmasters, also of Woodside, who every Friday, at the same time between two and three o'clock, took a cheque to the value of about £280 (the weekly wages) to the Birmingham, Dudley & District Bank in the High Street, Dudley, and returned with the cash in a black leather bag with the name 'Messrs. Hill & Smith of Brierley Hill' on the side.

On Friday 6 December 1878, about 2 p.m., Enoch Whiston stood in the Junction Inn at Woodside having a drink, but was preoccupied in looking through the window. At about three o'clock he left the public house and was seen by a number of witnesses to be closely following a man carrying a black bag. At about 3.30 a pistol shot was heard by a number of people, who looked in the direction from which it came and saw a man struggling on the ground and another running away carrying a black bag.

Police Constable Stains, who also heard the report from the firearm, attended to Mr. Meredith, who could not speak, his mouth full of blood from a wound beneath the right ear. He was rushed to Dudley Guest Hospital.

The bag now in Whiston's possession contained about £280, consisting of 164 sovereigns, 90 half sovereigns, £5 notes, silver and copper, which he hid in various places as he made his way to Mary Terry's house at Commonside. At approximately 4.30 a knock on the front door was answered by Enoch Whiston, who was confronted by two policemen. He immediately about turned and rushed to his coat to obtain his loaded pistol. He was immediately seized and secured and charged with highway robbery by Police Superintendent Burton and detained at Brierley Hill police station.

The money was later recovered.

On 12 December Mr. Alfred Meredith died from wounds caused by three lead slugs, and an Inquest held at Dudley Town Hall brought in a verdict of Wilful Murder by Enoch Whiston, who stated he did not intend to kill him. It was clearly a robbery that had gone wrong and in the struggle to obtain the bag he shot him. Nevertheless, it was murder. Whiston was then committed to appear at the Worcester Assizes, where he appeared at the Crown Court before Justice Huddlestone charged with the Wilful Murder of Alfred Meredith. The jury retired and returned after twenty minutes with a verdict of Guilty.

The learned Judge then read out the sentence of death.

Whiston was executed behind the walls of Worcester Prison at 8 a.m., 10 February 1879, by William Marwood, a man of about fifty, in accordance with the Private Execution Act, witnessed only by officials. Members of the press were excluded.

THE MURDER OF
LITTLE JIMMY WYRE AT WOLVERLEY

BERROW'S WORCESTER JOURNAL, 7 JULY 1888

On the 1st of June two men were cutting down trees at Highwood, near Wolverley, Kidderminster. It was warm work and they were thirsty. Nearby was an unoccupied cottage called Highwood, owned by a farmer named James Davies, which had been unoccupied for two years. In the garden was a well, covered with timber weighed down by an old heavy furnace, to prevent the cover being moved. The thirst of the men and the thought of the cool, refreshing water made them remove the covers to get to the water. On looking into the well, which was about 30 feet deep they noticed something floating in the water which they thought was a human body. Their thirst was quickly quenched after realising it was the decomposed body of a small child floating in the water, which they were about to drink! They quickly replaced the covers and next day they told Henry Field, a local farmer and also Police Constable Edwards. A rope was obtained and a noose formed on the end, and together they fished out the partly dressed body of a small child, which was badly decomposed. The post-mortem by Mr. Howell, surgeon, said that it was a male child aged about four years and had been in the water at least three months, and it had a tooth missing from the lower jaw.

PC Walker, who also assisted with the recovery of the body, stated that the chemise the child had on had been identified by Mrs. Roden, who had given it to his mother, Mrs. Wyre. On this information the child was identified as James Wyre, known as Jimmy, the son of Thomas Wyre and his wife. There was also a daughter. Mrs. Roden was their next door neighbour.

PC Walker immediately went looking for Thomas Wyre, and found him at Mamble on the 4th of June and arrested him, and took him to Kidderminster Police Station and locked him up, and charged him on suspicion of causing the death of his son.

William Roden and his wife and children lived next door to the Wyre family at 'Bird's Barn'. They had known them for five or six years. His wife had made the chemise. Jimmy had been last seen by Mr. Roden being carried, with a shawl around him, by his father, Thomas Wyre, who said he was taking the boy to his grandmother at Kidderminster, at 5.30 on the morning of the 3rd of March.

The wife of Wyre was a loose woman who had had a number of affairs, and due to her infidelity they decided to split up. His wife would leave her little girl with a friend and go into service, and Wyre would take his son, aged four, to his mother's at Kidderminster. Wyre, at the end of his tether, with no wife, no job and no future, was in a very confused state of mind with a young child to care for. At one point he was seen standing in the middle of the road as if he was lost and did not know what to do or

where to go. They were living at Bird's barn and had agreed to break up, and at 5.30 on the morning of the 3rd of March, he left home with his son. Intending to take the boy to his grandmother, Wyre changed his mind, and made his way to Highwood cottage and uncovered the well.

The Wyres were not very well off; they had two children, Jimmy and an older girl, who often played with Elizabeth Roden's children. Elizabeth passed down some of her children's clothing to the Wyres as they were 'bad off', and added that sometimes the children did not have enough to eat and she gave them food. They were a poverty-stricken family receiving hand-me-downs and charity from others. Margaret Wyre was the mother of the prisoner. She lived at Kidderminster and said that the last time she had seen her grandson was at Christmas.

Worcester, 21 July 1888
Before the hanging, Wyre's wife left without seeing him or visiting him; she left for the New World. He had a long criminal record of petty crimes. He had attempted to violate Mary Ann Bytheway, the illegitimate daughter of his wife, aged four and a half, but was discharged due to lack of evidence.

When asked where the boy was, and how he was, Wyre gave various answers. It was only by the chance discovery by the two thirsty timber cutters that the truth was known. His wife meanwhile had gone into service at Woverton. Wyre, now at a loose end, wandered about the neighbourhood, doing nothing. The identification of the body was difficult due to the advanced state of decomposition which rendered the corpse beyond recognition. The mother could not be called as she could not give evidence against her husband.

His wife was a servant at the Salway Arms at Woverton. For about three months he stayed, off and on, at the house of his sister in Kidderminster. He was found at Mamble on the 4th of June and on being asked where his son was, he said with his wife.

It was suggested that poverty was the reason for the crime, or inconvenience to the parents, who were splitting up. The judge in summing up told the jury it was not for them to decide on a motive, as to whether the child's death was due to poverty or other circumstances, or if he was just an inconvenience to his parents.

The jury retired at 5.15 and after half an hour returned a verdict of guilty. The judge, after giving the usual dismal ditty, put on the black cap and proceeded with the death sentence.

The prisoner bowed his head and wept. A reprieve was applied for, but was denied. James Berry was the executioner. He had just hung Robert Upton at Oxford, for the murder of his wife. Many people came to see this infamous hangman when he arrived, out of morbid curiosity. He arrived two days before his services were required, at Foregate Street station, dressed in a black coat, silk top hat and a flower in his buttonhole. The gallows was set up in the wheelhouse, and on the day of the execution a crowd of about 150 to 200 people gathered outside the prison gates. The bell began to toll a few minutes before eight and the black flag was raised shortly afterwards.

Wyre apparently ate a hearty breakfast and was visited by the chaplain, and a few minutes before eight Berry arrived at his cell and pinioned his hands. He was then escorted to the wheelhouse, accompanied by the tolling of the bell, where the scaffold was assembled, and positioned beneath the beam, where Berry made everything ready, the cap being drawn over his face, the noose adjusted and his ankles strapped. On the

stroke of eight the bolt was withdrawn and Wyre fell into the abyss beneath his feet, his neck broken. After hanging the usual time he was cut down and placed in an elm coffin. Berry, his task now complete, caught the 10.15 train from Foregate Street.

The confession of Wyre included the words 'I did it, but I don't know why'. He thought a lot of his wife, but admitted that one man was never enough for her. His wages were sent to him from the farmer who employed him at Mamble, less the sum of 10 pence for washing.

He talked to the chaplain and unburdened his mind about the conduct of his wife, to whom he had been married for six years, and about the many men she had had liaisons with.

She did not visit him in gaol and was said to have left the area with another person and emigrated.

Wyre was thirty years old, born near the Clee Hills and had lived in the surrounding areas of Staffordshire, Salop, Herefordshire and Worcestershire. He had a criminal record dating back to 1874, consisting of stealing, cruelty to animals, stealing peas at Brierley Hill, larceny, being charged as being a rogue and vagabond at Brierley Hill, stealing a drinking horn, stealing bread, housebreaking and assault on two young girls. He led a lazy, vagabondish sort of life for years.

A little before the cord was fixed about his neck, and while the executioner was making it ready, he said to the person abovementioned, "Now I feel the truth of that promise, 'As thy day is, so shall thy strength be.'" When the cap was drawn over his face, and the jailor asked him to give a signal with his handkerchief, he replied with all the calmness of a man in the most easy circumstance – "I am ready."

FINIS

The above are the final words of Henry Young, executed for forgery at Worcester, 21 March 1805.